原點

學會平面設計中難懂的數學題＆美學邏輯，
最基礎的版型理論

版型研究室

the Layout Book

2nd Edition

往雅晴————譯

Gavin Ambrose｜**Paul Harris**

設計是令元素排列最符合特定目的之計劃。

查爾斯・伊姆斯 Charles Eames

老黑膠廠（Old Vinyl Factory）的
黑膠聯誼廳（Vinyl Lounge）外觀，
位於英國海斯，由麥耶斯考設計工
作室（Studio Myerscough）設計，
第 56 頁有主題介紹。

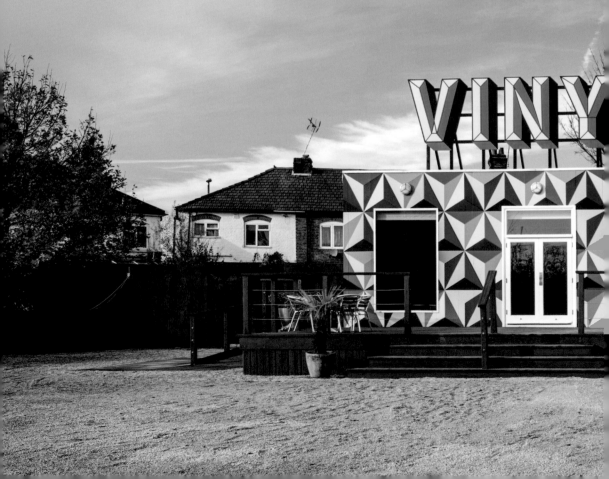

平面設計是個體性、詭奇性、異端、非凡、嗜好與樂興的天堂。

喬治・桑塔亞那 George Santayana

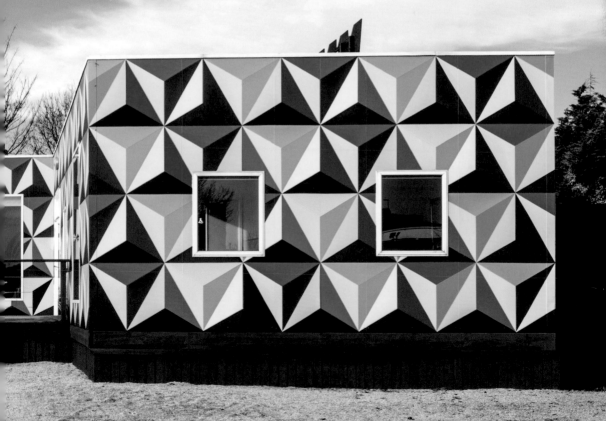

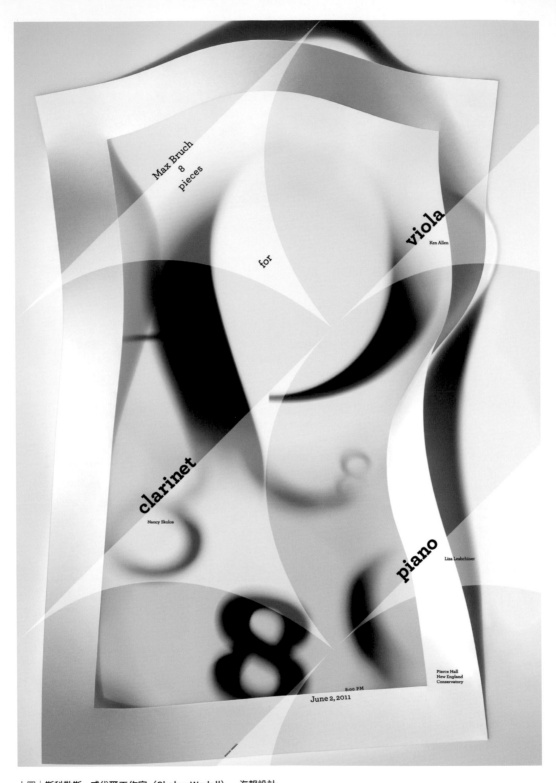

上圖│斯科勒斯 - 威代爾工作室（Skolos-Wedell）　海報設計

布魯赫八首小品室內樂演奏會。這張獨立發行的演奏會海報，宣傳馬克斯·布魯赫（Max Bruch）的單簧管、中提琴及鋼琴三重奏音樂會。海報由傾斜的排字，搭配字體和圖像，組合成整體構圖。

本書集合全球古今的排版範例，包含許多重要平面設計師的案例，
為排版的創意運用提供豐富多變的參考可能。

19 July, 2043

THOUSANDS FLOCK TO 'TROPICAL' THAMES BEACHES

09 May, 2056

DEER REINTRODUCED IN REGENT'S PARK

上圖｜帽子戲法設計公司（hat-trick Design） 版面設計
土地證券（Land Securities）「尋找倫敦未來」活動的個案研究版面，將無意義標語以報
紙標題的形式簡單安排，留白空間環繞著大字體，使文字更有力道。

目次

Introduction｜關於本書 **12**

Chapter 1｜Historical Context
歷史背景 **15**

排版小史 Historical Context **16**
數值與比例 Numbers and Proportion **20**
黃金分割 The Golden Section **22**
范‧德‧格拉夫準則 The Van de Graaf Canon **28**
維拉爾‧德‧歐內庫爾圖形 Villard de Honnecourt's Diagram **32**
費波那契數 Fibonacci Numbers **34**
從優數 Preferred Numbers **38**
特殊數字 Special Numbers **40**
柯比意 Le Corbusier **44**

Chapter 2｜Basic Principles and 'Rules'
基本原則和「規範」 **47**

敘事：閱讀內容 Narrative – What We Read **48**
閱讀頁面的方式 How We Read a Page **50**
節奏 Pace **51**
圖案與造型 Pattern and Form **56**
頁面上的形狀 Shapes on a Page **58**
點與圈 Dots and Circles **62**
線條 Lines **66**
平衡 Balance **72**
相對與絕對測量 Relative and Absolute Measurements **76**
動態矩形 Dynamic Rectangles **77**
比例 Proportion **78**
國際標準化組織 ISO **80**
書本尺寸 Book Sizes **84**

Chapter 3｜Grids and Formations
網格與構形 **87**

網格的構造 Anatomy of a Grid **88**
螢幕上的網格 The Screen-based Grid **90**
網格 The Grid **92**
欄 Columns **93**
書溝與欄間 Gutters and Alleys **94**
場區或模組 Fields or Modules **96**
基線網格 The Baseline Grid **98**
動態元素 Dynamic Elements **100**
多欄網格 Multi-column Grids **104**
方向 Orientation **108**
角度 Angles **110**
橫列 Broadside **116**
強調 Emphasis **120**

Chapter 4 │ **Objects on a page**
頁面上的物件 **123**

版面設計詞彙 The Vocabulary of Layout Design **124**
煉金術還是研究應用？ Alchemy or Studied Application? **126**
並置 Juxtaposition **136**
字體排印 Typography **132**
行距與字型 Leading and Fonts **136**
斷字齊行 Hyphenation and Justification **137**
對齊 Alignment **140**
內縮 Indentation **142**
階層 Hierarchy **148**
行寬 Measure **156**
層次 Layers **158**
留白 White Space **166**
質地與字體排印色調 Texture and Typographic Color **172**
襯邊 Passepartout **178**

Chapter 5 │ **Interviews**
訪談 **181**

鮑伯‧奧福第許／奧福第許與瓦利納 Bob Aufuldish ／ Aufuldish & Warinner **182**
安妮特‧史達默／飛行粒子 Annette Stahmer ／ fliegende Teilchen **186**
南西‧斯科勒斯與湯瑪斯‧威代爾／斯科勒斯 - 威代爾
Nancy Skolos and Thomas Wedell ／ Skolos-Wedell **188**
彼得‧道森／層級設計 Peter Dawson ／ Grade Design **196**
麥可‧沃辛頓／更真？感實性時代的藝術
Michael Worthington ／ More Real? Art in the Age of Truthiness **198**
大衛‧皮爾森／字體圖像 David Pearson ／ Type as Image **202**

Chapter 6 │ **Exercises**
練習 **205**

練習一：范‧德‧格拉夫網格 The Van de Graaf Grid **206**
練習二：海報設計 Poster Design **208**
練習三：編列複雜性 Editorial Complexity **210**
練習四：動作排版 Action Layout **212**
練習五：平面國 Flatland **213**
練習六：視覺敘事與記敘形式 Visual Storytelling and Narrative Form **214**
練習七：6×6 協作式活版印刷專題 6×6 Collaborative Letterpress Project **216**

Acknowledgements │ **誌謝 218**

本書探討最廣義的排版，舉例觀察排版涉及日常生活的眾多元素，以及平面設計的商業操作，並展示基本原則的應用方式。交互融合是本書的中心理念，跨越熟悉的事物，便能湧現概念與靈感的泉源。

說到「排版」，就想到設計師排列頁面上的物件、影像和字體這些常見的平面設計元素。雖然平面設計產業相當年輕，其遵循的許多原則卻在上古時代就已察覺，文藝復興時期又重新洞悉。我們熟悉印刷頁面、建築外牆、海報、電影和數位格式，然而在這些多元、豐富設計的領域背後，重點原則早已存在數個世紀。這些原則將超越設計師現正面對的任何技術發展與限制，於未來世代持續使用。本書要談的是引導排版的整體原則，和這些原則的形成背景，並非描述技術發展的確切歷史及其對版面設計的影響。我們的重點將會是相關案例，像是頁面尺寸選擇及建立和諧平衡，還有我們在安排自己日益複雜的生活時，排版所擔任的協助角色。

書中納入各學科的概念，供藝術家、新媒體開發師及印刷設計師等人彼此溝通所需，傳達各自的考量、解決手法及理念。依文藝復興的精神，無論熟稔的或陌生的事物，都有值得深究之處，不同學科的不同實質挑戰，都同樣需要在實驗與商業操作間取得平衡。設計師希冀為老問題、新挑戰找到更好的解決方式，而許多解答的關鍵就在於研究前人過往發現的基礎原則。

隨著資訊經網路等媒體的自由流動持續發展，人們暴露於大量資訊與多元文化。設計也不例外，因此不但出現更多變化與實驗，大家對一般事物的期待也更高。當科技進步，平面設計不再是神祕的領域，反而能觸及任何人。如此一來也產生一些問題，例如：人們為何對某個版面有反應，對另一個版面卻沒感覺？為什麼這個字體排印元素比那個更合適？重複現在或抄襲過往，並不能解決設計師的問題，但設計師瞭解了本書討論的原則，便具備整個設計生涯都受用的知識。當我們進入流暢的數位媒體時代，工作、生活及媒體消費方式也不斷演進。接下來二十年、十年或甚至五年，將出現什麼？更重要的是，我們會給未來帶來什麼？

對頁 | **Poulin+Morris** 環境標誌
紐約雪城的新屋公共傳播學院（S. I. Newhouse School of Public Communications）的環境標誌局部，運用線條鼓勵觀者水平移動，誘使人們進行探索。

mmunications

id. Meeting each other and forming it

don't care. Watch TV, listen to the radio, enjoy a magazine? Who not? It

Be is good!

u Smith

he most accomplished teachers who can be foun

Newhouse changed my life for

NEWHOUSE SCHOOL

We gratefully acknowledge the following alumni and friends whose generous gifts have made Newhouse 3 and the renovation of the Newhouse Complex possible.

ay for 100% ... 997

test of democracy is free

Newhouse School

"Music is the fountain of youth.

n, professors and othe

14

上圖｜迪歐‧凡‧杜斯伯格（Theo van Doesburg）、萊茲洛‧莫霍里－那基（Laszlo Moholy-Nagy）　書籍封面　1925
該書封呈現原始的形色、秩序感和剛銳的文字構圖，是一件融合排版設計與藝術的作品。

CHAPTER 1

第一章

歷史背景

人類從第一次以楔形文字在泥板上記錄訊息，就有整理資訊的需求。古埃及人導入了幾何學，古希臘人則加上比例，古典風格的概念與資訊的陳列發展至今，我們能輕鬆瀏覽報章、網站或操作手冊的高級排版。本章指出平面設計整理資訊時使用的排版歷史基礎，許多仍在運用中，或是可於當今依循的手法中窺見其形。

無論科技如何進步，還是能應用某些互古不變的原則組織及陳列資訊。確實我們生活在充滿新媒體的數位時代，但毫不減損古典概念中平衡與和諧的重要性。

●排版設計如何演變成今天的模樣？

排版設計的發展是為了解決在頁面上組織元素的問題。西元前 4000 年，人類初次在泥板刻上楔形記號記錄資訊以來，一直有整理頁面資訊的需求。綜觀寫作史，過去到現在所能及的科技與理念，驅使著排版設計，並持續推行。舉例來說，最早的手稿根據人們寫作或刻劃的模式來排版，可能是直書或橫書（東方或西方書體）、由左至右或由右至左（希臘文或希伯來文）。古埃及人向世人發表幾何學，古希臘人則介紹了比例及古典風格意識。

這些早期原則為人們閱讀圖文的方式立下規範，因此隨著印刷的發展，頁面排版也沿用人們的文字閱讀模式。活字印刷術開發後，其他排版元素如行距與邊界要求、標準字型大小及頁面尺寸等，則逐漸標準化。現今使用的頁面和邊界尺寸大多來自訂立已久的設計準則，例如以黃金分割（golden section）制定頁面大小、或是以范‧德‧格拉夫（Van de Graaf）方法將頁面作適當分配。

●最初的設計原則

人類喜歡解決問題，會試著尋求周遭世界的道理，並加諸秩序。不同時代的設計師都曾想藉不同方式解決問題。古代「設計師」取材於大自然，嘗試瞭解天然運行的模式，並複製他們所觀察解析到的原則。黃金準則（Golden Rule）和費波那契數（Fibonacci numbers）的發展，以及近代柯比意（Corbusier）的模矩（Modulator），都是這類範例。

十九世紀末及二十世紀初，設計被當作政治宣言的工具。當時有社會主義（Socialism）、共產主義（Communism）、帝國主義（Imperialism）及資本主義（Capitalism）政治變革的推動，加上兩次世界大戰的大規模毀滅與傷害，為極度創新及充滿質疑的年代。

●現代主義興起

一次世界大戰結束後誕生的現代主義（Modernism），拒絕那些因戰爭產生的原則，希望打造嶄新、和善的世界。現代主義反對維多利亞風格美術工藝運動（Victorian Arts & Crafts movement）及新藝術運動（Art Nouveau）那些源於自然界的花俏設計以及襯線字體，推崇工業時代的科技希望。裝飾風藝術（Art Deco）與包浩斯（The Bauhaus）創造了第一套無襯線字體，兩者也屬於更廣泛的現代主義運動，目標是理性與幾何形狀的重現。

對頁｜荷蘭馬斯垂克陶瓷中心（Centre Céramique）以品牌為主題的展覽
博伊‧巴斯蒂安斯（Boy Bastiaens）的展出作品即是為排版提供秩序、訂定節奏的例子。此展覽對歷年來發展的圖形語言提出深刻見解，呈現想法、創作與生產之間的連結，說明設計是問題解決過程中的溝通工具。

建築創作即設立秩序。為誰設立秩序呢？機能與物件。

—— 柯比意 Le Corbusier

此時代重視功能與進步，以「形隨機能」為號召，建立了許多目前使用的手法。現代主義重視整體效益大過個人表達，熱衷於不對稱的排版形式，嚴守網格制度，並強調留白與無襯線字體。揚・奇肖爾德（Jan Tschichold）的作品《新字體排印》（Die Neue Typographie）是此時指標性的排印著作，其中列出許多這類新準則，受到荷蘭風格派運動（De Stijl）、包浩斯，及國際主義設計風格（International style，又稱瑞士風格 Swiss style）採納。阿德里安・弗魯提格（Adrian Frutiger）創造的 Univers 字體可說是這項哲學的巔峰，這套字體家族（font family）包含超過五十種版本，且具有編號系統（弗魯提格表，Frutiger's Grid），是執著於秩序的典範。

二十世紀下半，已開發國家逐漸富裕，興起商業主義和心理學等理解人類行為的新方法。1950 年代，平面設計學科誕生自當時所稱的「商業藝術」之中。隨著消費者文化和消費者雜誌的出現，平面設計運用心理學家和行為科學家破解人類行為的新發現，成為建立品牌及教育消費者的工具。透過這些作品，我們得以理解人們掃視頁面尋找促銷花招時，眼睛的運動方式，並藉此明瞭熱點的特性，以及留白與色彩的重要性。

●後現代主義時代

1960 年代，後現代主義（post-modernism）甚至對「確切真實」（reliable reality）這個概念的存在提出懷疑，透過分裂、不連貫與單純荒謬的手法，解構權威與既有秩序，破壞思考模式背後的參考架構與假設，以探究建立意義的方式。最初將後現代主義加以闡釋的人是法國哲學家雅克‧德希達（Jacques Derrida），其受到弗里德里希‧尼采（Friedrich Nietzsche）影響，他在論述中發掘並認識到那些——潛在的、無法言明的、暗含的——假設、理念及架構，它們形成了思想與信仰的根基。對於當代的影響是「具體呈現」（manifestation）這個概念，即非典型且經常屬實驗性質的操作手法之應用。

如今數位科技已讓排版超越紙張，到達長寬無限的虛擬頁面。設計師還能加入點選連結，叫出延伸資訊或動態內容。然而即便擁有數位發展，排版設計仍尋求解決相同的問題：在空間內安排元素以供閱讀。我們現在能輕鬆無礙地瀏覽內含廣泛資訊的複雜排版，極大原因是長久以來組織資訊的原則持續有效。

排版設計回收再循環過去理念，同時不斷演化。當今觀者已是成熟的排版消費者，能熟練地從繁雜中擷取資訊，但各種不同的媒體亦供應更多內容，爭奪觀眾的注意力。意即，排版設計師的工作一方面本質上數十年如一日，另一方面卻要在更複雜的環境中執行呈現。因此，《版型研究室》第二版的目標是提供讀者排版設計發展上的基礎知識，並介紹排版在現代的變化。

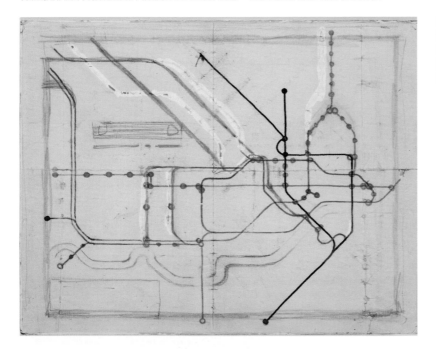

哈利‧貝克（Harry Beck）倫敦地鐵路線圖草稿
為發展經典的倫敦地鐵路線圖而繪製的草稿，展現排版對閱覽的助力。

自然法則
不過是神的數學理念。

—— 歐幾里得 Euclid

●幾何學與古典準則的發源

古埃及人率先發展幾何學,描述物體的空間關係,以便進行尼羅河漫灘的田地劃分等工作。幾何學英文 Geometry,意思就是土地量測。隨著基礎工具的進步,開始建立幾何原則,例如埃及人用來打造巨大石材建築的 3:4:5 直角三角形。這些基本原則演變至今,稱為古典典範(classical ideals),涉及比值、黃金比例、建築技術和裝飾,並於古希臘時期(西元前 490 至 323 年)達到巔峰。歐幾里得(Euclid)約在西元前 300 年撰寫的《幾何原本》(The Elements of Geometry)也許是流傳至今最早的幾何學文本,從頭實際說明平面與三維幾何的知識,現代稱之為歐幾里得幾何(Euclidean geometry)。雖然幾何學、古典原則和當代設計間互相關聯,光靠遵循幾何原則並不能保證做出好的設計。但知曉這些原則,有助於製作排版設計,並瞭解某些設計、頁面排版學說及標準是如何發展的。

歐幾里得的原則相當直覺明瞭,因此許多至今仍在流傳。舉例來說,歐幾里得幾何的基本量測項目是角度和距離,角度是絕對的,依據的基本單位是直角;距離則是相對的,基本單位是一線段。歐幾里得系統中,面積與體積由距離計算而來:邊長五公分的正方形,占據二十五平方公分的面積。歐幾里得原則使頁面大小或文字區域等物件的量測和設計更加精準,並顯示出設計與世界緊密共生,借助其他學科成長進步。設計並非獨立存在、完全論述性的,而是承襲幾何學、數學、環境與材料科學等更多學科。其他學科的進展,也影響設計師創作與面對設計挑戰的方式。

約瑟夫・瑪羅德・威廉・泰納(J.M.W. Turner)根據歐幾里得幾何創作的圖畫,即歐幾里得幾何構形的範例。

裝飾畫板

《聖家族逃往埃及》（*The Flight into Egypt*）與《耶穌十二齡講道》（*Dispute of Jesus in the Temple*）裝飾畫板（illuminated panel），畫作根據我們將於第 34 頁講述的費波那契數列（Fibonacci number sequence），明確分割空間比例。衍生自費波那契數的頁面比例再三出現在設計中，證明此數列的變通性，能在各種不同設計情境中創造和諧效果。

古騰堡聖經

《古騰堡聖經》（*The Gutenberg Bible*）中的一頁。此書為歐洲第一本印刷品，西元 1454 至 1455 年左右由約翰尼斯・古騰堡（Johannes Gutenberg）出版於德國美茵茨。請留意文字方塊在頁面上的位置，與四邊界和整體頁面的空間關係各有不同。

●數值、比例與空間關係

瞭解設計原則，即是瞭解數值、比例與空間關係的運作與互動方式。這些特質的使用與發展經年累月形成所謂「神聖」分割比例，視覺感受之美好、空間之和諧，能令觀者「直覺認可」。

這類分割比例有些存在於大自然，有些則是人工創作。許多組織原則都發現於藝術史早期，後續才轉變為字體與頁面排版原則。

接下來幾頁中，我們將介紹黃金分割（golden section）及其如何融入設計，還有數字對排版設計的影響。上方的頁面設計範例中，可在《聖家族逃往埃及》（左上圖）見到一些數值系統的運用。五與八這兩個數字應用在畫板的比例，也引導出頁首頁尾的邊界比例。但並非所有排版都適用此分割比例，與其盲從特定作品使用的原則，成功的構圖更在於挑選出能配合內容或格式的恰當手法。

● **黃金分割的運用**

黃金分割大約根據 8：13 的比例分配，可見於藝術、設計和建築等各類學
科之中。費波那契螺旋（Fibonacci spiral）便是以相同比例與數值關係為基
礎，可當作構圖工具，幫助設計師或藝術家排列或縮放不同元素，創造和諧
的效果。

將一線段按此比例分割（如下圖），則長段與短段間的關係和全段與長段間
的關係相同。因此，基於此比例構築的設計看起來特別順眼。在平面設計領
域中，黃金分割因能提供和諧的比例而成為紙張尺寸的標準，其原則亦是讓
設計達到平衡的一種方法。但隨著現代平面設計師常用的電腦排版軟體多以
線性測量取代比例分配，黃金分割的應用狀況已不如從前。

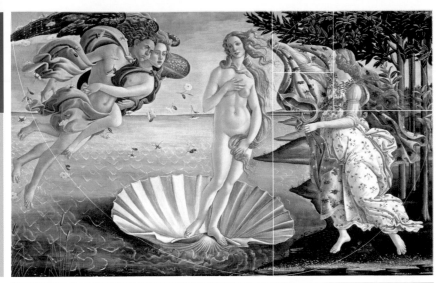

維納斯的誕生

《維納斯的誕生》(*The Birth of Venus*) 是西元 1486 年山德羅‧波提且利(Sandro Botticelli) 為佛羅倫斯的梅迪奇 (Medici) 家族繪製的作品。畫布的長寬比 1.614，幾乎是完美的黃金比例 (1.618)。畫面中的重點元素位在黃金比例點上，如維納斯的肚臍剛好由水平黃金比例線穿過，且處於維納斯身高的黃金比例點。

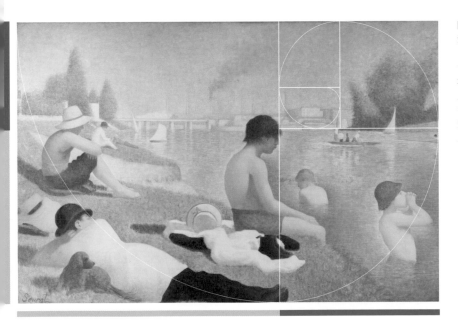

阿尼埃爾的浴場

法國畫家喬治‧皮埃爾‧秀拉 (Georges Pierre Seurat) 1884 年的作品《阿尼埃爾的浴場》(*Bathers at Asnières*)。此例使用黃金分割找到趣味中心，或構成「甜蜜點」。畫作的甜蜜點位於主角額頭上，帽沿與眉頭的交點。

新字體排印

此海報根據黃金比例排版，內容介紹德國字體排印師奇肖爾德及其影響深遠的著作《新字體排印》（*Die Neue Typographie*）。運用黃金比例進行排版時，各文字方塊的擺放受到指引，且透過探索與頌揚數值與空間的關係，有助強調字體排印之美。古典美學的比例及觀點，與現代主義者的當代瑞士字體排印，第一眼看似不搭，但兩者被奇肖爾德成功地融合了。

Im VERLAG DES BILDUNGSVERBANDES der Deutschen Buchdrucker, Berlin SW 61, Dreibundstr. 5, erscheint demnächst:

JAN TSCHICHOLD
Lehrer an der Meisterschule für Deutschlands Buchdrucker in München

DIE NEUE TYPOGRAPHIE

Handbuch für die gesamte Fachwelt und die drucksachenverbrauchenden Kreise

Das Problem der neuen gestaltenden Typographie hat eine lebhafte Diskussion bei allen Beteiligten hervorgerufen. Wir glauben dem Bedürfnis, die aufgeworfenen Fragen ausführlich behandelt zu sehen, zu entsprechen, wenn wir jetzt ein Handbuch der **NEUEN TYPOGRAPHIE** herausbringen.

Es kam dem Verfasser, einem ihrer bekanntesten Vertreter, in diesem Buche zunächst darauf an, den engen Zusammenhang der neuen Typographie mit dem **Gesamtkomplex heutigen Lebens** aufzuzeigen und zu beweisen, daß die neue Typographie ein ebenso notwendiger Ausdruck einer neuen Gesinnung ist wie die neue Baukunst und alles Neue, das mit unserer Zeit anbricht. Diese geschichtliche Notwendigkeit der neuen Typographie belegt weiterhin eine kritische Darstellung der **alten Typographie**. Die Entwicklung der **neuen Malerei**, die für alles Neue unserer Zeit geistig bahnbrechend gewesen ist, wird in einem reich illustrierten Aufsatz des Buches leicht faßlich dargestellt. Ein kurzer Abschnitt „**Zur Geschichte der neuen Typographie**" leitet zu dem wichtigsten Teile des Buches, den **Grundbegriffen der neuen Typographie** über. Diese werden klar herausgeschält, richtige und falsche Beispiele einander gegenübergestellt. Zwei weitere Artikel behandeln „**Photographie und Typographie**" und „**Neue Typographie und Normung**".

Der Hauptwert des Buches für den Praktiker besteht in dem zweiten Teil „**Typographische Hauptformen**" (siehe das nebenstehende Inhaltsverzeichnis). Es fehlte bisher an einem Werke, das wie dieses Buch die schon bei einfachen Satzaufgaben auftauchenden gestalterischen Fragen in gebührender Ausführlichkeit behandelte. Jeder Teilabschnitt enthält neben **allgemeinen typographischen Regeln** vor allem die Abbildungen aller in Betracht kommenden **Normblätter** des Deutschen Normenausschusses, alle andern (z. B. postalischen) **Vorschriften** und zahlreiche Beispiele, Gegenbeispiele und Schemen.

Für jeden Buchdrucker, insbesondere jeden Akzidenzsetzer, wird „Die neue Typographie" ein **unentbehrliches Handbuch** sein. Von nicht geringerer Bedeutung ist es für Reklamefachleute, Gebrauchsgraphiker, Kaufleute, Photographen, Architekten, Ingenieure und Schriftsteller, also für alle, die mit dem Buchdruck in Berührung kommen.

typ. tschichold

INHALT DES BUCHES

Werden und Wesen der neuen Typographie
Das neue Weltbild
Die alte Typographie (Rückblick und Kritik)
Die neue Kunst
Zur Geschichte der neuen Typographie
Die Grundbegriffe der neuen Typographie
Photographie und Typographie
Neue Typographie und Normung

Typographische Hauptformen
Das Typosignet
Der Geschäftsbrief
Der Halbbrief
Briefhüllen ohne Fenster
Fensterbriefhüllen
Die Postkarte
Die Postkarte mit Klappe
Die Geschäftskarte
Die Besuchskarte
Werbsachen (Karten, Blätter, Prospekte, Kataloge)
Das Typoplakat
Das Bildplakat
Schildformate, Tafeln und Rahmen
Inserate
Die Zeitschrift
Die Tageszeitung
Die illustrierte Zeitung
Tabellensatz
Das neue Buch

Bibliographie
Verzeichnis der Abbildungen
Register

Das Buch enthält über **125 Abbildungen**, von denen etwa ein Viertel **zweifarbig** gedruckt ist, und umfaßt gegen **200** Seiten auf gutem Kunstdruckpapier. Es erscheint im Format DIN A5 (148× 210 mm) und ist biegsam in Ganzleinen gebunden.

Preis bei Vorbestellung bis 1. Juni 1928: **5.00** RM
durch den Buchhandel nur zum Preise von **6.50** RM

Bestellschein umstehend ➡

24

Im VERLAG DES BILDUNGSVERBANDES der Deutschen Buchdrucker,
Berlin SW 61, Dreibundstr. 5, erscheint demnächst:

JAN TSCHICHOLD

Lehrer an der Meisterschule für Deutschlands Buchdrucker in München

DIE NEUE TYPOGRAPHIE

**Handbuch für die gesamte Fachwelt
und die drucksachenverbrauchenden Kreise**

Das Problem der neuen gestaltenden Typographie hat eine lebhafte
Diskussion bei allen Beteiligten hervorgerufen. Wir glauben dem Bedürfnis, die aufgeworfenen Fragen ausführlich behandelt zu sehen, zu entsprechen, wenn wir jetzt ein Handbuch der **NEUEN TYPOGRAPHIE**
herausbringen.

Es kam dem Verfasser, einem ihrer bekanntesten Vertreter, in diesem
Buche zunächst darauf an, den engen Zusammenhang der neuen
Typographie mit dem **Gesamtkomplex heutigen Lebens** aufzuzeigen und zu beweisen, daß die neue Typographie ein ebenso notwendiger Ausdruck einer neuen Gesinnung ist wie die neue Baukunst und
alles Neue, das mit unserer Zeit anbricht. Diese geschichtliche Notwendigkeit der neuen Typographie belegt weiterhin eine kritische Darstellung der **alten Typographie**. Die Entwicklung der **neuen Malerei**, die für alles Neue unserer Zeit geistig bahnbrechend gewesen ist,
wird in einem reich illustrierten Aufsatz des Buches leicht faßlich dargestellt. Ein kurzer Abschnitt „**Zur Geschichte der neuen Typographie**" leitet zu dem wichtigsten Teile des Buches, den **Grundbegriffen
der neuen Typographie** über. Diese werden klar herausgeschält,
richtige und falsche Beispiele einander gegenübergestellt. Zwei weitere Artikel behandeln „**Photographie und Typographie**" und
„**Neue Typographie und Normung**".

Der Hauptwert des Buches für den Praktiker besteht in dem zweiten
Teil „**Typographische Hauptformen**" (siehe das nebenstehende
Inhaltsverzeichnis). Es fehlte bisher an einem Werke, das wie dieses Buch
die schon bei einfachen Satzaufgaben auftauchenden gestalterischen
Fragen in gebührender Ausführlichkeit behandelte. Jeder Teilabschnitt
enthält neben **allgemeinen typographischen Regeln** vor allem die
Abbildungen aller in Betracht kommenden **Normblätter** des Deutschen
Normenausschusses, alle andern (z. B. postalischen) **Vorschriften** und
zahlreiche Beispiele, Gegenbeispiele und Schemen.

Für jeden Buchdrucker, insbesondere jeden Akzidenzsetzer, wird „Die
neue Typographie" ein **unentbehrliches Handbuch** sein. Von nicht
geringerer Bedeutung ist es für Reklamefachleute, Gebrauchsgraphiker,
Kaufleute, Photographen, Architekten, Ingenieure und Schriftsteller,
also für alle, die mit dem Buchdruck in Berührung kommen.

typ. tschichold

INHALT DES BUCHES

Werden und Wesen der neuen Typographie
Das neue Weltbild
Die alte Typographie (Rückblick und Kritik)
Die neue Kunst
Zur Geschichte der neuen Typographie
Die Grundbegriffe der neuen Typographie
Photographie und Typographie
Neue Typographie und Normung

Typographische Hauptformen
Das Typosignet
Der Geschäftsbrief
Der Halbbrief
Briefhüllen ohne Fenster
Fensterbriefhüllen
Die Postkarte
Die Postkarte mit Klappe
Die Geschäftskarte
Die Besuchskarte
Werbsachen (Karten, Blätter, Prospekte, Kataloge)
Das Typoplakat
Das Bildplakat
Schildformate, Tafeln und Rahmen
Inserate
Die Zeitschrift
Die Tageszeitung
Die illustrierte Zeitung
Tabellensatz
Das neue Buch

Bibliographie
Verzeichnis der Abbildungen
Register

Das Buch enthält über **125 Abbildungen,** von
denen etwa ein Viertel **zweifarbig** gedruckt ist,
und umfaßt gegen **200** Seiten auf gutem Kunstdruckpapier. Es erscheint im Format DIN A5 (148 ×
210 mm) und ist biegsam in Ganzleinen gebunden.

Preis bei Vorbestellung bis 1. Juni 1928: **5.00** RM
durch den Buchhandel nur zum Preise von **6.50** RM

Bestellschein umstehend ➡

●當代設計中的黃金分割

設計過程中,不一定要刻意採取黃金分割等操作。然而,由於黃金分割反映天然美觀及自然中出現的比例,許多設計師作品中喜歡運用此比例,不令人意外。黃金比例有直覺性,人眼會不自主地對生成的空間關係有所反應。以下排版覆蓋上黃金分割圖形,就能清楚看到比例之美。黃金分割應用在排版中,能導引文字和圖像元素的配置,調控兩者之間、及其與頁面其他部分之間的空間關係。此處理還製造出重要的留白或開放空間,框住文字與圖像,讓內容產生最大衝擊。

下圖及對頁｜廣闊設計事務所(Vast)　刊物設計
廣闊設計事務所出版的刊物《及時一補,省縫九針》(*A STITCH IN TIME SAVES NINE*)。即使設計師原本沒有意識到,仍展現出符合黃金分割與費波那契螺旋的配置。「我很想說一切是透過數學創作的,但設計師直覺還是占了些許重點。有或沒有,非常明確。直覺會成為你的第二天性。」

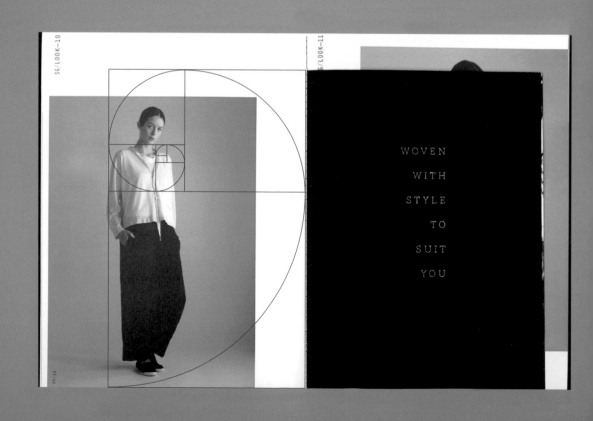

WOVEN
WITH
STYLE
TO
SUIT
YOU

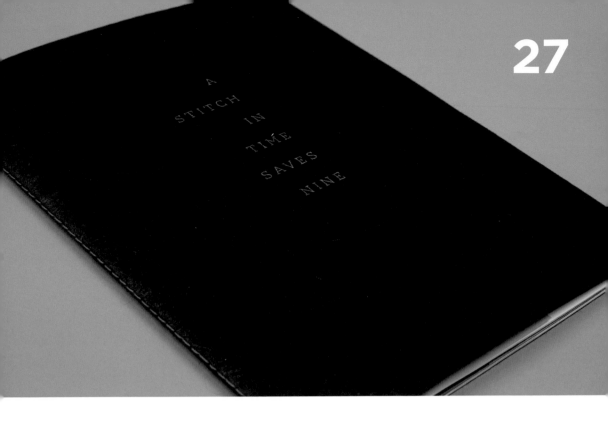

A STITCH IN TIME SAVES NINE

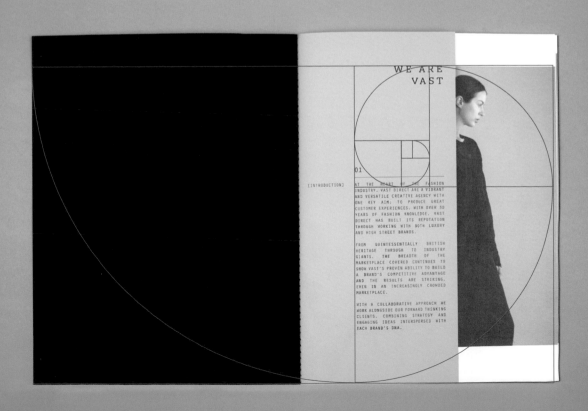

WE ARE VAST

[INTRODUCTION]

01

AT THE HEART OF THE FASHION INDUSTRY, VAST DIRECT ARE A VIBRANT AND VERSATILE CREATIVE AGENCY WITH ONE KEY AIM: TO PRODUCE GREAT CUSTOMER EXPERIENCES. WITH OVER 50 YEARS OF FASHION KNOWLEDGE, VAST DIRECT HAS BUILT ITS REPUTATION THROUGH WORKING WITH BOTH LUXURY AND HIGH STREET BRANDS.

FROM QUINTESSENTIALLY BRITISH HERITAGE THROUGH TO INDUSTRY GIANTS, THE BREADTH OF THE MARKETPLACE COVERED CONTINUES TO SHOW VAST'S PROVEN ABILITY TO BUILD A BRAND'S COMPETITIVE ADVANTAGE AND THE RESULTS ARE STRIKING, EVEN IN AN INCREASINGLY CROWDED MARKETPLACE.

WITH A COLLABORATIVE APPROACH WE WORK ALONGSIDE OUR FORWARD THINKING CLIENTS, COMBINING STRATEGY AND ENGAGING IDEAS INTERSPERSED WITH EACH BRAND'S DNA.

第一步
首先畫一條垂直中線，將頁面一分為二。

第二步
畫出全頁的兩條對角線，再從中軸頂端朝兩頁各畫對角線，得到前兩個有效點。

第三步
再由此兩個有效點朝正上方拉出直線至頁緣。

第四步
從這兩條直線與頁緣的交界處，各畫一條斜線連接至另一有效點，產生范・德・格拉夫準則的兩個關鍵點。

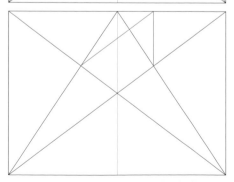

●繪製準則

范・德・格拉夫準則歷史性地重建了早期書商（如古騰堡）可能使用的操作，將頁面分割成美觀比例，配置文字方塊和邊界。任何長寬比的頁面都能應用范・德・格拉夫準則，讓設計師建立固定比例的文字方塊，且邊界為頁面的 1/9 與 2/9，相當漂亮。

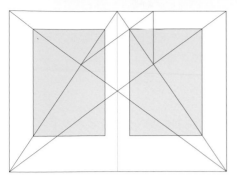

第五步

由關鍵點畫水平線與垂直線，延伸至碰到對角線處，即框出文字區域。兩頁排版時，中間兩個內邊界將接合，與外邊界等寬，形成美觀平衡的版面。

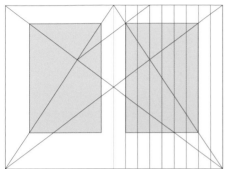

第六步

利用內邊界的寬度，將頁面平分為九欄。

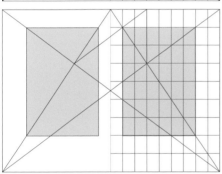

第七步

上邊界的高度則用來將頁面平分為九列。

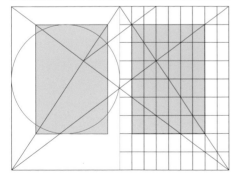

第八步

另一種方式是以頁寬為直徑畫圓，可構成相同的比例。

運用范·德·格拉夫準則，將使內邊界為外邊界的一半，上邊界為下邊界的一半。整體邊界比例，內：上：外：下，是 2：3：4：6。奇肖爾德受范·德·格拉夫作品的影響，尤其是 2：3 的比例，讓文字方塊與頁面長寬比相同，且文字區域高度等於頁寬。

●范‧德‧格拉夫準則的變化型

遵循范 ‧ 德 ‧ 格拉夫準則等古典原則的基本印刷排版，其厲害之處在於能發展演化出更活潑的排版。舉例來說，如前頁所示，採用基本范 ‧ 德 ‧ 格拉夫準則排版，改變文字和圖像分配的位置，就能提昇設計的節奏與活力。

運用奇肖爾德黃金準則（Tschichold's golden canon）的 9 × 9 頁面分割法，可縮小文字方塊的空間，生出空間給圖像，同時維持基礎的和諧比例，如這兩頁的範例所示。

上圖顯示如何運用網格排放主體文字和邊註，並產生圖像空間。

這些縮圖展現出網格運用的靈活性，提供同一份文字不同的排版處理。

維拉爾・德・歐內庫爾圖形

十三世紀的法國建築師歐內庫爾，開發出一套稱為維拉爾圖形（Villard's Figure）的系統，能將一直線分成 1／3、1／4、1／5 等有邏輯又和諧的線段。設計師應用維拉爾圖形可繪製各式網格，包括 6×6、9×9 及 12×12。

維拉爾系統的起手式，與范・德・格拉夫使用的初始對角線構造相同。以交叉點當作第一焦點，分別拉出水平和垂直線至邊線處，再以直線連接兩邊線交點，形成三角形的斜邊。此斜邊與版面中線頂端延伸的對角線相交處，即為焦點，由此點拉出水平線與垂直線表示文字方塊。

亦可利用此熱點再構成一個三角形：拉出水平線至中線，從此交點拉出斜邊，連接至原始三角形與上邊線的交點。重複此步驟，即產生逐步擴大範圍的文字方塊。無論使用哪組方格，邊界比例都保持 2：3：4：6 不變。

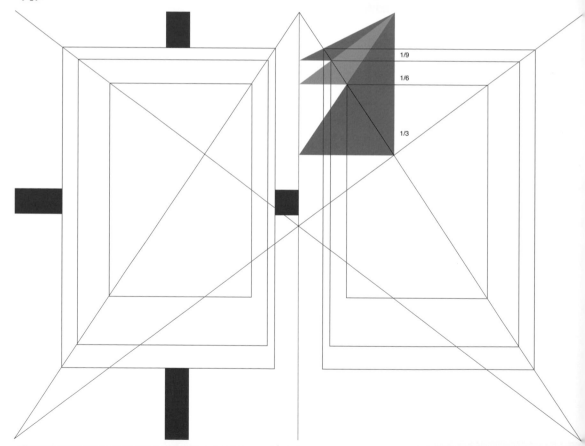

本圖說明如何使用維拉爾系統製作不同大小的文字方塊區，且所有文字方塊邊界都具有 2：3：4：6 的比例。

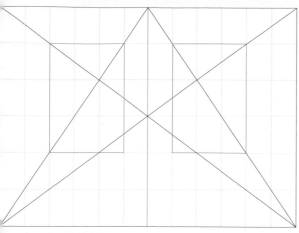

以 1／3 三角形為基礎的 6 × 6 網格

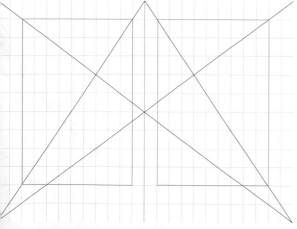

以 1／6 三角形為基礎的 9 × 9 網格

這些圖片說明了如何以維拉爾系統繪製 6 × 6、9 × 9 及 12 × 12 網格。其中每個小方塊的比例都與文字方塊相同，故彼此自然和睦。這樣一來設計師在不同元素的配置與縮放方面皆不需揣摩，還能達到舒適的視覺效果。維拉爾系統可供不同格數的網格，因此設計師能彈性處理各種數量與類型的元素。例如，數量繁多無法排版在 6 × 6 網格上的小段文字或小型圖片，可使用 12 × 12 網格安排。

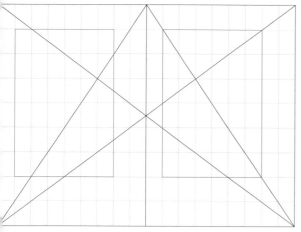

以 1／9 三角形為基礎的 12 × 12 網格

費波那契數列簡稱費氏數列，其中每一數值為前兩個數值的和。費氏數列的命名，來自首位在自然界比例中觀察到此序列的數學家費波那契（又稱比薩的李奧納多 Leonardo of Pisa）。費波那契數與 8：13 黃金比例有直接關係，這兩個數字都屬於費氏數列。數列於本版面底端列出。

對平面設計師來說，費波那契數提供現成的和諧數值系統，在設計中可用在頁面比例的構成、網格排列的發展，及字體大小的選擇。

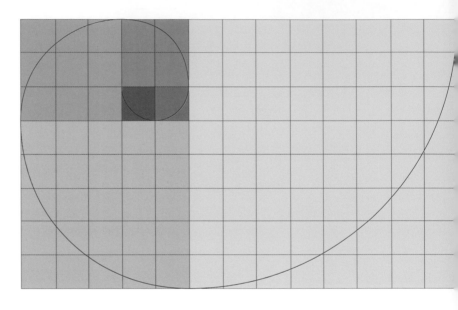

以費氏數列排列的正方形
每個正方形內含的方塊格數依據費氏數列，第一個正方形含一格，第二個正方形亦含一格，第三個正方形為 2×2 格，接下來是 3×3、5×5 及 8×8，永無止境地螺旋展開。

疊上螺旋線，可觀察到此數列之美。

0, 1, 1, 2, 3, 5, 8, 13, 21, 3
987, 1597, 2584, 4181, 67

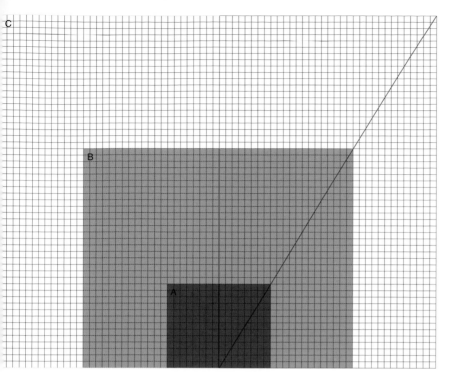

頁面尺寸
此圖中有三種不同的頁面大小，分別採費波那契數列中的連續兩個數構成。簡易除法即可發現數值與黃金比例的關係：取連續兩個費氏數列數值，較大的數除以較小的數，則商數等於黃金分割的比例 1：1.618。

費氏數列不僅限於繪製螺旋，還能引導構圖發展、定位各元素，令其在空間中相互關聯，彼此和諧。

可利用費波那契數將頁面分割為協調的比例。請見網格上呈現的頁面，尺寸分別是一對對連續的費波那契數。

上例中，最小的頁面（A）是 8 × 13 格，次之的（B）是 21 × 34 格，最後（C）是 34 × 55 格。

5, 89, 144, 233, 377, 610,
10946, 17711, 28657...

●應用

配合費氏數列進行排版,將產生等比例的網格和等比例的文字方塊配置,使頁面迷人好讀。與其說是根據確切的量測數據打稿,網格製作更多是美學評斷的過程,因此運用費氏數列有助於減少臆測,繪製出賞心悅目的比例。

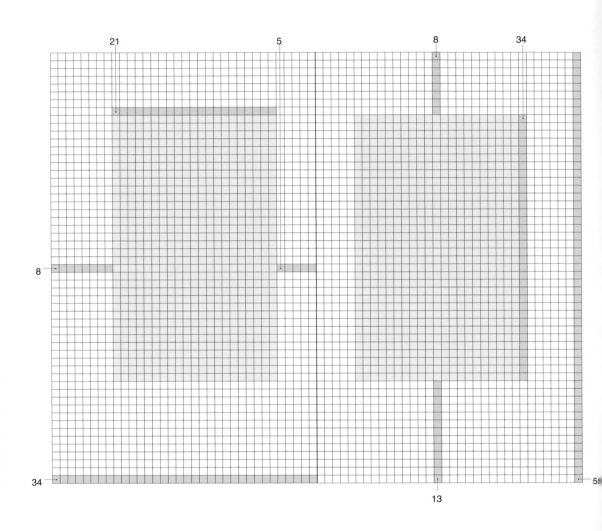

0, 1, 1, 2, 3, 5, 8, 13, 21, 34, 55

內邊界 Inner margin

外邊界 Outer margin
上邊界 Top margin

下邊界 Bottom margin

文字方塊寬度 Text block width

網格寬度 Grid width
文字方塊高度 Text block height

網格高度

對頁的 34 × 55 網格上，文字方塊距離內邊線 5 格，距離外邊線與上邊線各 8 格，至下邊線有 13 格。如此擺放文字方塊時，網格寬度與文字方塊高度達成一體連貫的效果，設計師也能放心知道，最終空間關係會和諧互襯，藉此節省工作時間。

下圖為 21 × 34 網格，其文字方塊取用費氏數列中的數字 3、5 及 8。

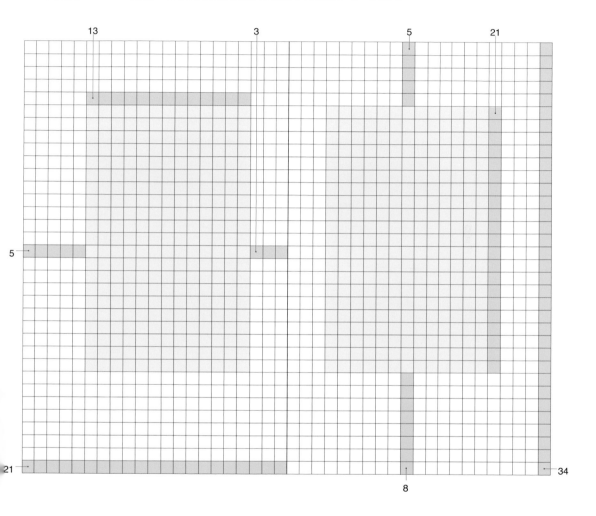

0, 1, 1, 2, 3, 5, 8, 13, 21, 34, 55

內邊界 Inner margin

外邊界 Outer margin
上邊界 Top margin

下邊界 Bottom margin

文字方塊寬度 Text block width

網格寬度 Grid width
文字方塊高度 Text block height

網格高度 Grid height

在設計師為其設計挑選數值時,從優數系統提供了另一種便利的手法。從優數與費氏數列一樣,讓人不用多加揣摩,就能確保各分割區塊間連貫和睦的關係,可取代隨機或等值的數字。對設計師來說,使用雷納數值(Renard values)等從優數系統的寶貴之處,在於能輕鬆將線段或空間切分為比簡單均分更有趣的比例,如下方的線段所示。

● 雷納數列

雷納從優數系統將 1 到 10 的數值分成 5 段、10 段、20 段或 40 段,其實就是取 10 的 5 次、10 次、20 次或 40 次方根(分別為 1.58、1.26、1.12、1.06)。這樣一來,任兩個連續數的比值皆相同,形成等比數列。雷納數列由字母「R」開頭表示,最基礎的 R5 數列可化作五個簡單數值:1.00、1.60、2.50、4.00 及 6.30。下面兩組網格都是利用雷納數列構成的,一個為非對稱型,一個為對稱型。此網格繪製手法納入設計師平常不會使用的數列,為空間關係的發展提供不同觀點。數列的有限性降低了變異量,卻不減創意的可能性及排版變化的方式,是此手法的精妙處之一。原本可能相當複雜的網格製作流程,因而變得流暢。底下範例使用 R10 數列。

非對稱網格

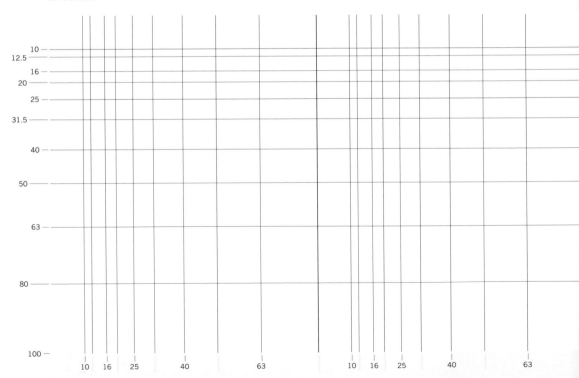

以下是各種雷納數列，其中「R」指的就是雷納（Renard）：

R5：10、16、25、40、63、100。

R10：10、12.5、16、20、25、31.5、40、50、63、80、100。

R20：10、11.2、12.5、14、16、18、20、22.4、25、28、31.5、35.5、40、45、50、56、63、71、80、90、100。

R40：10、10.6、11.2、11.8、12.5、13.2、14、15、16、17、18、19、20、21.2、22.4、23.6、25、26.5、28、30、31.5、33.5、35.5、37.5、40、42.5、45、47.5、50、53、56、60、63、67、71、75、80、85、90、95、100。

對稱網格

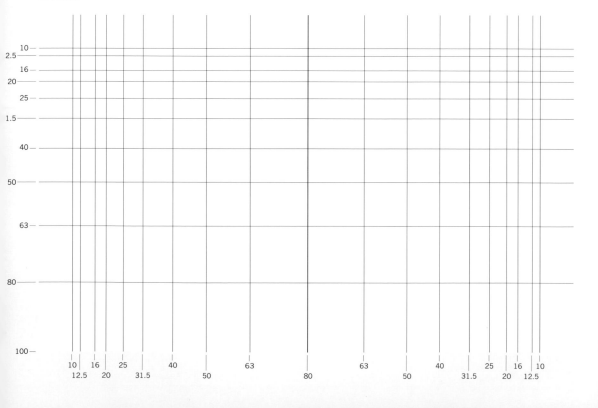

數字在設計中的內涵意義，絕不僅止於測量。一般而言，使用奇數進行排版設計，創造出的不對稱性常常比偶數排版的秩序性更有趣。

二這個數字在排版設計時非常好用，可以代表不同元素間的二元性、並置或對立，也可以顯現出平衡與相依。不過，設計中最常使用的數字應該是三。

・三等分原則

三等分原則是建構有趣排版的組織手法，將頁面水平及垂直各分三等分，重點元素則擺在此簡單網格的視覺焦點上。許多數位相機觀景螢幕有三等分原則的輔助線，幫助攝影師完成有魅力的構圖。

・三項法則

多應用於文學，三項法則指出「三項一組」在本質上，就是比其他數量更吸引人。三項一組的文句如「我來，我見，我征服」（Veni, vidi, vici）令人印象深刻，一系列的字詞或陳述也打造出相當張力。

・萬物皆三

拉丁片語「Omne trium perfectum」意指三件一組的事物皆完美，三即是全。透過此概念，說明了三等分或三項組為何能成為設計和廣告標語中有力的圖像工具。

三等分原則

此圖說明三等分原則可以如何在排版或設計上創造熱點。如你所見，熱點位置與數學方法準確切分出的區域並不完全對應。研究顯示，人眼掃過影像時，會停留在這些點上，故定義為熱點。設計師運用此相關知識，據以排列元素，幫助觀眾獲取重要資訊。

●視覺中心

影像或設計作品當中的數學中心（math-ematical ceter）並非視覺中心（visual center），視覺中心應位於數學中心的稍右上處，如右圖所示。視覺中心表示作品活躍的視覺焦點，可以利用來放置熱點，讓觀者視線停留。

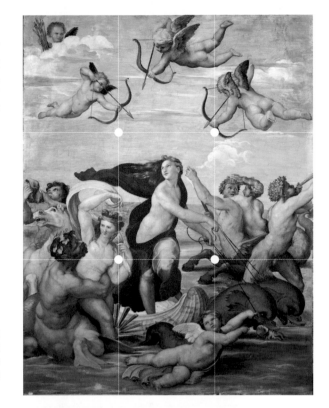

嘉拉提亞的凱旋

《嘉拉提亞的凱旋》（*Triumph of Galatea*）是拉斐爾（Raphael）於西元 1512 年為羅馬法列及那宮繪製的濕壁畫。我們用線條分割畫面，剛好框住畫面中央的嘉拉提亞女神。上方的三位愛神對稱排列，箭頭落在頂端熱點之上。

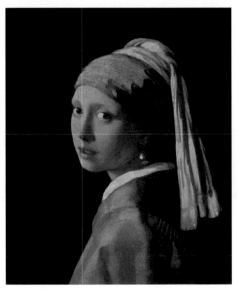

少女肖像

約翰尼斯·維梅爾（Johannes Vermeer）的少女肖像（*Portrait of a Young Girl*）畫作，一般稱為《戴珍珠耳環的少女》（*The Girl with the Pearl Earring*）。人臉的視覺焦點是嘴巴和眼睛，此作品中維梅爾捨棄數學中心，利用主角的眼鼻創造視覺中心。

41

Tuileries Gardens, Paris

The Beach, Brighton

Palace Pier, Brighton

London Zoo, London

上圖及對頁｜帽子戲法設計公司（hat-trick Design）　書籍內頁
該設計公司的書籍作品《三三三》（*Threee*），以簡單的三項組合為主題進行觀察，呈現出活潑又好玩的構圖。

●柯比意與費波那契

建築師柯比意（本名查理 - 艾杜阿·江耐瑞 Charles-Edouard Jeanneret）是現代建築風格的主要倡導者。其建立的模矩（Le Modulor）量測系統，以人體的量測數據、雙倍單位、費波那契數及黃金比例為基礎，提供「一系列和諧的量測數值，適合人體尺度，可各方應用於建築和機械物品」。模矩系統本質上像一把計算尺，依六呎高人士的身高和肚臍高度作黃金分割，數值間的增量值為 27 或 16。

模矩

下圖為柯比意模矩網格的示意圖。

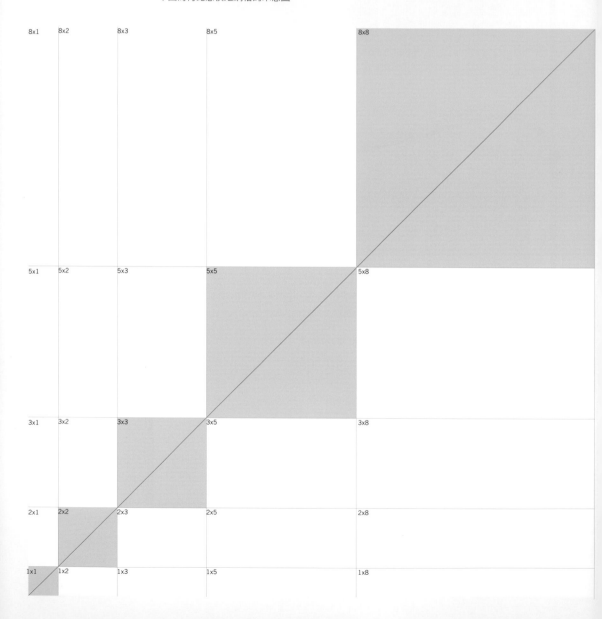

以下數個圖示，說明排版不同形狀和大小時，柯比意的網格如何提供多種相異可能性及高靈活度。
矩形皆由網格和柯比意的計數手法建立，故彼此間能和諧共處。

46

上圖｜ **Frost* Design　雜誌設計**
此為《弦波拉》（Zembla）雜誌的版面，這個設計挑戰了我們對於文字欄位的概念。一般我們想到的牢固、穩定且規律的文字欄位，在此完全不符合。

CHAPTER

2

基本原則和「規範」

任何設計的過程都參照了某些特定原則，也許是刻意選擇遵循，或可能存心略過或加以顛覆。整體原則代表著長久以來，設計與排版建構發展出的各式手法。

本節提到的原則，多年來應用在生產賞心悅目、清晰達意——這兩項是每一位平面設計師都要面對的挑戰——的設計。這些原則影響設計過程裡最中心的決策，因為它們為空間分配提供了標準。

設計師對排版設計的基本原則和規範有了概括瞭解，就等於擁有一套經得起考驗的工具，能著手於任何設計問題。更熟悉這些工具後，設計師將開始察覺到契機，有創意地背離原則，或進一步發揮原則。

●敘事類型

設計可能包含明確的敘事，為個別設計元素的視覺溝通提供意義。敘事透過排版中設計元素的選擇、擺放及順序產生。清楚明白敘事結構，對於成功的設計十分重要。

・線性敘事

線性敘事（Linear narrative）由刊物的開頭到末尾，一頁一頁順序發展出涵義。

・雙線敘事

當單一作品或單一頁面上出現超過一件敘事，則稱為雙線敘事（Dual narrative），例如傳達政治及環境訊息。征服者威廉（William the Conquerer）於 1066 年成為英國國王，描述此故事的貝葉掛毯（Bayeux Tapestry）即為著名的雙線敘事範例。主畫部分呈現接連發生的歷史事件，掛毯上下緣則說明當時的日常生活狀況。尼可森・貝克（Nicholson Baker）1988 年的著作《夾層》（*Mezzanine*）是較近代的例子，內容關於一位男子在午休時間的腦中運作。男子腦中大量盤旋的想法，在作品中化為延伸的註腳文字，還經常占據頁面大部分，提供第二組敘事。

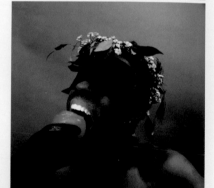

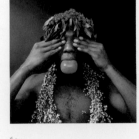

本頁｜無題設計（**Untitled**）　書籍內頁
無題設計的書籍作品《斷層線》（*Fault Lines*），前半本文字排在圖片邊線下方，後半本則改列
在此線上方。如此一來，文字與圖片間的敘事關係由雙方對等默默轉為文字居上位。

人們會直覺地經由果決掃視圖像或設計，尋找能夠參透閱覽對象的切入點，試著從中擷取資訊。設計師若能掌握此程序，即使是相當複雜、內含許多項目的設計，也能協助引導觀者悠遊其中。

●瀏覽頁面

觀者總會尋覓設計的切入點，對他們認識、瞭解的事物投以關注，並藉此事物的指示找到更多資訊。人類受色彩與動態吸引，因此設計師可將設計中的元素作策略性佈置，抓住讀者的注意力。

切入點是供觀者進入設計的途徑，通常位於左上方（A），因為這是我們自然會優先望向的位置。接著眼光將往中央（B）掃過，然後才朝外部（C）尋求資訊。

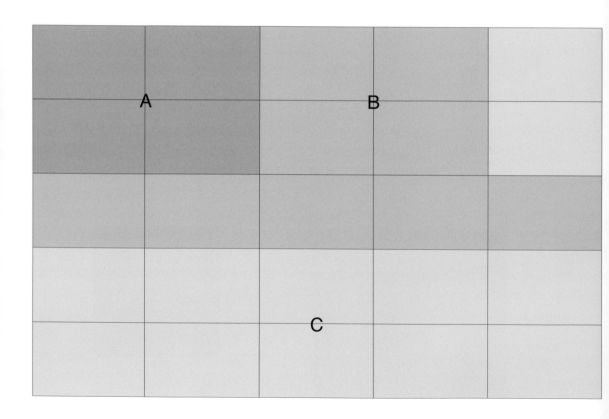

印刷資訊常喜歡有固定節奏，供讀者一路順暢地閱覽。若刊物太乏味，讀者很可能看不下去。排版能在文字中加入間隔，幫助維持讀者的興趣，並供休息暫停，思考接受到的資訊，期待後續發展。

●動作

所有創作都很自然地擁有動作和節奏變化。電影或樂曲放慢或加快速度時，我們很容易感受得到。電影的節奏改變來自劇情膠著與否、對話起伏及配樂穿插，而設計出版物時也能以同樣的考量進行。書籍的敘事節奏隨章節變更，且能作不同的排版和設計方法調整。出版計劃常使用組版圖，在出版物裁切、折合及修邊前，呈現頁面的順序及位置安排，有助於規劃出版物的節奏。讓文字全部在刊物的前半、圖像擺最後，或是將圖像平均散佈在刊物之中，兩者產生的節奏很不相同。

●音樂記譜類比法

如下圖所示，可將刊物規劃成模仿音樂節奏。在這份單純的頁面規劃圖中，白色的文字頁若與彩色的影像頁輪流排列，即形成模擬簡單節奏的重複音調：一二、一二、一二。

根據同樣的原則，也能建立更複雜的視覺韻律。將此重複節拍與對比節拍融合構成複節奏，則如下方呈現的多層示意圖，即使在這樣簡單的頁面規劃圖中，設計也更顯活潑。利用此方法可用來配置特殊的色彩或色調、排放影像，或設計師選擇的其他元素。

本頁及對頁 I 湯瑪斯 · 曼司公司（**Thomas Manss & Company**） **書籍內頁**

此為諾曼 · 福斯特爵士（Sir Norman Foster）的建築事務所專書。書中藉文字頁與相片的交錯來控制節奏，令人每次翻頁都充滿期待。

New German Parliament, Reichstag
Berlin, Germany 1992–1999

Our transformation of the Reichstag is rooted in four related issues: the Bundestag's significance as a democratic forum, an understanding of history, a commitment to public accessibility, and a vigorous environmental agenda. The reconstruction takes cues from the old building; as we peeled away the layers of history we revealed striking imprints of the past – mason's marks and Soviet graffiti – scars that have been preserved as a 'living museum'. But in other ways it represents a radical departure: within its heavy shell it is transparent – its activities on view. Public and politicians enter the building together and the public realm continues on the roof. The cupola is symbolic of rebirth, but it is also fundamental to our daylighting and ventilation strategies. And the building provides a model for the future by burning renewable vegetable oil to produce electricity. In its vision of a public architecture that redresses the ecological balance, providing energy rather than consuming it, lies one of its most intrinsic expressions of optimism.
Norman Foster

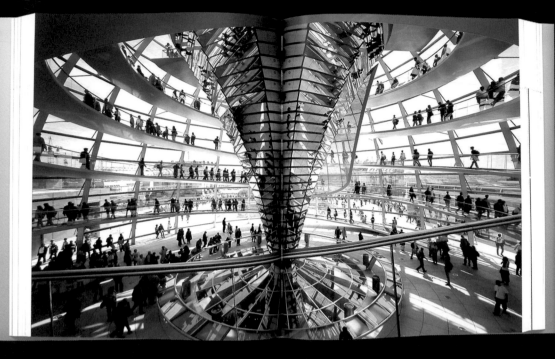

The Reichstag has given us the opportunity to stretch the boundaries of two issues which I believe are particularly significant in the future growth of cities: the role of public space and the quest for a more ecologically responsive architecture. It is in these two areas that I believe the Reichstag truly raises the threshold of expectations and offers a model for a coming generation of public buildings, whether they be new structures or historical buildings given a new lease of life. *Norman Foster, Rebuilding the Reichstag, Weidenfeld & Nicolson 2000*

Without question this provides one of the world's best sky walks. The Reichstag looks out over a glorious sea of trees extending into the distance. No matter that it is nothing like as high as the Eiffel Tower or the Empire State – Berlin is largely a low-rise city. *Marcus Binney, The Times, 19 April 1999*

The building's tour de force is the dome. Its skin looks delightfully delicate from a distance. A futuristic, double spiral of ramps spins lightheartedly within. It has already become the city's new icon, visible everywhere among the skyline of new glass and metal office towers and the dour domes and spires of the imperial past. *Herbert Muschamp, rebuilding the Reichstag, New York Times, 13 July 1999*

There was a residual fear that the 'new' Reichstag would still be seen as a symbol of bombastic Teutonism. Foster and Partners overcame this problem with greater effect than anyone had bargained for. The dome's steel ribs give a much needed focus to many streets and routes in the city centre and the sun glinting on the dome's surface promotes a serenity beyond the governmental district. *David Jenkins, AA Files*

I think the final compromise of the dome is quite wonderful; it must have been frustrating for Foster but he should be very happy with the result. Die Zeit recently ran a series of articles about the new Berlin republic and they had the drawing of the dome as a signature for the articles – it was not even finished at the time, but already it was an icon. *Christoph Ingenhoven, World Architecture, April 1999*

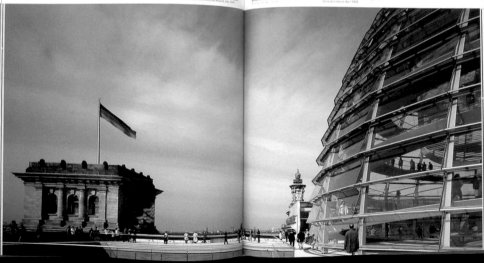

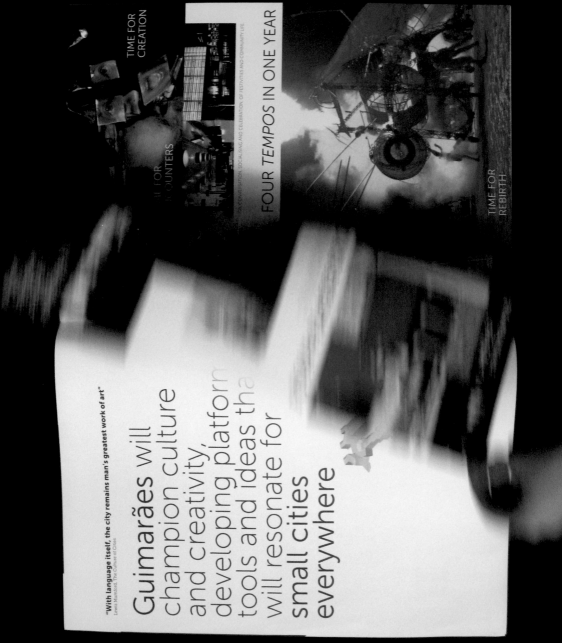

TIME FOR
CREATION

TIME FOR
ENCOUNTERS

...ON, CONVERSATION, SOCIALISING AND CELEBRATION. OF FESTIVITIES AND COMMUNITY LIFE.

FOUR *TEMPOS* IN ONE YEAR

TIME FOR
REBIRTH

Guimarães will
champion culture
and creativity,
developing platform
tools and ideas tha
will resonate for
small cities
everywhere

●建立驚奇感

改變節奏，能在出版品中添加驚奇感。變動圖像風格，如增加或減少留白、色彩、文字或圖像元素，會產生一絲意外，刺激讀者興趣。使用節奏變化來間隔不同類型的內容，可為讀者注入激情或保持興致，或兩者皆達成。設計出版品，尤其是設計多頁刊物時，設計師必須想著讀者翻頁時將發生什麼事？如果每一頁的畫面與感受都一樣，讀者會開始失去樂趣，要是刊物篇幅綿長則更是如此，敘事好像嗡嗡地延續不停。節奏變化是文學、電影和音樂常見的敘事操作，在排版設計中也同等重要。

對頁｜努尼斯與朋工作室（Atelier Nunes e Pã）刊物設計

刊物《吉馬良斯 2012》（*Guimarães 2012*）。葡萄牙城鎮吉馬良斯在 2012 年獲選為歐洲文化之都，這個刊物嘗試轉譯當中的大量相關發表及背後的規劃作業，讓人能以歷史演化看待整個活動，將之視為一體。

本頁｜努尼斯與朋工作室手冊內頁

不動產公司 RAR Imobiliária 手冊的內頁版面，透過顏色、文字和圖像的使用，實現許多節奏變更。

圖案與造型

想要填滿區塊，相較於使用單一顏色，圖案與造型的運用是更大膽有趣的方式，能納入多種色彩、各式形狀質地，產生更豐富的視覺效果。

圖案可用於創造氛圍，使空間更活潑新穎、舒適而不沉悶。許多公司的辦公室裝潢都強調選用圖案與造型，以增添辦公環境的活力，成為更吸引人的場所。

幾乎任何表面或物體都能當作畫布，於版面上佈置圖案與造型。舉例來說，牆壁和建築物都具有可觀的表面積供覆蓋，雖然大多只覆上低調的單一色系，但其實能接受更有張力的處置。

・鑲嵌 Tessellation

表面覆蓋鑲嵌，即是以不重疊也不留空的方式，重複或排列一種以上的幾何形狀。鑲嵌亦可為週期性，圖案與無鑲嵌的空間彼此交替。

・馬賽克 Mosaic

馬賽克是由小片彩色玻璃、石子、陶瓷或其他材質構成的圖像，例如羅馬別墅中的拼貼畫。

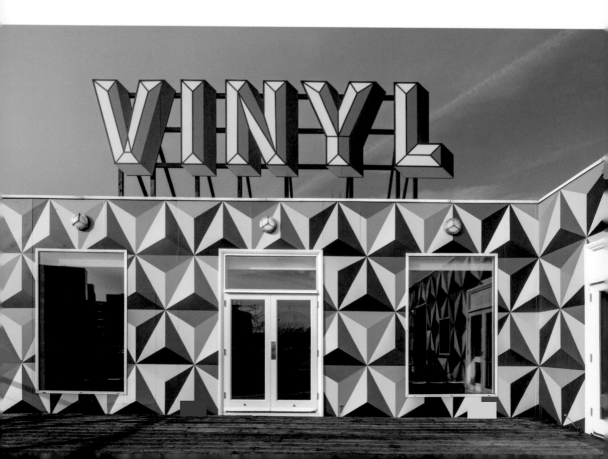

· 紋飾 Motif
紋飾是圖案的一部分，在圖案中重複出現或只出現一次。常見的裝飾性紋飾包括爵床葉（acanthus leaves）、卵錨飾（egg and dart）和渦捲裝飾（scrollwork）。伊斯蘭藝術的紋飾則有天體（celestial bodies）、動物與花卉。

· 重複 Repetition
重複指的是在整個表面上不斷出現相同影像或紋飾。如果重複圖案排得很緊密或相互連接，則可能失去本身的辨識度，融入巨大的抽象圖形之中。鮑·吉爾（Bob Gill）在《設計我的第 2 母語》（*Graphic Design as a Second Language*）書中提到：「單一影像是可以。但同樣的影像多次倍增後……往往令人無法抗拒。」

· 拼貼 Collage
拼貼技術常用到雜誌或新聞剪報，將不同形式的內容進行組合。

· 相片蒙太奇 Photomontage
相片蒙太奇技術取材於多張相片，以創作出最終圖像，其主題通常是跳脫現實的，例如詹恩·霍沃思（Jann Haworth）和彼得·布萊克（Peter Blake）為 1967 年披頭四專輯《派伯中士的寂寞芳心俱樂部樂隊》（*Sgt. Pepper's Lonely Hearts Club Band*）封面所設計的「名人群」。

上圖及對頁 | 麥耶斯考設計工作室（Studio Myerscough）黑膠聯誼廳
老黑膠廠（Old Vinyl Factory）的黑膠聯誼廳，位於英國海斯。該設計呈現重複的幾何圖案，樣貌特殊。

57

頁面上的形狀

頁面上每一點、每個記號，再小都有力量。形狀在頁面上能夠操控注意力、引導視線，或藉由重複來創造背景圖案。

形狀可作為起始或切入點，讓觀者得以理解較複雜的設計。或者，形狀本身就可能是設計的整體。添加色彩會改變形狀的能量動力，使其顯得更友善或更邪惡，注入繽紛的文化或社會意義。

阿敏·霍夫曼（Armin Hoffman）表示：「設計有很大一部分其實相當簡單，幾乎是原始的。瓦希里·康丁斯基（Wassily Kandinsky）在包浩斯就曾提出理論，認為我們本質上以一致的方式對某些形狀和顏色產生反應。」

這段發言也許有所偏限，但特定形狀的力量仍值得留意。基本形狀包括圓形或圓點、線條、正方形和三角形，是簡單好處理的單位元件，然而從圓形的平靜、方形的穩健，到三角形的動感及神祕，卻能讓觀者產生南轅北轍的反應。

幾何形狀表現出的簡單乾淨，是二十世紀初荷蘭風格派運動和包浩斯等不斷推崇的設計條件。當時讓幾何形狀搭配紅、黃、藍等原色。

也許因為形狀是抽象的，鼓勵我們於其上投射想法與理念，才具有如此力度。人類喜歡解決問題，並引用抽象形狀探索意義或連結，從中尋找存在的或虛幻的事物。三角形成為金字塔、圓形成為臉龐、方形則成為房屋。

下圖｜**大衛・皮爾森（David Pearson） 書封選輯**
該設計大方運用了特定形狀和線條。

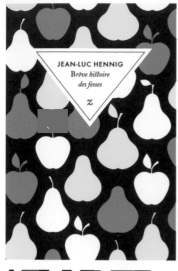

JEAN-LUC HENNIG
*Brève histoire
des fesses*

Z

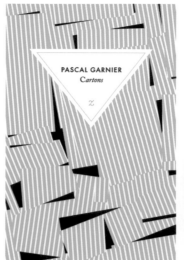

PASCAL GARNIER
Cartons

Z

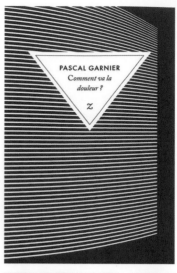

PASCAL GARNIER
*Comment va la
douleur ?*

Z

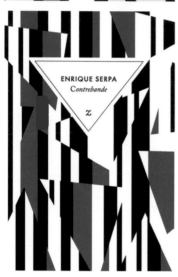

ENRIQUE SERPA
Contrebande

Z

DAVID TOSCANA
El último lector

Z

FERENC
KARINTHY
Épépé

Z

JACQUES ROUMAIN
*Gouverneurs de
la rosée*

Z

AUÐUR AVA
ÓLAFSDÓTTIR
L'Exception

Z

JEAN-MARIE BLAS
DE ROBLÈS
*L'Île du Point
Némo*

Z

要將兩套迥異的系統和諧並置，
必先具備更有深度的藝術知覺……

—— 霍夫曼《平面設計手冊》 Armin Hofmann, *Graphic Design Manual*

本頁及對頁│大衛 · 皮爾森　書封選輯
這些為 Zulma 出版社設計的書封，以鮮明呈現的形狀和圖案為特色。

點是平面藝術的基礎,能引導視線、吸引注意、納入或排除。一點色彩強調,甚至能讓設計或構圖生動起來,荷蘭畫家維梅爾就以發展此道聞名。

圓點或圓圈,和方形、三角形共同組成基本三形狀,卻常被視為其中最神祕迷人者。圓形不同於方形或三角形,沒有支開眼光的角度,因此顯得完整純粹。金柏麗・伊蘭姆(Kimberly Elam)在《網格系統》(*Grid Systems*)一書提到:「圓圈是視覺上最有力的幾何圖形,人眼無可避免地受吸引。即使非常小的圓圈,也會掠取一定的關注,故必須酌量小心使用,以免勢壓整個構圖。」圓點有著如此引人注目的特性,因此也被運用在速限等指示型路標。

●點在平面設計的重要性

圓圈具有這樣的能力,意味著設計師可利用圓點捕捉並集中觀者的注意力。圓形可以當作框架,裁除多餘的資訊,像文氏圖(Venn diagrams)那樣指定納入的內容,以此為唯一要務。點還主動引導我們找到更多、也許更重要的資訊,像是文章結尾處吊人胃口的刪節號,或目錄頁的指示。

點是最重要的圖形元素,
其操作練習特別具啟發性……

——霍夫曼《平面設計手冊》
Armin Hofmann, Graphic Design Manual

對頁 | 彼得・葛瑞格森工作室(**Peter Gregson Studio**)　**書籍封面**
當代巴爾幹小說家作品封面。當中裁成圓形的影像令人聚焦於特定細節,且失焦的畫面亦使觀者更認真察看。

Stefan Kisjov EKZEKUTOR

OKTOИХ / ШТАМПАР МАКАРИЈЕ

Маро Дука ЛАЖНО ЗЛАТО

OKTOИХ / ШТАМПАР МАКАРИЈЕ

Emil Andreev STAKLENA REKA

OKTOИХ / ШТАМПАР МАКАРИЈЕ

Елена Алексиева ВИТЕЗ, ЂАВО, СМРТ

OKTOИХ / ШТАМПАР МАКАРИЈЕ

MUNICATIONS MA

EWSPAPER

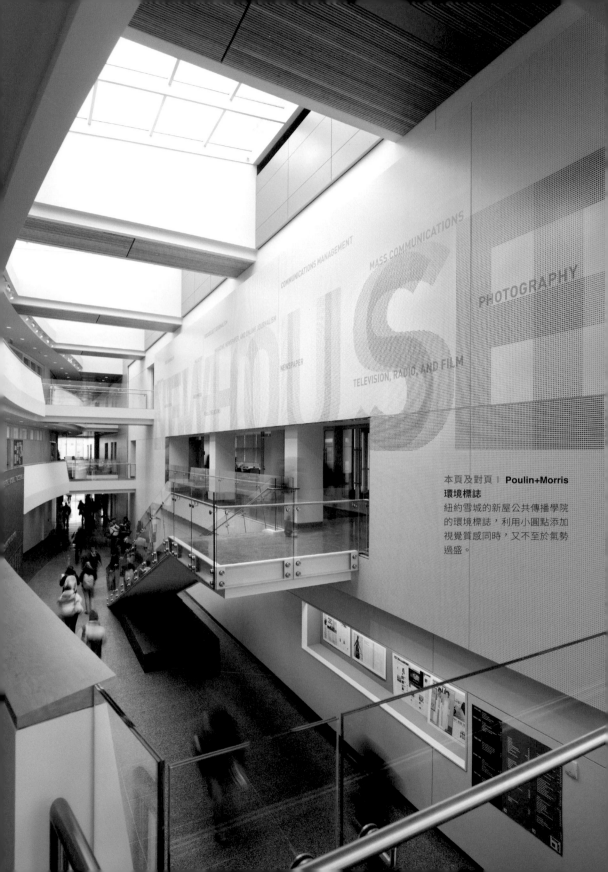

本頁及對頁｜**Poulin+Morris**
環境標誌
紐約雪城的新屋公共傳播學院
的環境標誌，利用小圓點添加
視覺質感同時，又不至於氣勢
過盛。

很難想像平面設計沒有線條該怎麼辦。線條以網格和基線網格的形式,作為構圖輔助或組織工具,讓設計過程更簡單,生產更穩定有效率。線條提供連繫與結構、調性與階層,為雕刻和繪畫帶來造型與深度。

線條的相關思辨,推動發展了平面藝術的重要原則。數世紀以來,思者琢磨於如何將線段分割為和諧比例,衍生出黃金比例等答案。十五世紀逐漸興起的消失點、透視線和視平線,則代表線條運用對藝術的革命。透視是文藝復興藝術與先前中世紀作品的分辨特性之一。

如果說點是結構與分析的最主要元素,線就擔負建築重任。線條進行連結、表達、承擔、支持、聚集和保護,還能交叉以及分支。

—— 霍夫曼《平面設計手冊》Armin Hofmann, *Graphic Design Manual*

對頁∣斯科勒斯 - 威代爾(Skolos-Wedell) 海報設計
為慶祝蕭邦(Frederick Chopin)兩百歲誕辰製作的海報《蕭邦 200》(*Chopin 200*),以一系列抽象線條表現琴鍵。此設計贏得第二十二屆波蘭華沙國際海報雙年展特別類金牌。

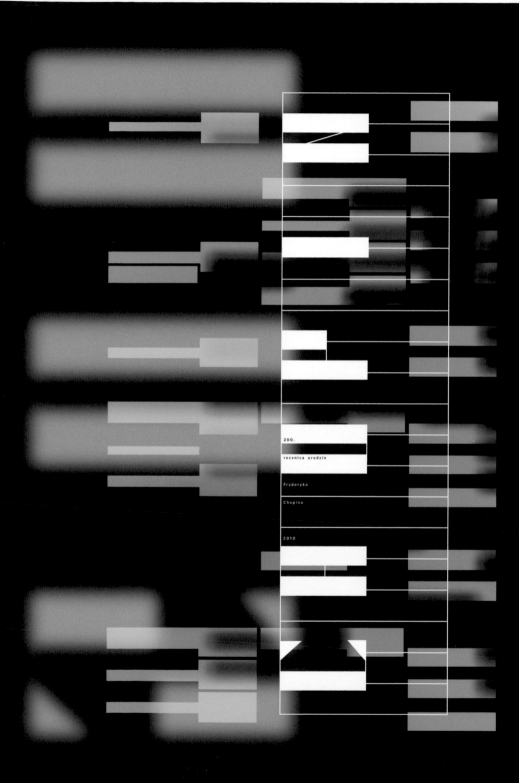

200.

rocznica urodzin

Fryderyka

Chopina

2010

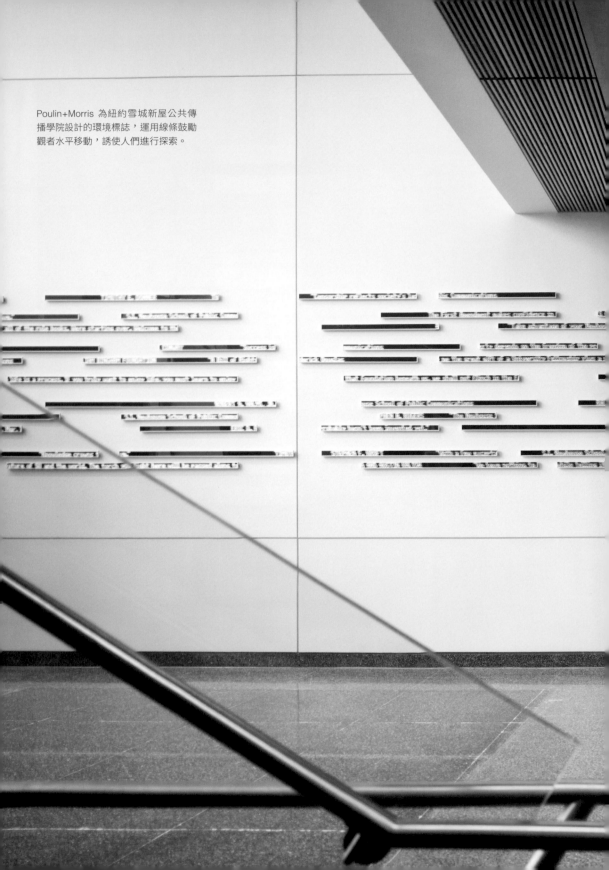

Poulin+Morris 為紐約雪城新屋公共傳播學院設計的環境標誌，運用線條鼓勵觀者水平移動，誘使人們進行探索。

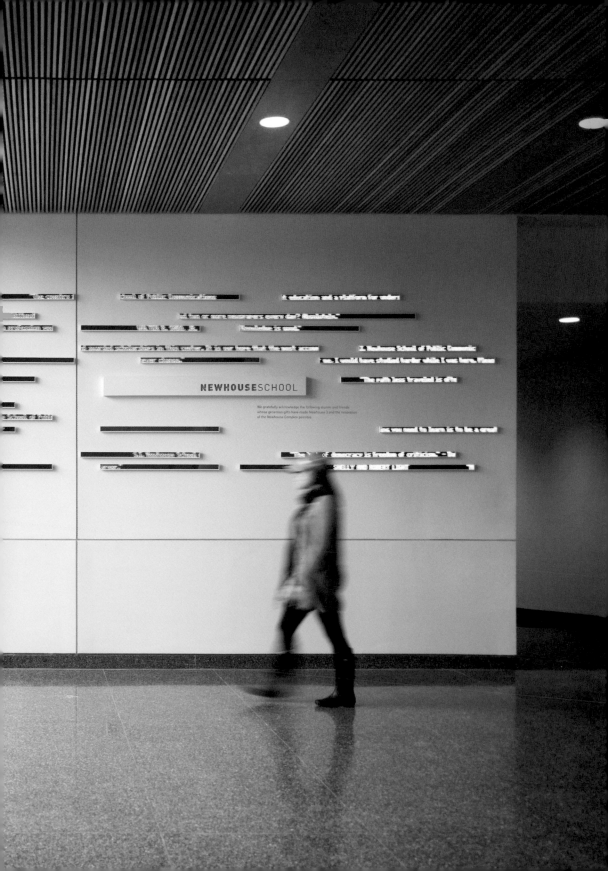

●轉到螢幕上

線條能引領目光,進一步為設計提供方向感與導航性,可作為不同元素間的
傳輸帶或連結帶。

螢幕上的設計往往要求比印刷設計更直接,因為螢幕是相對動態的媒體。線
條有辦法動態串聯內容,故常運用在螢幕介面設計。

本頁及對頁︱規劃單位設
計公司（Planning Unit）
螢幕介面設計
此專案利用線條，連接、
框取各種文字和影像元
素，進行結合與構形。
線條亦讓不同頁面具有
一致觀感。

平衡即是讓設計作品看起來均衡的概念，協調構圖中的對立，達到穩定。成功的構圖通常以下面兩種手法的其中一種實現平衡：對稱，或非對稱。

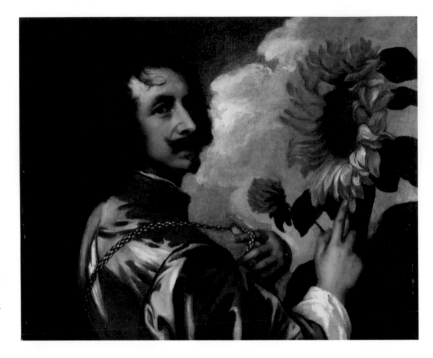

右圖｜范‧戴克爵士（1599 - 1641） 自畫像
這幅自畫像屬近似對稱平衡，重點元素雖然不相同，但平均分配於軸線兩側。

對頁｜母鳥設計工作室（Motherbird） 品牌宣傳
為塊動舞團（Chunky Move）的公開舞蹈課程設計的品牌宣傳，以非對稱創造出富有動感的活潑字體排印作品。

●對稱平衡與近似對稱平衡

選擇文本各層級的字體粗細和寬度，是影響設計外觀及風格的重要決定。各層級文字必須充分協調，供順暢閱讀，又要有足夠差異，以清楚定義階層。弗魯提格表（Frutiger's Grid）令設計師能從彼此相容的近似子族間挑選編號值。

近似對稱平衡（near-symmetrical balance）是對稱平衡（symmetrical balance）的變化型，將相等但不相同的形體排列在支點線（fulcrum line）周圍。上圖安東尼‧范‧戴克爵士（Sir Anthony van Dyck）的自畫像中有兩樣互異的主題：男人與向日葵。兩者的整體形狀類似，於是為作品帶來平衡。

●非對稱平衡

非對稱平衡（Asymmetrical balance）又稱非正式平衡（informal balance），係透過排列方式讓不同視覺重量的物品繞著支點相互牽制，較複雜也較難想像畫面。

●對稱的盛宴

對稱形成秩序與平衡，進一步令人感到舒適安全。有時設計師會想降低產品或服務的刺激，強調樸實的特質如可靠度，或無意外性。

透過置中對齊所表現出的對稱字體排印，還能予人一種實在、傳統的感覺，讓人想起十九世紀末、維多利亞時代製作的海報。當時的風格主要利用文字表達產品內容或功能。

對稱也能造就迷惑。許多餐廳置中對齊菜單文字，消費者便較難分辨不同選項的價格，也許想嘗試挑選低價項目時，將遭受混淆。價格若靠右對齊，比價過程就容易多了。

下圖及對頁 |
設計遊戲（Design is Play）
食品標籤

藉由置中對齊的文字表現對稱、統一，毫不囉嗦的處理方式。留意不同字體大小的運用，係引人注意各包裝內容的關鍵手法。

從頁面的空間尺寸，到各文字及圖片元素的間隔，測量是排版與設計的一大重點。瞭解不同的測量概念，有助於強化、加深排版設計的相關知識。

●絕對測量

絕對測量的基礎是固定量值，例如以一公釐作為一公分的增量，定義明確。字體排印的基本測量單位點（point，縮寫 pt）和派卡（pica）都具有固定實際的值。所有絕對的測量都以有限項次表達，不得改變。為求簡單，通常以有理整數表示。舉例來說 11 公釐算是有理整數，1.1 公分則不算。

●相對測量

字體排印中字元間距、分數和破折號等許多量值與字體大小直接相關，也就是不以絕對測量表示，由一組相對測量為定義。如此的好處是定義元素永遠與設定字體尺寸直接關連，其相對大小隨字體尺寸改變。這類排印字元的基本測量單位稱作 em，係最寬字元的寬度測量值。最寬的字元通常是大寫體 M，而其大小又與字體尺寸直接對應。譬如 12pt 大小的字，em 值為12pt。

●設計與測量

・em 與 en

「em」是一種相對單位，由金屬鑄造的方型大寫體「M」活字寬度衍生而來，與字體的大小值相等。例如選用 24pt 大小的字，em 值為 24pt。「en」則等於「em」的一半。

・黃金分割

黃金分割比例出現在各種領域，包括藝術、設計和建築。然而隨著其賴為基礎的幾何原則退居線性測量之後，現代社會已較少運用黃金分割。像是平面設計師使用的電腦排版軟體，就以測量取代比例分配。黃金分割或黃金比例的原始功能之一是定義頁面大小。

・長寬比

動態矩形（dynamic rectangle）或根號矩形（root rectangle）是一系列矩形，衍生自一原始矩形的對角線。藉此對角線繪製的矩形，與系列中其他矩形的長寬比都相同。使用動態矩形時，強調的是矩形的幾何比例，而不是實際測量值。以這種手法繪製的矩形，應用範例包括定義排版中的文字方塊，第 79 頁有更深入說明。

動態矩形的發現者是加拿大裔美國藝術家杰・罕比治（Jay Hambidge，1867-1924）。他提出想法，認為希臘建築與雕塑的比例和對稱，都是根據數學與幾何學。

罕比治鑽研古典希臘建築如帕德嫩神廟（Parthenon），構思出比例的「動態理論」，1926 年發表於著作《動態對稱基礎》（The Elements of Dynamic Symmetry）。

動態矩形可應用於構圖、畫作尺寸，及出版品比例。根號矩形為當中一例，其長短邊比值為整數的平方根，如 $\sqrt{2}$、$\sqrt{3}$ 等等。

下圖｜加埃塔諾・普雷維亞蒂（Gaetano Previati） 太平洋鐵路（*The Pacific Railway*）1916
該作品的畫布尺寸具 8：13 黃金比例。

根號 2 1 × 1.414

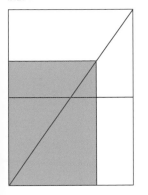

根號 3 1 × 1.732

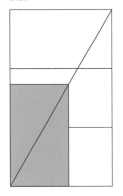

根號 4 1 × 2

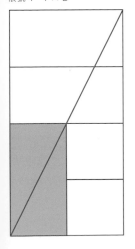

根號 5 1 × 2.236

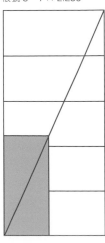

比例是一個物件部分與整體的視覺關係或結構關係，比如說文字方塊與整個頁面間的關係。要達到平衡的版面，比例是相當有用的工具，幫助決定不同設計元素的尺寸關係，像是相對大小和間距。

古人認為大約 8：13 的比值代表萬無一失的美好比例。將線段依此比例切分，則短段對長段及長段對全段的關係將會相同，這就是以希臘字母 φ 作表示的黃金分割。基於這個比例的物品與設計，令人感到特別順眼。平面藝術領域中，黃金分割因能提供和諧的比例而構成紙張尺寸的標準，其原則亦是讓設計成功平衡的一種方法。切勿混淆黃金分割與黃金中道（golden mean，兩極端值的中點）或黃金數字（golden numbers，天文與曆法研究中的紀年法）。

●大自然的黃金比例

黃金比例 8：13 存在於自然界中，蝸牛殼、向日葵種子與蜂巢的排列紋路都觀察得到，海豚的眼、鰭與尾巴也位在全身的黃金分割點上。

利用測量法或幾何法，都能畫出黃金比例。兩種方式得到的結果相同，但實際應用互異，取決於設計師遇到的工作問題或個人操作習慣。譬如說，確切數據和比例，哪一樣比較重要？

下圖｜**出自天然**
這些自然造物的生長圖紋或構造都展現出 8：13 黃金比例。

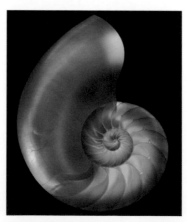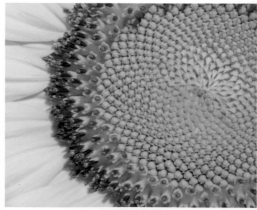

●幾何法繪製黃金比例

圖為使用圓規和三角板畫出黃金比例的流程。此法能形成黃金分割的比例，但未著墨於準確的數據測量。首先畫一個正方形（A），並垂直平分（B）。由底邊上這個交點拉出對角線至上端一角，構成三角形（C）。接下來將圓規的針腳擺在底邊中央交點，從三角形的上端拉出弧線，接到延伸的基線（D），再自此接點垂直畫一條與原正方形等高的直線。拉長正方形的上邊，即完成具有黃金比例的矩形（E）。

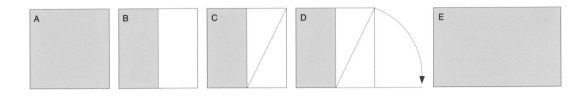

●數學法繪製黃金比例

運用簡單數學計算，也可以畫出黃金比例。拉一條直線（A），依 8：13 的比例分切（B）。透過黃金比例 1：1.618，各線段都能當成黃金矩形的長邊（C）。長邊是比值中 1.618 的部分，將長邊除以 1.618 再乘以 1，就得到短邊的長度。

下圖｜黃金矩形
以全長線段為長邊、除以 1.618 為短邊繪成的黃金矩形（golden rectangle）。此形狀的應用可見於印刷（設計）、藝術與建築。

A

B

C

標準化的紙張大小，提供設計師和出版者方便有效率的溝通方式。人們在好幾世紀前就意識到標準紙張大小的實際效益，相關操作歷史可回溯至十四世紀的義大利。ISO 系統依據的長寬比是根號二（1：1.4142），也就是說每個尺寸與前後一號大小相差二或二分之一倍。

尺寸	標準用途
A0、A1	海報與工程圖，例如藍圖
A1、A2	會議掛圖
A2、A3	示意圖、繪圖與大型表格報表
A4	雜誌、信件、表單、傳單、影印機、雷射印表機與一般使用
A5	筆記本與日誌
A6	明信片
B5、A5、B6、A6	書籍
C4、C5、C6	A4 信件的信封：未摺（C4）、對摺（C5）、兩摺（C6）
B4、A3	報紙。許多影印機也接受這些尺寸
B8、A8	撲克牌

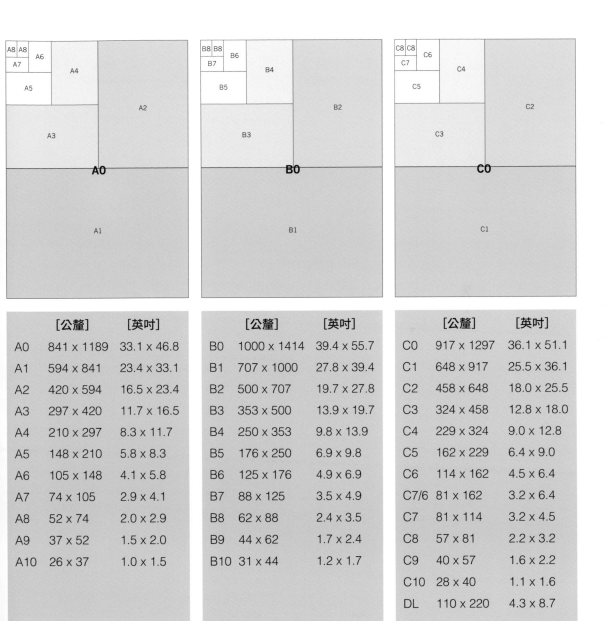

	[公釐]	[英吋]
A0	841 x 1189	33.1 x 46.8
A1	594 x 841	23.4 x 33.1
A2	420 x 594	16.5 x 23.4
A3	297 x 420	11.7 x 16.5
A4	210 x 297	8.3 x 11.7
A5	148 x 210	5.8 x 8.3
A6	105 x 148	4.1 x 5.8
A7	74 x 105	2.9 x 4.1
A8	52 x 74	2.0 x 2.9
A9	37 x 52	1.5 x 2.0
A10	26 x 37	1.0 x 1.5

	[公釐]	[英吋]
B0	1000 x 1414	39.4 x 55.7
B1	707 x 1000	27.8 x 39.4
B2	500 x 707	19.7 x 27.8
B3	353 x 500	13.9 x 19.7
B4	250 x 353	9.8 x 13.9
B5	176 x 250	6.9 x 9.8
B6	125 x 176	4.9 x 6.9
B7	88 x 125	3.5 x 4.9
B8	62 x 88	2.4 x 3.5
B9	44 x 62	1.7 x 2.4
B10	31 x 44	1.2 x 1.7

	[公釐]	[英吋]
C0	917 x 1297	36.1 x 51.1
C1	648 x 917	25.5 x 36.1
C2	458 x 648	18.0 x 25.5
C3	324 x 458	12.8 x 18.0
C4	229 x 324	9.0 x 12.8
C5	162 x 229	6.4 x 9.0
C6	114 x 162	4.5 x 6.4
C7/6	81 x 162	3.2 x 6.4
C7	81 x 114	3.2 x 4.5
C8	57 x 81	2.2 x 3.2
C9	40 x 57	1.6 x 2.2
C10	28 x 40	1.1 x 1.6
DL	110 x 220	4.3 x 8.7

●例外

國際標準化組織的紙張尺寸全球通用，但美國與加拿大系統除外，這些地方多使用美國國家標準格式規範。最常見的尺寸包括信函（letter）、法務（legal）、行政（executive）及帳簿／小報（ledger/tabloid），圖示於下，並列出規格。

信函
(letter)

法務
(legal)

行政
(executive)

帳簿／小報
(ledger/tabloid)

・美國系統

美國紙張尺寸分類法與國際標準一樣，各尺寸間保持比例關係。不過國際標準系統固定單一長寬比，美國系統則交錯使用兩組比值：17／11 ＝ 1.545與 22／17 ＝ 1.294。這表示由一種格式放大或縮小至前後一個尺寸時，必定產生空白邊界。

格式	[公釐／英吋]	比值
ANSI A	279.4 x 215.9 8.5 x 11 in	1.2941
ANSI B	431.8 x 279.4 11 x 17 in	1.5455
ANSI C	538.8 x 431.8 17 x 32 in	1.2941
ANSI D	863.6 x 538.8 22 x 34 in	1.5455
ANSI E	1117.6 x 863.6 34 x 44 in	1.2941

·加拿大系統

1976 年問世的加拿大標準 CAN 2-9.60M 定義了六個 P 格式，為美國尺寸的整數捨入版本。加拿大尺寸如同對應的美國尺寸，沒有固定的長寬比，且異於全世界其他人所用。

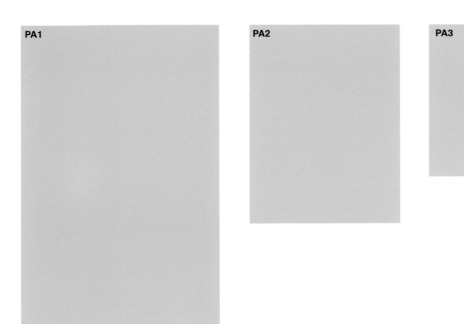

格式	[公釐／英吋]	比值
PA1	560 x 840	2:3
	22.05 x 33.07 in	
PA2	420 x 560	3:4
	16.53 x 22.05 in	
PA3	280 x 420	2:3
	11.02 x 16.53 in	
PA4	210 x 280	3:4
	8.27 x 11.02 in	
PA5	140 x 210	2:3
	5.51 x 8.27 in	
PA6	105 x 140	3:4
	4.13 x 5.51 in	

書本尺寸廣泛，提供多種格式以容納不同內容類型。各格式間的比例變化如下表所示。

裝訂書尺寸	高 × 寬	裝訂書尺寸	高 × 寬
1 Demy 16mo	143mm x 111mm 5 $^5/_8$ in x 4 $^3/_8$ in	11 Foolscap Quarto (4to)	216mm x 171mm 8 $^1/_2$ in x 6 $^3/_4$ in
2 Demy 18mo	146mm x 95mm 5 $^3/_4$ in x 3 $^3/_4$ in	12 Crown (4to)	254mm x 191mm 10 in x 7 $^1/_2$ in
3 Foolscap Octavo (8vo)	171mm x 108mm 6 $^3/_4$ in x 4 $^1/_4$ in	13 Demy (4to)	286mm x 222mm 11 $^1/_4$ in x 8 $^3/_4$ in
4 Crown (8vo)	191mm x 127mm 7 $^1/_2$ in x 5 in	14 Royal (4to)	318mm x 254mm 12 $^1/_2$ in x 10 in
5 Large Crown (8vo)	203mm x 133mm 8 in x 5 $^1/_4$ in	15 Imperial (4to)	381mm x 279mm 15 in x 11 in
6 Demy (8vo)	222mm x 143mm 8 $^3/_4$ in x 5 $^5/_8$ in	16 Crown Folio	381mm x 254mm 15 in x 10 in
7 Medium (8vo)	241mm x 152mm 9 $^1/_2$ in x 6 in	17 Demy Folio	445mm x 286mm 17 $^1/_2$ in x 11 $^1/_4$ in
8 Royal (8vo)	254mm x 159mm 10 in x 6 $^1/_4$ in	18 Royal Folio	508mm x 318mm 20 in x 12 $^1/_2$ in
9 Super Royal (8vo)	260mm x 175mm 10 $^1/_4$ in x 6 $^3/_4$ in	19 Music	356mm x 260mm 14 in x 10 $^1/_4$ in
10 Imperial (8vo)	279mm x 191mm 11 in x 7 $^1/_2$ in		

●對開本、四開本與八開本

書本尺寸是由書脊的頭到腳、書封的左際到右際測量得來。書頁尺寸則受到兩項因素影響：印刷紙張的尺寸，及紙張裁切前對摺的次數。印刷業根據一台的標準尺寸紙張所構成的頁數，定義書本尺寸。對開版本代表每台對摺一次所製作的書，四開版本每台對摺兩次，構成四頁八面，八開版本每台對摺三次，有八頁十六面。每張都雙面印刷，因此八開版本的一台通常等於書中的十六面。

頁面尺寸
這些示意圖說明同一張紙能生產的相對頁面大小：16 Crown Folio、12 Crown (4to) 及 4 Crown (8vo)。

對開本
Folio

四開本
Quarto

八開本
Octavo

●等比例性

書本尺寸自標準紙張尺寸衍生而來，故彼此間存在數學關係，大小為前後尺寸的兩倍或一半，且連續兩個尺寸有一邊長度相同。舉例來說，Crown folio 邊長為 381 × 254 公釐（15 × 10 英吋），對摺後變成邊長 254 × 191 公釐（10 × 7 ½ 英吋）的 Crown quarto，再摺一次形成 Crown octavo，邊長 191 × 127 公釐（7 ½ × 5 英吋）。

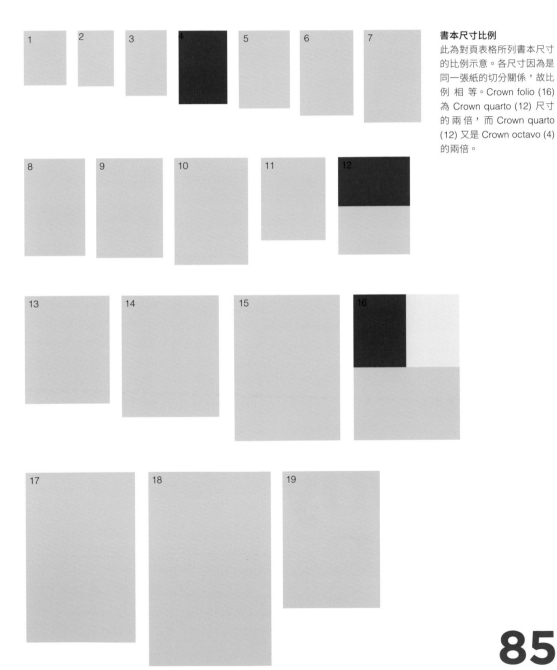

書本尺寸比例

此為對頁表格所列書本尺寸的比例示意。各尺寸因為是同一張紙的切分關係，故比例相等。Crown folio (16) 為 Crown quarto (12) 尺寸的兩倍，而 Crown quarto (12) 又是 Crown octavo (4) 的兩倍。

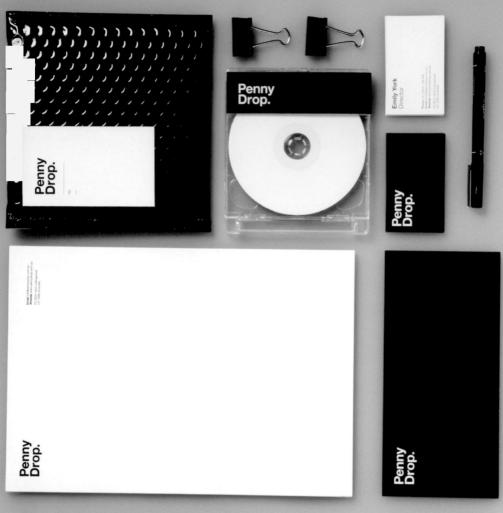

母鳥設計工作室（Motherbird）品牌識別設計
巡演宣傳暨演藝經紀公司 Penny Drop 品牌識別，主打出一個充滿活力、簡潔又明白的品牌，可輕
鬆融入各式各樣的印刷品與線上版本。極簡到近乎粗野的排字，實則經仔細排列，以達最大效果。

CHAPTER

3

網格與構形

透過網格手法定位及組織設計元素，能促使決策過程更容易。網格是版面的骨架，擔任設計師實現平衡的工具，同時潛在提供大幅創新的機會。

設計師善用網格、場區（fields）和矩陣（matrices），便能以經過考量的方式著手設計，有效率運用時間。由於欄（columns）與模組（modules）等網格元件有助於引導文字和圖像擺放，如此操作還能保證不同的設計元素配合協調，維持相關作品整體的一致性與連貫性。

網格的構造

設計作品包含各種需排列在頁面上的元素，像是文字方塊和影像。設計師常借助網格來擺放不同元素，這樣能得到完備的操作準則，指引擺位與對齊的相關決策。網格不具有規範性，卻能提供架構，協助製作有組織、合邏輯的成品。

基線網格是網格的關鍵要素，本質上就是排列文字用的支架。它是一系列平行等距的基線，文字座落其上。

將文字依基線網格安排，則文字會具有均等行距。基線間的寬度測量單位是點（pt），一般設定在能適切容納字體與行距的數值，造就緊密、穩定的文字方塊。舉例來說，10pt內文字體加 2pt 行距，使用12pt 基線網格。

C

E F

A

圖像模組 Image Modules
網格中建立的空間，供圖像元
素擺置。

B

網格可視為頁面的骨架。
此結構容納許多不同部
件，譬如：

A
天頭／上邊界
top margin / head margin
頁面頂端的邊界。

B
地腳／下邊界
foot / bottom margin
頁面底端的邊界。

C
書口／外邊界
fore edge / outer margin
外側邊界有助於在設計
中框架文字的呈現。

D
訂口／內邊界
back edge / inner margin
最靠近書脊（spine）或
中 摺 處（center fold）
的 邊 界，又 稱 為 書 溝
（gutter）。

E
欄 column
擺放內文用的垂直空間，
幫助橫書文字呈現好讀
的行寬。

F
欄間距
inter-column space
跨頁間摺起處的邊界區
域。兩欄文字之間的空
白也稱為溝間（gutter）
或欄間距。

螢幕上的網格

螢幕介面設計使用的網格，通常遵循與印刷出版相同的原則。螢幕介面設計的排版仍需有階層，以分辨資訊、節奏和空間分配之間的重要程度。

然而，螢幕是相對動態的媒體，讀者也許還能與之互動，故有更多待考量的地方。

許多螢幕介面設計是靜止的，但可內含動態元素，或點按後導向其他資訊的元素。獨立的螢幕元素經常缺乏文字加以互相連結，因此螢幕介面設計的網格必須多擔當這部分的責任。網頁設計可能極度流動，且內容幾乎全是移動的元素，需作安排與調控。

目標觀眾操作螢幕介面設計的方式，也要納入考慮。若將進行互動，就務必有清楚的瀏覽機制，且複雜程度要配合目標使用者的經驗與背景。連結失效和無法輕鬆找到自己想要的資訊，都會令使用者困擾。重點是，希望別人造

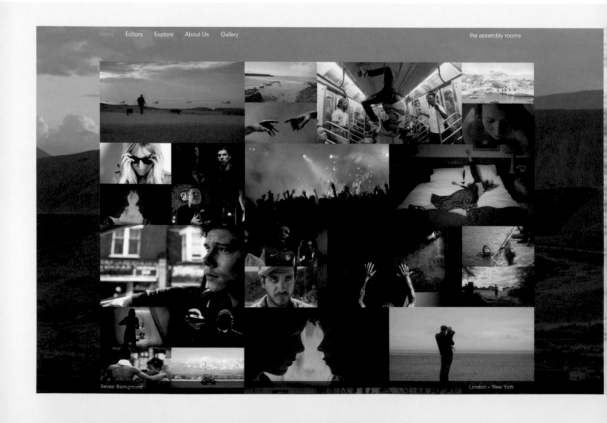

訪網站後記得什麼，要明白定義並在每頁中保持一致，讓每個頁面或畫面都能辨認出屬於這個機構。若業主想傳達制度與權威性，就應該表現在頁面排版和結構中。若業主想展露無限創意與自由思想，則可能適合無拘束、恣意組織的結構。不過即便如此，網站仍必須能輕易瀏覽。

設計師還要考量到技術層面，像是如何讓內容透過不同裝置不同軟體觀看（及修改）。自此設計師得進行調整，從原本設計絕對而靜止的頁面，完全依指定的樣子印刷，轉到依裝置來調整數位網格的媒體，在各種平台上，顯現的模樣各有千秋。

下方｜規劃單位設計公司（Planning Unit）　螢幕介面設計
這個為集會廳影片公司（The Assembly Rooms）設計的網頁，突顯出我們多麼需要能以明確的圖像式手法貫串整體的強大設計。此處的解決方案呈現一系列方形，供靈活操縱和組織個別視覺元素。

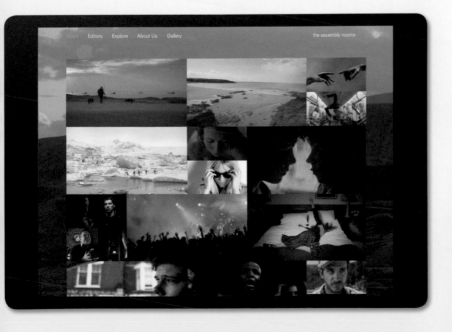
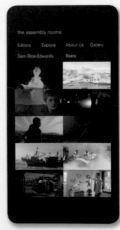

網格是基礎的設計工具，是設計中擺放各類元素的導引。我們透過以下幾個版面解析網格，檢視其組成。

對稱網格

對稱網格所呈現的版面格式，左右頁互為鏡像，且擁有等寬的內邊界與外邊界。圖示外邊界占比例較大，以容納邊註。網格中還可見其他主要元素如書溝、溝間、天頭和地腳。

非對稱網格

非對稱網格左右頁使用相同的版面格式。圖示中四排窄文字欄，與上方對稱網格的相同，但非對稱網格也常有一欄比其他欄窄，讓人閱讀時偏向某邊，且一般偏左。較窄的這欄可作為開放的邊幅，供圖說、註釋、圖標或其他各類元素使用。

排版內垂直向的分割區域稱為欄，文字大多書寫其中。欄或寬或窄，甚至可能偏向一邊，處理手法對文字閱讀有顯著影響。

欄
此圖展現對稱的四欄版面，可以涵容文本的欄位以淺灰表示。

書溝與欄間
圖中以淺灰色標示的欄間，讓欄與欄之間有視覺分隔。中央的欄間稱為書溝，作用為容納裝訂（深灰色處）。要注意的是，所有這些欄間也常被稱為溝間。欄間提供留白，使文字方塊跳出，因此其大小、形狀與格式都會大幅影響設計氛圍。

書溝（gutter）在版面上雖然有重要功能，卻常常被忽略。通常提到書溝，指的是兩頁於書脊交接處的中央欄間，但「溝間」（gutter）一詞也能表示欄間、以及文字欄到書口（fore-edge）的空間。這些區域多被棄置不顧，其實可作靈活運用，尤其隨著印刷技術的精密度提昇，裁切裝訂過程導致此空間元素喪失的風險也降低。

●被動與主動

一般將書溝或溝間視為版面上消極的視覺休止，係因需要而插入至裝訂邊、或用來分隔文字欄的被動空間。然而書溝或溝間作為頁間或元素間具體隔閡的同時，亦可創意運用。例如將物件排列在溝邊，傳達其相對重要性。只要放一點巧思，總顯被動的書溝或溝間，其實能像處理留白一樣進行操控，成為版面的關鍵元素，幫助建立和保持張力、調整節奏，或發展敘事。收緊書溝或溝間的寬度，將為兩側元素創造較近的連結，而延展書溝或溝間的寬度則削弱此關係。圖像橫越中央書溝，則尺寸可放大，會產生較大衝擊。不過文字要跨越書溝的困難度較高，字體偏小時更是如此。

●蠕變

刊物設計排版過程中，依選擇的裝訂方式和紙張延展程度，有時需將蠕變（Creep）這項物理因素納入考量，用到騎馬釘時尤其要注意。最終修邊裁切出版物時，可能需將影像移開蠕變頁的書口邊。蠕變是多頁出版物常常分台生產的眾多原因之一。

對頁｜貝多設計工作室（Bedow）　書籍內頁
藝術家漢斯・伊塞克森（Hans Isaksson）的專書版面，當中呈現跨中央書溝印刷圖片的主動書溝與溝間，以及幫助建立不同頁面影像間關係的被動書溝與溝間。全書以紅線縫裝，使書溝更添亮點。

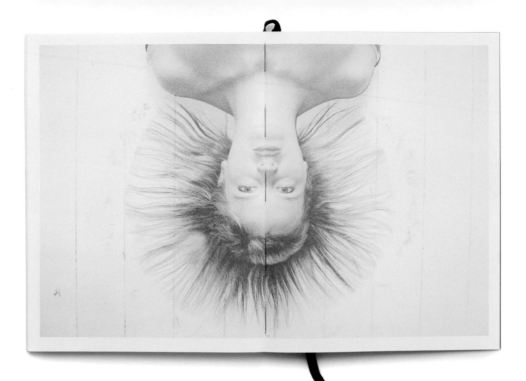

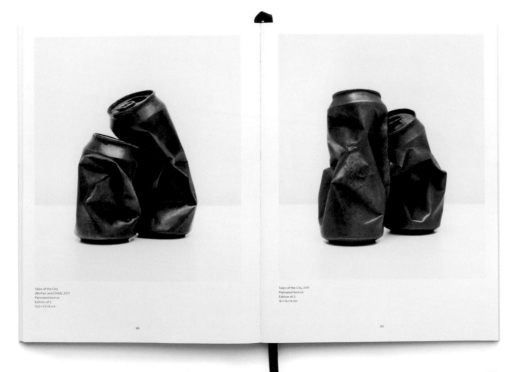

Tales of the City
(Mother and Child), 2011
Patinated bronze
Edition of 3
15,5 × 13 × 9 cm

Tales of the City, 2011
Patinated bronze
Edition of 3
16 × 15 × 8 cm

95

將網格分為不同場區或模組，能增廣設計師可用的主動空間類型，在保有基本欄位架構同時，促進更活潑的文字與圖片使用。

等場網格
此圖示為非對稱網格，大小均等的模組等間距排列成四欄。這是非對稱四欄網格的簡單變化型。

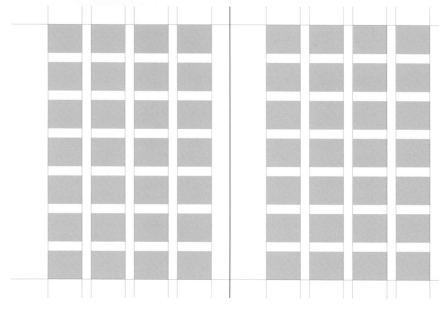

交替
此網格同樣以非對稱四欄網格為基礎，但其中的模組尺寸相異，形成較大、較動感的圖片空間。

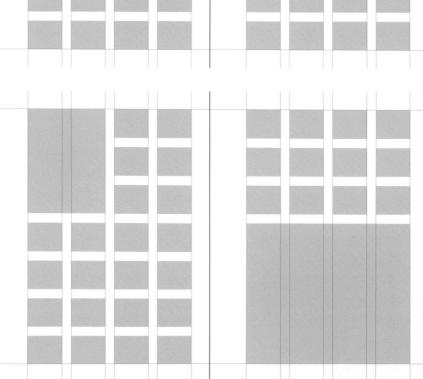

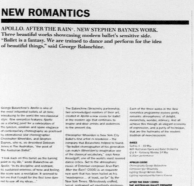

NEW ROMANTICS

APOLLO. AFTER THE RAIN°. NEW STEPHEN BAYNES WORK.
Three beautiful works showcasing modern ballet's sensitive side.
"Ballet is a fantasy. We are trained to dance and perform for the idea of beautiful things," said George Balanchine.

"Sensuous and deeply romantic" —
The New York Times on 'After the Rain'

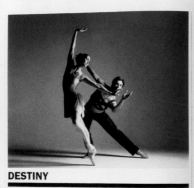

DESTINY

ONE CLASSIC, AND ONE WORLD PREMIERE, in tribute to Leonide Massine. Featuring the iconic *Les Présages*, this extraordinary double bill explores Massine's bold use of symphonic music.

"...it would seem that much as Melbourne's theatregoers may be charmed by the languor and graces of the traditional story ballet, it takes a thorough-going piece of calisthenic abstraction to rouse them to a pitch of frenzy" —
The Argus on *Les Présages*, Melbourne 1936

●利用欄位與場區

通常設計師在作品中不會單獨使用欄位或場區，而是兩者併用，建立和諧又活潑的文字和圖像呈現。一般令文字分欄排列，圖像填充模組，不過整合欄位和場區所造就的彈性，可供充分的創意發揮空間。

基線網格是（無形的）平面基礎，設計建構於其上。同時基線網格為頁面元素的擺放和對齊提供視覺導引，光靠人眼很難達到其準確性。

基線由一系列青色（cyan）水平線組成，指示文字元素排列同時，也擔任圖片框的定位點。基線網格一般配合特定的文字大小和行距。舉例來說，12pt 網格適合搭配 10pt 字體加上 2pt 行距。基線網格的線距可因應不同排字需求，作增大或縮小。

計算和設定頁面參數，也許要用到一些簡單數學。例如當使用相距 12pt 的基線網格時，欄間距或溝間可以設定在 12pt，書口外側邊界為 24pt，上邊界 36pt。制定好頁面邊界後，接著可以天頭／上邊界作為起始點開始描繪，每隔 12pt 拉一條平行線，建立基線網格。

只要字體大小為基線網格線距的倍數，就能運用於該網格上。像是在 12pt 網格上，12pt、24pt、36pt、48pt、60pt 和 72pt 字體大小都適用，較小的尺寸如 10pt 或 8pt 也沒問題。

72pt 字體

48pt 字體

36pt 字體

24pt 字體

12pt 字體

10pt 字體

8pt 字體

●運用基線網格的優點

運用基線可獲得雙倍優勢。首先，由於為每條線安排了準確位置，擺放文字時就不用多加嘗試。再來，不同欄或不同頁的文字也能互相對齊。

無論 大小 **或字型**

基線網格橫跨整個頁幅，因此再小的排字元素（如圖說和註釋），基線網格都能助其擺位及交互對齊。

●基線位移

有時必須放棄基線的擺位指示，因此設計師可以選擇啟用基線位移（baseline shift），相對於基線來調整文字的編排。基線位移對於處理有排字困難的元素相當有用，如標在右上或標在右下的註釋與註腳。

●交互對齊

同時使用多種字型或字體大小時，就需要交互對齊（cross alignment）。這時基線成為對齊各字體的工具。大字體擺放在與小字體相同的基線網格上，但每行文字間可能跳過一條以上基線。

●應用邏輯數學

若在著手設計之前進行數學運算，利用特定點數大小的基線有助於輕鬆決策。譬如說，假設內文選用 10pt 字體，合理的基線會訂在 12pt，以得到 10pt 字體加 2pt 行距的空間。如果要使用 12pt 字體，則 14pt 基線是較佳選項。決定好基本字體大小和網格尺寸後，即可定義其他排字元素。像是若以 12pt 基線網格排列 10pt 字體，則標題可為 36pt 字體，占據三列（12pt × 3 列 = 36pt）。若內文 12pt 或更大，也許就需要更大的基線網格。

文字設計中經常是小型元素造成最大影響，因此必須審慎考量。

●朝非對稱前進

由奇肖爾德帶頭的現代圖像，背離置中元素如頁碼、逐頁標題或頁尾。奇肖爾德在其開拓性的著作《新字體排印》（*Die Neue Typographie*）中提倡「文章的標題不應再置中，要推到最左側……非對稱性絕不該受置中的標題或形式干擾。頁碼永遠（如當今一般操作）位於頁面外側。」雖然奇肖爾德晚年摒棄了自己早期某些獨斷的處理手法，此書仍突顯出許多出版物的缺陷與圖像排列活力的不足。

頁碼的排列方式，應兼具功能和美感。
原則上文字區的上下左右都能擺放，
由文字區在頁面上的位置與可用邊界的寬度，
決定可能的定點。

—— 約瑟夫·米勒·布羅克曼《平面設計中的網格系統》
Josef Müller-Brockmann, *Grid Systems in Graphic Design*

逐頁標題

逐頁標題

22

23

對稱版面

對稱版面中，頁面上的各類元素透過對稱、置中的關係，散發靜止的感覺，使設計「腳踏實地」。某些狀況下，可以說這種感覺是好事，鼓勵讀者暫停、休息。但這樣也可能造成活力缺乏。

逐頁標題

逐頁標題

22

23

非對稱版面

相對於對稱、置中的設計，在頁面上非對稱排列圖像物件，將形成動態感與節奏，鼓勵人眼在畫面中游移。當然，此原則還能轉用在螢幕、動態影像或建築環境。

101

Thomas Elsaesser
Fassbinder's Germany

Instead of making Hollywood films for German audiences, Fassbinder had in fact appropriated the classical system to the point of rethinking not only what it meant to address audiences in what remained of the public space that was cinema, but what it meant to organize the field of vision that is the cinematic apparatus. It suggests that his approach to the three-way interaction between spectator, character and screen space came to differ from that of both classical and modernist cinema, and that via the spaces his films construct, the texture of his sound spaces and sound effects, but above all, via the looks that circulate within these spaces and across them, Fassbinder invited his spectators not only to 'enter' his world, but also managed to pull the ground from under them.

A Hollywood film discreetly or spectacularly puts the viewer at the centre of events. It subordinates camera movement and the characters' looks to our presumed need to know something has happened and what is about to happen: narration acts as guide, always at our service, rarely asking to be applauded for the unobtrusive skills deployed. Yet almost the first point to make, even on casual acquaintance about a Fassbinder film is the sense one has of an especially strong investment in vision itself, for its own sake, so to speak. Examples already mentioned are the frontal shots of people sitting behind tables in LOVE IS COLDER THAN DEATH and KATZELMACHER, looking past the cinema, though we never know what they are looking at. In other films, a seemingly unmotivated camera movement reveals a space, not while but before a character enters it, or it reveals someone else in a space, who seems to be watching us, watching. The typical Fassbinder scene opens without an establishing shot, gives what one imagines is a point of view, maybe because it is angled in a particular way, or taken from behind a beam, as in THE BITTER TEARS OF PETRA VON KANT, from where we see Marlene enter. But there is no reverse shot, and it is in fact Marlene who will be the silent, all-seeing witness throughout. Here, as in so many other instances, one immediately recognizes a Fassbinder film from the obsessive framing of the image, whether by means of doorways (FEAR EATS THE SOUL) or partitions (DESPAIR), or because the shot includes objects that are themselves framed, like pictures on the wall (EFFI BRIEST), a hallway mirror (MOTHER KÜSTER), or huge murals and mounted photos (as in PETRA VON KANT, GODS OF THE PLAGUE and KATZELMACHER).

As a modernist form of deconstruction, this draws attention to the artifice of representation, or critically comments on the claustrophobic, stifling and cluttered world in which these characters are at home. One remembers Sirk's frequent mirror shots in the opulent mansion of WRITTEN ON THE WIND and the final tableau with a picture-window in Rock Hudson's cabin in ALL THAT HEAVEN ALLOWS. But Fassbinder

also cites the cinema itself, whether by 'fetishizing' its apparatus and thus barring us from the pleasure of unmediated transparency to which the director himself is nonetheless attached, or by drawing attention to an extra presence, whether originating from the camera, the audience as voyeurs, or some other perceiving instance. While the classical Hollywood cinema disguises such a presence by either motivating it internally or by leaving this extra look unacknowledged (the characters never look at the camera, they do not 'return' our looking at them), Fassbinder often makes us – more or less uncomfortably – aware of our invisible presence, and by extension, of the fact that the 'frame' is not a window on the world outside. ... The outside is the inside also in the opening of BERLIN ALEXANDERPLATZ, where Franz Biberkopf, just released from Tegel prison, is so overwhelmed by the unbounded, unframed world invading him that, overcome with anxiety, he collapses into a nervous heap.

Fassbinder's use of mirror-shots or internal framing is a typical feature of much 'self-reflexive' cinema, in the tradition of European auteurs, from Bergman to Visconti, or Godard to Almodóvar. It is also common in the work of Europe's preferred American auteurs, such as Nicholas Ray, Orson Welles, Joseph Losey, as well as émigré directors like Sirk and Fritz Lang. And yet, to explain the frequent mirror shots in Fassbinder's films, neither modernist self-reflexivity nor pastiche finally accounts for the foregrounding of vision and the excess of [Fassbinder's] framing.... When, in FEAR EATS THE SOUL, Ali visits Barbara, the owner of the bar, at her home, he is framed in front of the bed by two sets of doors, rather like Elvira in IN A YEAR OF THIRTEEN MOONS, when she pays a visit to Anton Saitz in his office, and where she is seen wavering along a sheer endless corridor

... den University Press, Amsterdam, 1996; ... n omitted. Reprinted with permission

Laura Mulvey
Visual Pleasure and Narrative Cinema

Woman as image, man as bearer of the look

In Hitchcock… the male hero does see precisely what the audience sees. However, although fascination with an image through scopophilic eroticism can be the subject of the film, it is the role of the hero to portray the contradictions and tensions experienced by the spectator. In *Vertigo* in particular, but also in *Marnie* and *Rear Window*, the look is central to the plot, oscillating between voyeurism and fetishistic fascination. Hitchcock has never concealed his interest in voyeurism, cinematic and non-cinematic. His heroes are exemplary of the symbolic order and the law – a policeman (*Vertigo*), a dominant male possessing money and power (*Marnie*) – but their erotic drives lead them into compromised situations. The power to subject another person to the will sadistically or to the gaze voyeuristically is turned onto the woman as the object of both. Power is backed by a certainty of legal right and the established guilt of the woman (evoking castration, psychoanalytically speaking). True perversion is barely concealed under a shallow mask of ideological correctness – the man is on the right side of the law, the woman on the wrong. Hitchcock's skilful use of identification processes and liberal use of subjective camera from the point of view of the male protagonist draw the spectators deeply into his position, making them share his uneasy gaze. The spectator is absorbed into a voyeuristic situation within the screen scene and diegesis, which parodies his own in the cinema.

In an analysis of *Rear Window*, Douchet takes the film as a metaphor for the cinema. Jeffries is the audience, the events in the apartment block opposite correspond to the screen. As he watches, an erotic dimension is added to his look, a central image to the drama. His

Alfred Hitchcock
Rear Window, 1954

girlfrie…
drag, su…
the bar…
is rebo…
as a di…
expose…
thus fin…
has alm…
style, ir…
and ac…
journal…
enforce…
square…

In Verti…
from Ju…
sees or…
obsess…

Scottie's voyeurism is blatant: he falls in love with a woman he follows and spies on without speaking to. Its sadistic side is equally blatant: he has chosen (and freely chosen, for he had been a successful lawyer) to be a policeman, with all the attendant possibilities of pursuit and investigation. As a result, he follows, watches and falls in love with a perfect image of female beauty and mystery. Once he actually confronts her, his erotic drive is to break her down and force her to tell by persistent cross-questioning.

In the second part of the film, he re-enacts his obsessive involvement with the image he loved to watch secretly. He reconstructs Judy as Madeleine, forces her to conform in every detail to the actual physical appearance of his fetish. Her exhibitionism, her masochism, make her an ideal passive counterpart to Scottie's active sadistic voyeurism. She knows her part is to perform, and only by playing it through and then replaying it can she keep Scottie's erotic interest. But in the repetition he does break her down and succeeds in exposing her guilt. His curiosity wins through; she is punished.

Thus, in *Vertigo*, erotic involvement with the look boomerangs: the spectator's own fascination is revealed as illicit voyeurism as the narrative content enacts the processes and pleasures that he is himself exercising and enjoying. The Hitchcock hero here is firmly placed within the symbolic order, in narrative terms. He has all the attributes of the patriarchal superego. Hence the spectator, lulled into a false sense of security by the apparent legality of his surrogate, sees through his look and finds himself exposed as complicit, caught in the moral ambiguity of looking. Far from being simply an aside on the perversion of the police, *Vertigo* focuses on the implications of the active/looking, passive/looked-at split in terms of sexual difference and the power of the male symbolic encapsulated in the hero. Marnie, too, performs for Mark Rutland's gaze and masquerades as the perfect to-be-looked-at image. He, too, is on the side of the law until, drawn in by obsession with her guilt, her secret, he longs to see her in the act of committing a crime, make her confess and thus save her. So he, too, becomes complicit as he acts out the implications of his power. He controls money and words; he can have his cake and eat it.

Source
Visual and Other Pleasures, first published in 1989. Reprinted from second edition, Palgrave Macmillan, 2009, pp. 23–25. Reproduced with permission of Palgrave Macmillan and the author.

本頁及對頁｜日常生活實踐工作室（A Practice for Everyday Life） 書籍內頁
這本《達里亞・馬丁：感官測試》（*Daria Martin: Sensorium Tests*）記錄了藝術家達里亞・馬丁對於「鏡像觸覺聯覺症」（mirror-touch synaesthesia）這種新發現的神經症狀的觀察。精緻的版面，精心排列的頁碼和逐頁標題，使作品給人的印象介於科學研究論文與藝術書籍之間。

多欄或多場網格（multi-field grids）內含數個網格，為設計師擺放元素提供驚人的彈性。這類網格對於需維持一致性、又需處理各式不同內容的工作特別管用，例如雜誌設計。

●卡爾·傑賀斯特內

瑞士字體排印師卡爾·傑賀斯特內（Karl Gerstner）在 1960 年代為《資本》（Capital）季刊研發出 58 格網格。傑賀斯特內的手法是將一正方形分成 58 個相等單位或方塊，再用這些方塊組織成二至六欄的網格。《資本》為經濟學刊物，其名稱來自卡爾·馬克思（Karl Marx）的曠世鉅作《資本論》（Das Kapital），所以傑賀斯特內發展出數字系統作為頁面設計的基礎，名正言順。他表示：「我跟許多人一樣，視商業與經濟為抽象的、主要是與數字有關的事物。」58 單位網格非常靈活，讓相片、表格和內文等混合媒材並置，輕鬆提供數百種可能變化，促進創造性與自由，而不是加諸限制。

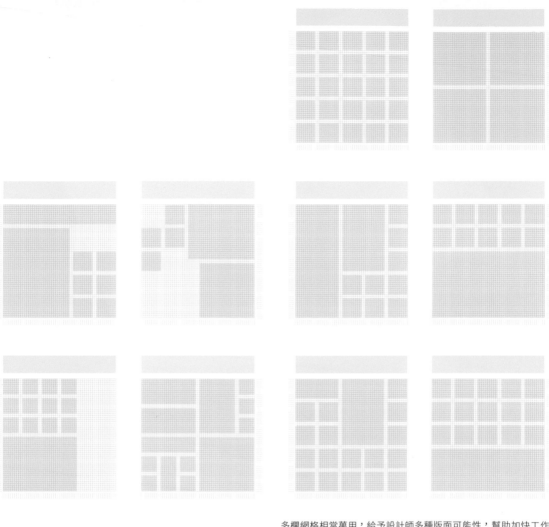

多欄網格相當萬用,給予設計師多種版面可能性,幫助加快工作流程,並促使生成有組織、連貫的頁面。這類網格能容納文字與不同尺寸圖像元素,提供各式內容處理的辦法。

105

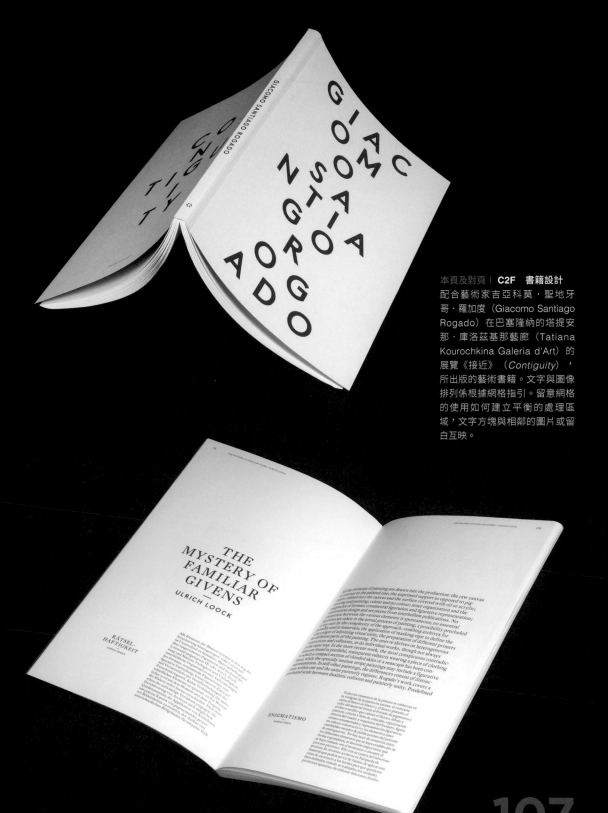

本頁及對頁｜**C2F　書籍設計**
配合藝術家吉亞科莫・聖地牙哥・羅加度（Giacomo Santiago Rogado）在巴塞隆納的塔提安那・庫洛茲基那藝廊（Tatiana Kourochkina Galeria d'Art）的展覽《接近》（*Contiguity*），所出版的藝術書籍。文字與圖像排列係根據網格指引。留意網格的使用如何建立平衡的處理區域，文字方塊與相鄰的圖片或留白互映。

印刷設計一般以橫式版面佈置文字和圖像，因為人眼會自然採橫向瀏覽頁面（或物件）。改變方向，即打破以水平向為主環境的單調感，是個強而有力的圖像手法。

●階層和方向

方向可吸引人注意階層內特定的標題或資訊類型，藉此形成階層的一部分。如此擺放文字，會透過改變的定向建立視覺屏障，阻斷自然閱覽過程。不過，變換方向將需要不同的空間條件，所以通常小段文字效果會比較好。

THE PLANE FACTS

Sydney Airport takes flight

Officially licensed in 1920, Sydney Airport proudly holds the record as the world's oldest international airport – but as Australia's busiest and most important axis, today's numbers give us equal reason to be proud. Sydney Airport welcomes millions of passengers annually, with an average of 800 traffic movements per day. We are constantly evolving alongside the dynamic aviation industry – and always ready for take off.

THE PLANE FACTS
01 AIRPORT

The Southern Hemisphere's star player

Sydney Airport stands tall as the largest airport in the Southern Hemisphere with the highest yielding traffic in the country. Located in Australia's most global city, Sydney Airport is the gateway to Australia and the hub of Oceania – providing peerless international access to the region.

Last year, visitors spent more than **AUD 5.1 billion** during their stay in Sydney. While the world recovers from the crisis, our economy and migration grows.[4]

TOP 12 INTERNATIONAL MARKETS FROM SYDNEY[1]

- New Zealand 17%
- UK 13%
- USA 11%
- China 8%
- Korea 5%
- Japan 6%
- Germany 3%
- France 3%
- Canada 3%
- India 3%
- Indonesia 2%
- Singapore 1%

Continuous growth in challenging times with traffic up by 0.34% on the previous year. Visitors spent 69 million nights in Sydney[3]

"$5.1 BILLION

WE'RE POPULAR

With **33 million passengers per year**[2] (or around 90,000 passengers a day) we attract about half of Australia's international air traffic, making us the 33rd busiest airport worldwide.[5]

33M

THE PLANE FACTS
05 BUSINESS

Open for Business

Sydney Airport's international status is underpinned by the city's crucial role as a business hub for Australasia. Sydney is the business centre for banking, insurance, tourism, business conventions, trade fairs, and a major port for international trade and commerce. A destination for business and leisure.

We don't just direct the traffic; we contribute to it

As a vital economic hub of the Sydney and NSW economies, Sydney Airport is a major creator of employment, generating **206,000 full-time jobs** and contributing AUD 8 billion directly to NSW Gross State Product (and AUD 16.5 billion as economic flow-on). [10]

206,000

Sydney is the capital of Australia's largest and most diverse State economy, NSW – the Powerhouse State is home to **46% of Australia's Top 500 Companies** [9]
(total revenue: AUD 620.3 billion)

46%

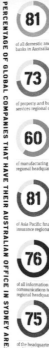
PERCENTAGE OF GLOBAL COMPANIES THAT HAVE THEIR AUSTRALIAN OFFICE IN SYDNEY ARE: [11]

81 of all domestic and foreign banks in Australia [12]

73 of property and business services regional offices

60 of manufacturing regional headquarters

81 of Asia Pacific finance and insurance regional offices

76 of all information and communications technologies regional headquarters

75 of the headquarters of multinational pharmaceutical companies in Australia [13]

$1.096

BILLION (AUD)
CASHED UP

The fastest growing service industry in NSW is financial services. Sydney's workforce is now nearly half the size of London's and more than one-third the size of New York City's. Australia has the largest pool of investment fund assets in Asia Pacific, with consolidated assets of over **AUD 1,096 billion.** [14]

Size Matters
Sydney's Central Business District is the largest in the country, surrounded by booming satellite cities.

Swing Shift
Since the 1980s, the biggest shift in Sydney's job growth has been from manufacturing to IT and the services sector.

❝
Voted as the second global financial centre by The World Economic Forum in 2009, overtaking the US. Incorporating features like business environment and financial stability.

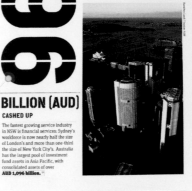

THE PLANE FACTS
04 LOCATION

Sydney Airport goes to town

Sydney boasts the one travel asset that other great global cities, like London, Tokyo, New York and Paris just don't have – an airport in the city. Upon arrival passengers are an enviable 9kms from the Central Business District, just three stops away on our Airport Link train. Sydney Airport is the gold standard for international travellers who want to get places. Fast. Frequent. Direct.

60% of the Australian population lives within **75** minutes flying time from Sydney; we are their gateway to the world. [1]

60%

Sydney Airport is the Gateway to Australia and the aviation hub of Oceania, with the most to offer international, domestic and regional passengers.

In 2009 Sydney – Melbourne was the world's 5th busiest airline route, with Sydney – Brisbane coming in at Number 12. [1]

7 domestic and regional airlines ensure that Sydney delivers domestic traffic in Australia. Sydney Airport is Australia's busiest domestic airport, with **22,350,550** domestic passengers annually. [1]

22,350,550

Sydney Airport is one of the few primary airports to be centrally located – only **9km drive from the Sydney Central Business District** in a city of 4.3 million people.

20

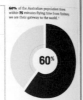

9KM

20 minutes on the Airport Link train to Central Business District – just three stops away.

10 minutes travel to Central Station – Sydney's biggest city and regional railway hub.

本頁及對頁 | **Frost* Design**
手冊設計
為雪梨機場製作的《登機》
（*Get on Board*）版面，其
中相異的排字方向，強調機
場的特定資訊與數據。

109

角度分割視野，為設計增添戲劇性元素，與正常的水平資訊展現方式呈強烈對比。有角度的文字令人意外又震撼，能真正擷取讀者的關注。

●常見角度

活版印刷的時代，活字排在水平結構的框架內，很難做出角度，且傾斜文字常需手繪，運用上較為費時。如今有了電腦和排版軟體，製作有角度的文字相對容易了。

設計開始認真用到傾斜文字，是在 1920 年源自革命時期俄國的構成主義運動（constructivist movement）。此運動的特徵是運用工業材料如玻璃、板金和塑膠，針對政治主題構築出抽象、且多為幾何形式的物體，讓代表革命的紅色三角穿刺代表帝國主義的白色圓圈。其重點工業材料與幾何形狀如三角形的採用，反映在非對稱的塊狀排字。三角形等幾何圖案也是包浩斯1919 年到 1933 年的要角。設計中著重三角形，自然導致文字斜角排列，做為映襯。

雖然設計師能以任何角度設置文字，某些慣例仍有助於保有秩序感，建立好懂易讀的作品。傾角文字通常擺成相對於水平線或垂直線的 90 度角，或說分別傾斜 60 與 30 度，以使文字方塊之間仍然維持 90 度，呈現足夠對比。文字方塊分別傾斜 45 及 135 度，也能達到類似效果，依然保留文字方塊之間對比的 90 度角。

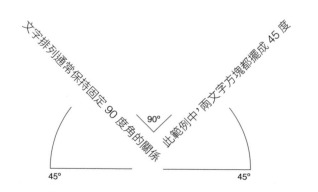

文字排列通常保持固定 90 度角的關係

此範例中，兩文字方塊都擺成 45 度

90°

45°　　　　45°

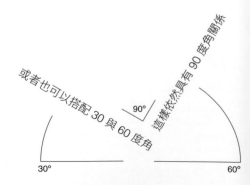

或者也可以搭配 30 與 60 度角

這樣依然具有 90 度角關係

90°

30°　　　　60°

●方向

方向能用來改變節奏和可讀性。文字配置的角度越極端，可以說就越活潑動感。相對地，極端角度或許也代表難以閱讀，讀者必須幾經曲折，才有辦法看懂文字，如底下的範例所示。注意到範例中搭配使用相對文字基線 30 度與 60 度，或 45 度與 45 度，維持兩段間的 90 度角，讓人有掌控感與秩序感。

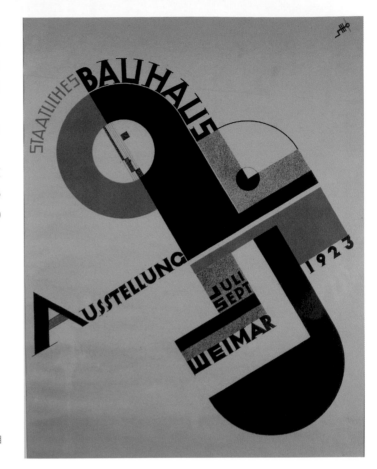

右圖 | 喬斯特‧舒密特（**Joost Schmidt**）
海報設計　1923

1923 年包浩斯大展（Bauhaus Exhibition）海報，主題文字配合設計的線條，擺成相對水平線 30 度。

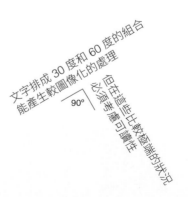

90°　本例中兩個文字方塊都傾斜 45 度如此保留了一貫的 90 度角，但傾斜的文字可說較難閱讀

文字排成 30 度和 60 度的組合能產生較圖像化的處理　但在這些比較極端的狀況必須考慮可讀性 90°

STAIRS UP TO

BRIC MEDIA CENTER

BRIC OFFICES

URBANGLASS

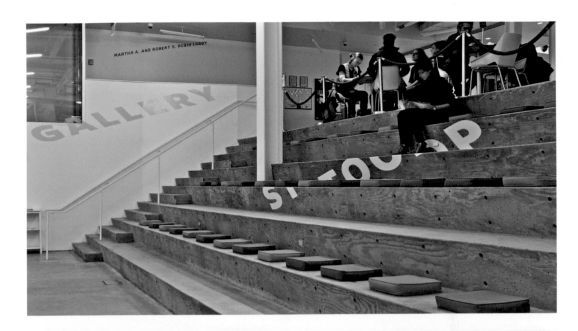

本頁及對頁 | **Poulin+Morris** 環境標誌
布魯克林資訊與文化中心（Brooklyn Information & Culture，
BRIC）的環境標誌與室內空間圖像，它們在不同的表面以各
式角度呈現，產生吸引人又有活力的環境。

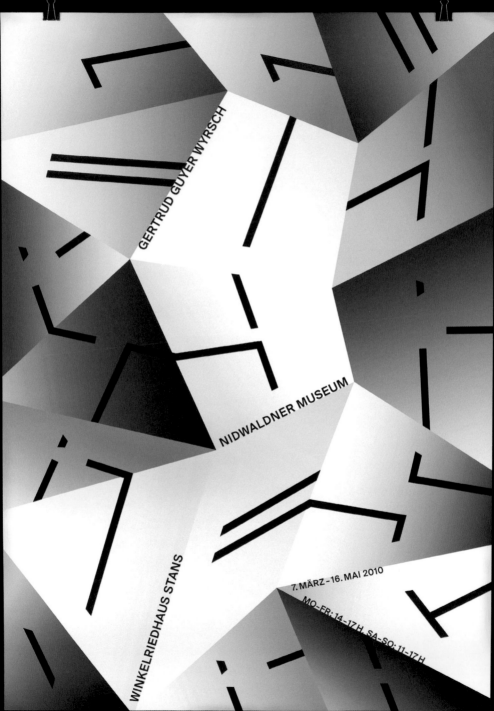

GERTRUD GUYER WYRSCH

NIDWALDNER MUSEUM

WINKELRIEDHAUS STANS

7. MÄRZ – 16. MAI 2010

MO–FR: 14–17H, SA–SO: 11–17H

●極端角度

前面展示了運用傾角排字的版面。使用傾斜文字時，一般操作是維持上下方向，方便以閱讀。然而在極端的範例中，如此處所示，呈現上下顛倒的文字。這樣的手法在處理小量文字如名稱或標誌時，效果可能很好，特別的角度增加趣味和活力，但用在較長的文字段落，就會令任何人都難以理解。

對頁｜**C2F　海報設計**
為下瓦爾登美術館（Museum of Art Nidwalden）的葛楚 · 蓋爾 · 魏爾許（Gertrud Guyer Wyrsch）特展設計的海報，展現擺放於極端角度、沿設計圖案排列的文字。

上圖｜**貝多設計工作室（Bedow）　視覺識別**
為設計公司薛爾朋工作室（Studio Källbom）製作的部分視覺識別，這個標誌以極端角度擺放工作室名稱。

「橫列」一詞衍生自海事作戰隊形「broadside」，此狀態下戰艦橫向列隊，使全部槍砲都能向敵軍開火。在設計中，這個詞彙意指相對書脊旋轉 90 度，必須倒置閱覽的排版或文字。

●改變觀點

橫列通常用於垂直呈現表格資料，例如當頁面尺寸狹窄而表格欄數眾多的狀況。不過橫列也用於提供特別的文字處理，使觀者改變視角。當刊物中主體並非橫列，則橫列的表現就很明顯。

90 度旋轉文字和圖像除了實際解決用途，也可以是美學操作，為版面增添動力，迫使觀者對圖像內容意圖表現的重要性提出疑問。下面的例子展現出有創意的定向運用如何讓出版品更有特色。

下圖及對頁∣日常生活實踐工作室（A Practice for Everyday Life）　書籍設計
這本《預行動》（*Pre-enactments*）由藝術家維多利亞・哈爾福德（Victoria Halford）與史蒂夫・比爾德（Steve Beard）創作，為英國商業區的攝影紀錄。其格式源自商用 35 釐米膠卷樣片（film prints），並積極運用橫列呈現。

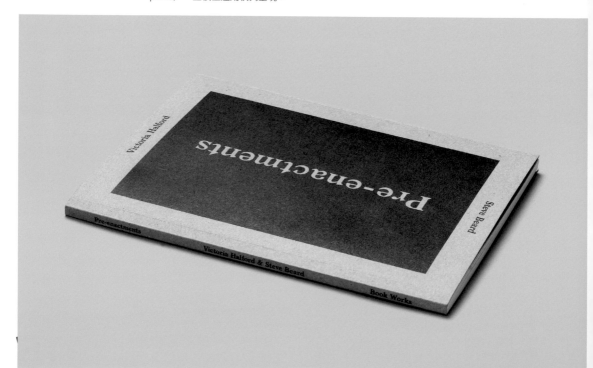

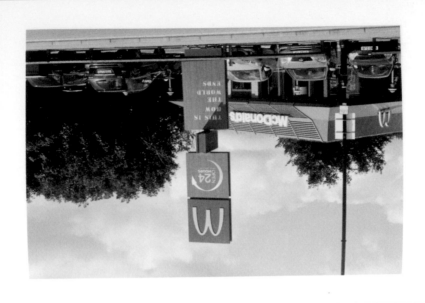

This is How The World Ends, 2012

有自信地選擇及使用字體，能產生持續性與辨識性。為倫敦的艾爾美達劇院（Almeida Theatre）設計的這個作品，既具功能性，又令人印象深刻。橫列展示的文字元素，更加強設計的記憶點。

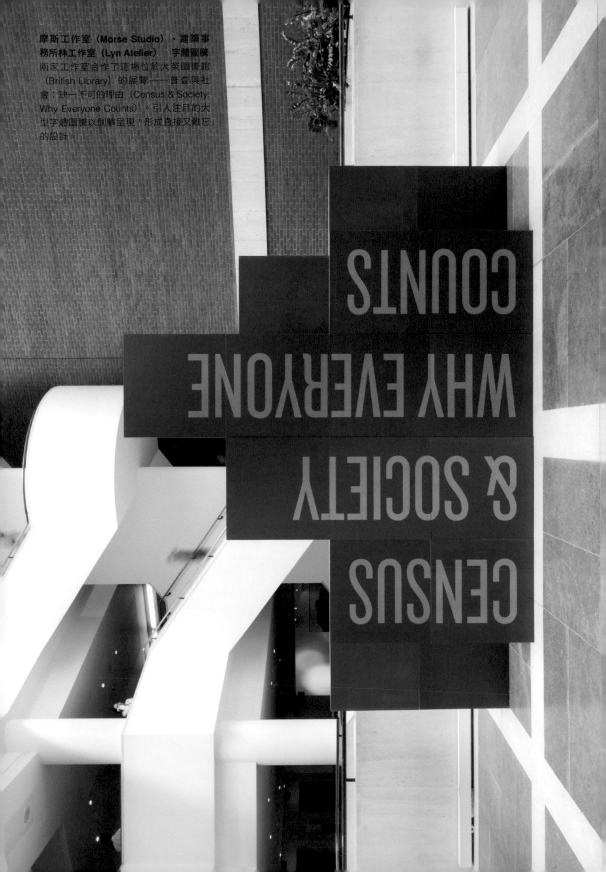

摩斯工作室（Morse Studio）、建築事
務所林工作室（Lyn Atelier） 字體圖騰
兩家工作室合作了這場位於大英圖書館
（British Library）的展覽──普查與社
會：缺一不可的理由（Census & Society:
Why Everyone Counts），引人注目的大
型字體圖騰以側躺呈現，形成直接又難忘
的設計。

強調意指給予某事物特殊的重要性、價值或力道。平面設計師可強調設計元素的工具庫內容幾乎無限，包括放大尺寸、獨立於留白處、加底線、著色及並置。

上圖及對頁｜Frost* Design　手冊設計

澳洲豐收（OzHarvest）2013 年度報告暨藝術計劃的手冊版面，透過大字體，以尺寸強調關鍵字。澳洲豐收是在多個澳洲城市搶救剩食的慈善組織，將這些原本會被丟棄的食物分送給協助弱勢的慈善團體。強調手法標明出「GENEROSITY」（慷慨）與「LOVE」（愛）等關鍵字，章節標題如「J(OUR)NEY」（旅程〔我們〕）與「BE:CAUSE」（因為〔成為：目標〕），以及組織的主要成就數據如「$7.8B」（78 億元）。

這份三十六頁的文件印在亮黃色紙板上，具有拉出式引言、粗體文字排版，且事實與數據以資料圖的形式呈現，方便理解。Frost* Design 的創辦人兼執行創意總監文斯·佛斯特（Vince Frost）說：「年報通常在講述錢。但這份報告講的是澳洲豐收幕後人員享受到的歡樂、尊嚴、連結，及愛的感覺，不可能以金錢量化。」

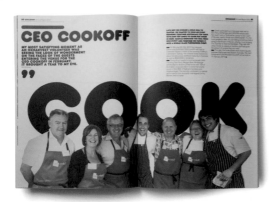
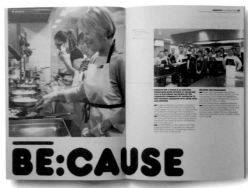
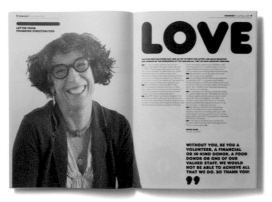
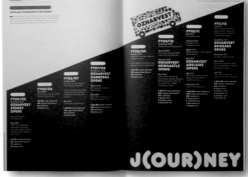
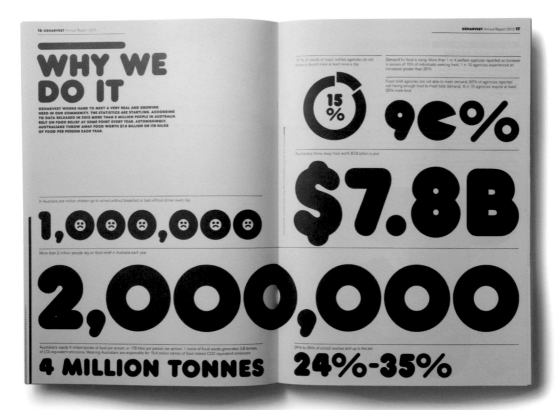

上圖｜**Happy F&B　刊物設計**
2013 年索德柏獎（Soderberg Prize）的刊物，呈現簡單乾淨的設計，將無襯線文字放在視覺熱點，
占據讀者的注意力。

CHAPTER

4

頁面上的物件

物件擺在頁面上的方式,會顯著影響觀者接收與解讀物件的方式以及獲得的訊息。我們已討論如何使用網格引導頁面上元素的安排,但維持秩序感並非排版設計的唯一考量。

物件的擺設,建立自我們對頁面閱覽方式的理解,並有助於形成設計敘事。可藉各式各樣的佈置和調整策略,構築與更改設計敘事,例如留白的使用手法、其他物件的平衡與相對權重、物件的並置或對比等等。

本章將概述物件排列的一些基本操作。

設計師能藉由廣泛詞彙,將極度隱晦或複雜的想法理念做流暢的視覺描述。

・鄰近 Proximity

鄰近指的是將元素靠近擺放,建立彼此間的關係。例如將圖說放在圖片附近,就暗示了這段圖說是在描寫這張圖片。

・統一 Unity

統一是將藝術作品中互異元素結合在一起,產生大於個別元素總合、一種密不可分的完整性。元素間的搭配性越高,作品呈現的統一感越高。利用鄰近和重複在不同物件間設立關係,有助於建立統一。

・正列 Alignment

正列表達出設計整體對架構的需求,提供體制讓我們接觸並解讀設計中的資訊。舉例來說,句子如果沒有正列,就會難以閱讀,頂多是一團字母。正列形成結構,讓設計師引導讀者或觀者瀏覽設計作品。

・對比 Contrast

對比意指排列設計中的不同元素,令相對處變得明顯。對比的使用為設計添加形體、構造和活力,還可能產生動態張力。

・階層 Hierarchy

階層表示設計元素重要性的排序呈現,可能依大小、間隔或顏色決定。

・平衡與張力 Balance and tension

藉由各設計元素間的平衡,可達到不同程度的和諧或衝突。一般來說,設計師希望建立平衡,使影像和文字幾乎天衣無縫地配合,但目標並不永遠如此,更戲劇化的表達也是可行。

・並置 Juxtaposition

將展現不同理念或觀點的元素相鄰擺放,便在其間構建出別種方式難以傳達的強烈連結。

・持續或重複 Consistency or repetition

重複會強化傳遞的訊息,顯示此資訊很重要。持續使用視覺元素如標記等,也會加強訊息,因為讀者不需重新解讀。一旦讀者熟悉了影像或訊息,下次再看到時多半會自動做出連結。

・留白 White space

留白的運用讓設計得以喘息,有人就形容留白是好設計的肺。留白有助於將目光吸引至被空白所圍繞的元素上,也常指示這項物件的相對重要性。

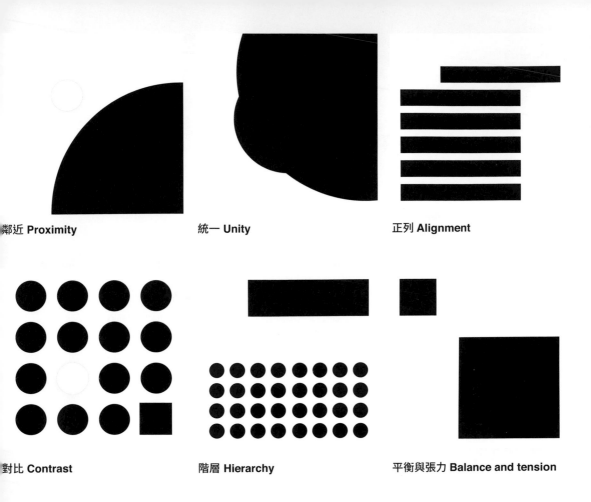

鄰近 Proximity

統一 Unity

正列 Alignment

對比 Contrast

階層 Hierarchy

平衡與張力 Balance and tension

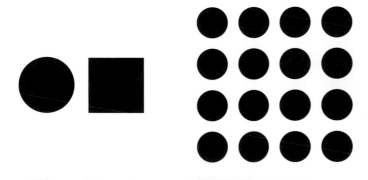

並置 Juxtaposition

持續或重複 Consistency or repetition

留白 White space

125

煉金術還是研究應用？

乍看之下，將物件擺在頁面上似乎是相對簡單的工作，不需要太多思考，只要手眼還算協調，再有一點判斷力就好。

操作得當的排版設計也許看起來乾淨協調，好像沒花什麼力氣就完成了。然而，在建立意義和秩序的同時，還要製作出讀起來誘人又有趣的東西，這任務可能極度耗神費力。網格能指引元素的擺放，使設計師的工作輕鬆些，但網格的存在不是為了阻礙或規範創意。

本頁及對頁｜目標品牌顧問公司（Purpose）　刊物設計
歐洲農業與食品聯盟（European Farming & Food Partnerships, EFFP）的《觀點雜誌》（*View Magazine*），其中呈現多種明確的設計元素。擺在相對頁面上的 FARM（農場）與 FOOD（食物）字樣，靠著鄰近性建立彼此的關係。同時這也是統一的例子，將不相關元素結合，形成比個別元素加總更強大、更整合無缺的完整性。

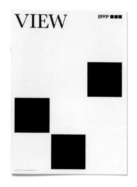

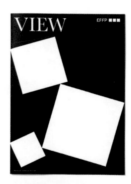

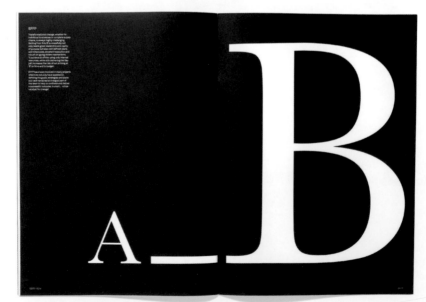

EFFP

Successful businesses are built on strong foundations. Excellent people and sound financial management are crucial but without a clear vision, stretching goals and innovative strategies a business will lack direction and not achieve its potential in the market place or maximise returns to its stakeholders.

EFFP has developed an excellent track record of working with boards to help develop strategic thinking, construct business plans and implement and support structural change. Successful delivery of these services alongside the work we do to address Board member development and leadership is why our clients use us repeatedly.

LAYING STRONG BUSINESS FOUNDATIONS

FARMING & FOOD, STRONGER TOGETHER

FARM FOOD

EFFP is a specialist agri-food business consultancy working across the whole supply chain. By using our combined knowledge and experience of the farming and food sectors we are able to help forge stronger chains. Through addressing strategic, structural and commercial issues from an independent and objective perspective we have been able to bring food companies and their raw material suppliers closer together to develop long term mutually beneficial business relationships. If you would like to know more about the benefits of developing a more strategic and transparent supply chain please call us on 020 7213 0430 or visit us at www.effp.com.

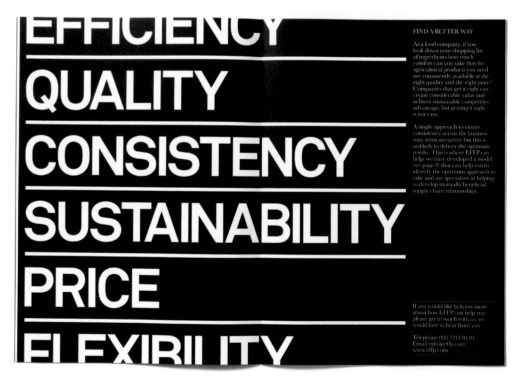

1 2 3 4

OUR
VIEW

The sudden and very sharp descent into recession over the last year, together with the rapid decline in retail food inflation has relegated discussion of the price and affordability of food to the background. This is understandable but the two events are not unrelated. One of the effects of the high rate of retail food inflation – as revealed in previous issues of VIEW – has been the sharp deterioration in the affordability of food after more than a generation of steady improvement. Now that the rate of increase in retail food prices is falling towards zero it is tempting to conclude that the affordability of food will soon revert to its longer-term improving trend. We are not so sanguine.

In our view, even on the basis of an optimistic future scenario, the recession has resulted in a permanent loss of food affordability for consumers. The impact of this for farming and food businesses will be an ongoing shift in their focus away from developing value added opportunities towards delivering greater value for money and a greater emphasis on production and supply chain efficiencies.

We define the affordability of food as the amount of their expenditure consumers' would have to devote to food in order to maintain a given volume and quality of food. In essence, the steady improvement in the affordability of food until 2006 reflected the fact that the rate of increase in retail food prices was less than the rate of increase in consumers' expenditure. This was sharply reversed in 2007 when the effect of retail food inflation took hold and just as the rate of increase in food prices is slowing, so the beneficial effects are being more than offset by the recession induced fall in consumers' expenditure. Whether or not the affordability of food resumes its longer-term improvement depends critically on the speed of economic recovery and the future performance of agricultural prices.

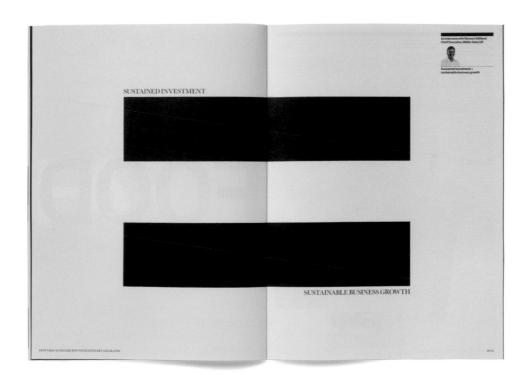

SUSTAINED INVESTMENT

SUSTAINABLE BUSINESS GROWTH

An Interview with Stewart Gilliland
Chief Executive, Müller Dairy UK

Sustained investment =
sustainable business growth

這些版面展現正列等設計元素。左下圖的文字列表整齊排列，因而產生感知與意義；但右上圖明顯未對齊的數字，給人強烈的視覺印象，並具有較自然的結構。此兩頁及前面的所有版面都應用了單色黑白對比，視覺效果驚人之外，也讓版面間一定程度地共通。

平面設計中，並置指的是將影像並排，創造兩者的關係。影像在這樣的安排下，彼此特性得以相交結合。

並置是引出圖片關係並呈現給讀者的簡易手法，影像互為相似時效果最佳。下方的範例中，兩圖的相似處包括同為頭像照片，且黑白呈現讓顏色不至於造成干擾。科學怪人的頸部螺栓和女人的耳環皆係金屬配件，也是一連結點。並置的影像間還必須有一定程度區別，才能傳達預期的意義。此版面的區別處可能是真實人像與創作角色照片的差異。

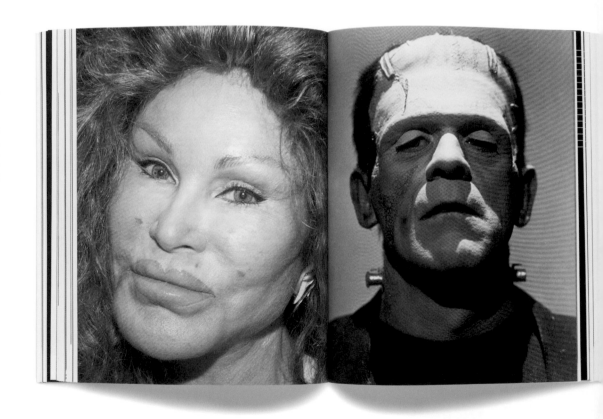

上圖∣麥耶斯考設計工作室（**Studio Myerscough**）　刊物設計
為 Profile Books 出版的刊物《未來的臉》（*Future Face*）所設計的版面。兩張並置照片分別是歷經多次臉部整形手術的名媛喬斯琳·威爾頓斯坦（Jocelyn Wildenstein），與 1931 年電影《科學怪人》（*Frankenstein*）中鮑里斯·卡洛夫（Boris Karloff）的科學怪人扮相。

對頁∣斯科勒斯 - 威代爾（**Skolos-Wedell**）　海報設計
公共單車公司（Public Bike）的海報《公共單車》（*Public Bike*），由單車特寫並置而成。該海報為公共單車公司的限量版系列《公共作品》（*Public Works*）的一部分。

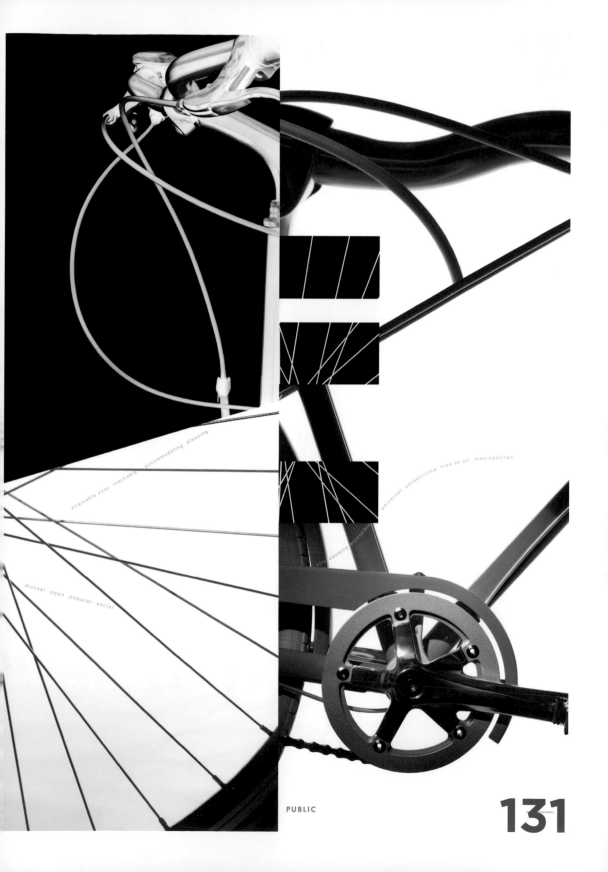

attainable easy reachable accommodating pleasing

universal unrestricted free to all metropolitan

city country accessible

mutual open popular social

排版將字體排印內容進行組織，讓字母建構出詞彙，再形成句子和有順序的文字方塊。沒有了秩序，就喪失傳遞資訊的能力。

著名字體排印師如弗魯提格（Adrian Frutiger），深刻感受到為字體建立秩序和結構的必要。弗魯提格鑽研字體家族內不同粗細和寬度的表達方法，得出以他命名的網格系統。

弗魯提格表 Frutiger's Grid
字體排印師弗魯提格開發出一套字型編號系統，識別字體家族內的粗細和寬度。此處以 Helvetica 字體示意的弗魯提格表，透過粗細和寬度的視覺關係，傳達秩序感與同質性，進而供人選擇協調的字體。

●合理的數值

選擇文字階層的粗細和寬度，是確立設計作品外觀風格的決策關鍵。各階層必須充分協調，以便閱讀，但又要有足夠差異，以清楚定義階層。弗魯提格表令設計師能從彼此相容的近似子族間挑選編號值。

・數值協調

選擇相互配合的文字粗細和寬度時，弗魯提格表提供立即可用的指引：

Helvetica Light 45

If the values of typefaces, and therefore their tonal values, are too similar then the difference in weight can be too subtle to detect. Helvetica Thin 35 Here, 45 and 35 are used but the difference between them is too subtle and looks odd rather than differentiated.

若字體編號值太相近，則其調性也將接近，那麼字體的粗細差異可能會太過微細而無法察覺。此處使用 45 和 35，但其間的分別太微細，無法進行辨識，反而看起來怪怪的。

Helvetica Black Extended 93

If the values selected are too different and exaggerated they can look disjointed, which while creating a strong graphic statement, may not be what was required. Helvetica Ultra Light Condensed Oblique 27 *In this example, the extremes from the grid effectively collide.*

若編號值差太多太誇張，可能看起來不連貫。如此能創造強烈的圖像表達，但不見得是想要的效果。此範例中，弗魯提格表兩端的字體明顯衝突。

Helvetica Heavy 85

Successful use of Frutiger's Grid typically requires that you select values that are at least two numbers apart. Helvetica 55 Here, 85 and 55 have been used which produce a difference that is enough to be clear without being overpowering.

要成功應用弗魯提格表，通常必須選擇編號相距兩級以上的值。此處使用 85 和 55，產生足以明白、但不過度衝擊的差別。

●字型與網格

字體家族能夠傳達特定屬性和個性，此特性已成為建立品牌識別的重要元件。這時可設置網格，規範品牌運用字體家族的方式，及哪種情況下使用哪些字族成員。

字體樣本
世代以來，字體排印師利用網格創作出風格迥異的字型，如範例所示。其共通元素就是在發展形式的過程中，拿網格當作秩序的基礎。

ABCDEFGHIJKLMNOPQRSTUVWXYZ
abcdefghijklmnopqrstuvwxyz
1234567890

· **Avant Garde**

赫伯·盧巴林（Herb Lubalin）和湯姆·卡內斯（Tom Carnase）於 1970 年設計的 Avant Garde 是一款無襯線字體，令人憶起德國 1920 年代以圓規和丁字尺繪製幾何圖形的包浩斯運動。

ABCDEFGHIJKLMNOPQRSTUVWXYZ
abcdefghijklmnopqrstuvwxyz
1234567890

· **Moonbase Alpha**

柯尼爾·溫德林（Cornel Windlin）1995 年的作品 Moonbase Alpha 以圓角方格為基礎，傳達稍微模糊的異世感。

ABCDEFGHIJKLMNOPQRSTUVWXYZ
abcdefghijklmnopqrstuvwxyz
1234567890

· **OCRA**

OCRA 的創造係為了搭配光學字元辨識（optical character recognition，OCR）軟體使用，能經由掃描轉換成可編輯的文本。字元造型以明確的網格為設計基礎，曲線也改成斜角，利於電腦識別。

abcdefghijklmnopqrstuvwxyz
1234567890

· **Cirkulus**

Cirkulus 由麥可·紐格包爾（Michael Neugebauer）於 1970 年推出，屬實驗性、無大小寫呈現的字型，將 1920 年代構成主義情懷的細線圓圈與直線融入數位時代，特色是升部（ascender）與降部（descender）穿透的幾何形狀。

ꜱabcdɛfꬶghijklmnopqrꜱtuv
wxчyzàáâãäåⱥæàáâãäåœçèé
êëğǧìíîïıłñòóôõöøœšşßùúûü
û́ĺḉ̈ýûÿžðþfbffbfffhffhfhfhffh
fiffiffjffifkffkflfflftfftʄ0123456789

€£\$¢ƒ¥¤+−×÷=~∧<>∕%‰°ᵃᵒ_–――＂
⌐⌐⌐⌐⌐ ⸜⸝‹›«».⸓˚°∘∘∘∘•¡¦?¿&()□⅓⁄/∖*†‡¶•
®©®™#`´^ˆ~…‐‑˘˚ˇ˙ . ＇＇

上及左 | 傑瑞米・唐卡德（Jeremy Tankard）、風暴設計工作室（Blast）
Inuit 字型

Inuit 是一款客製字型，靈感來自伊努特語（Inuktitut）字母深具召喚力的構造。這是一款為紙商阿爾若維根斯（Arjowiggins）的伊努特紙系列打造的字型。由原始伊努特文字結構衍生字型，將這種文字標準化，並因此更容易擔任品牌識別的一部分，結合在網格形式的設計與版面之中。

行距與字型

文字透過行距與字型等排字元素，呈現在版面上。字型即字元本身，行距則是用來分隔字句行列的工具。沒有行距的緊密文字會看起來擁擠，且升部和降部可能相交。

●行距值

行距值（Leading values）的挑選方式很多，通常數值比字體尺寸大，以構成間距充足的文字方塊。行距值與字體尺寸相同（緊密排列）會出現間隔問題。要輕鬆計算行距值，只要取字體尺寸多加幾點，像是 12pt 字體搭配 14pt 行距。另外，也可將字體尺寸乘上一定百分比，例如讓行距是字體尺寸的 120%，若字體是 7.5pt，行距就是 9pt。請注意，字體尺寸越大，行距需求就越小，因為大字體令人感受到的文字行間距離較大。

Leading values can be chosen in various ways. It is common for the leading value to have a larger point size than the typesize in order to create a well-spaced text block, as using the same value (set solid) presents spacing problems. A simple way to obtain a leading value is simply to add a couple of points to the typesize, such as 12pt type with 14pt leading. Another method is to take a percentage of the typesize, such as having leading that is 120 per cent of the typesize, which could be 7.5pt type with 9pt leading. Note that as typesize increases, less leading is required, as the perceived space between text lines increases.

行距
本段文字設定為 7.5pt 字體、9pt 行距。

Souvenir 字體中，x 字高（x-height）較大，造型又粗，就算字體尺寸和行距與下方所示的 Cochin 相同，Souvenir 的行間距離仍顯得較少。

Souvenir
Souvenir 字體，設定為 13.5pt 字體、15pt 行距，或可記為 13.5／15。

Souvenir, with its large x-height and bold appearance, seems to have less space between lines than Cochin (shown below), although both are set at the same typesize and on the same leading.

Cochin 因為有較細的造型和較小的 x 字高，距離感覺比上方 Souvenir 來得大。由於有這種視覺差異，透過目視調整行距常常比依賴數學公式更恰當。

Cochin
Cochin 字體，設定為 13.5pt 字體、15pt 行距。

Cochin, because of its lighter appearance and smaller x-height, appears to have more space than Souvenir (shown above). Because of this optical difference, it is often preferable to adjust leading by eye rather than relying on a mathematical formula.

斷字和字距調整，都能針對左右對齊的文字方塊進行調控。左右對齊會將文字推往兩側邊界，因而加大文字方塊裡的字距，產生過多留白。

使用帶有連字符號的斷字，可減少留白，但若連續幾行末尾都是斷字，可能會有問題。設計師搭配使用斷字與字距調整，能確保製作出好看的文字方塊。

●字距調整或左右對齊

字距是文句中各單字的間距，依文字方塊的設定而變化。任何對齊方式都會形成一致的間距，但靠右、靠左及置中對齊文字的字距為固定值，而左右對齊會調整字距，讓文字對齊左右邊界。字距的變化，能夠改善文字方塊的視覺外觀。

altering the spaces between words
altering the spaces between words
altering the spaces between words

字距
這三行呈現不同的字距。第一行增加了間距，第二行具有正常間距，最後一行則間距縮小。

一般來說，字體越小，字距越不需調整。文字越大，像是標題文字或甚至是看板尺寸，則可縮減越多距離，讓文字排版看起來更自然、更易讀。下面範例中，相較於第二例減低一半距離的「緊密」排版，第一例沒有減少距離的排版看起來不太順暢。

未減少字距的例子

Larger text can have more space taken out

減少 50% 字距的例子

Larger text can have more space taken out

137

space to meet in a prime location, discuss, digress, draw inspiration, develop, propose, present, define, achieve, aspire, envisage, shine **etc.**

etc.venues

Mary Powell
Director of Marketing & Sales

Call +44 (0)20 7518 8603
Send +44 (0)20 7297 6623
mfowell@etcvenues.co.uk

etc.venues

36 Park Street, London, W1K 2JE
www.etcvenues.co.uk
Your space to think, work and learn

a chance to shake a hand, show you round, discuss, digress, define, progress, meet, greet, work the room, share your thoughts, reflect, resume etc.

space to share, dream, dare, scheme, discuss, propose, oppose, run an idea up the flagpole to see if anyone salutes, develop, define, refine, inspire, think, work, learn **etc.**

Your space to think, work and learn

etc.venues Call +44 (0)20 7518 8600 venues@etcvenues.co.uk
36 Park Street, London, W1K 2JE Send +44 (0)20 7297 6623 www.etcvenues.co.uk

etc.venues

etc.venues Call +44 (0)20 7518 8600 venues@etcvenues.co.uk Your space to think, work and learn™
36 Park Street, London, W1K 2JE Send +44 (0)20 7297 6623 www.etcvenues.co.uk

etc venues limited. Registered in England, No. 2717522 36 Park Street, London, W1K 2JE. We don't just consider your working environment. All our paper is sourced from sustainable forests to keep your spaces green.

etc.venues London's leading independent
 provider of meeting and events space
 www.etcvenues.co.uk

a chance to talk, share, dream, dare scheme etc.

Park Street
36 Park Street, W1K 2JE
Call +44 (0)20 7297 6600
parkstreet@etcvenues.co.uk
www.etcvenues.co.uk/parkstreet

Creative Arts typeface
To reflect the innovative culture of the new University College a bespoke typeface has been created for use within the new identity. Exclusive to the University College, the Creative Arts' typeface is simple and modern, taking its influence from the classic Avant Garde. It has been cut in lower case letterforms only, maintaining a consistent and friendly appearance across all University College communications and partner organisations.

Typography
The consistent use of typography is critical to the success of the new visual identity. LT Univers is the primary typeface used for the University College. It should be used as the first choice typeface throughout the new identity, across all applications. LT Univers is both sympathetic to the Creative Arts typeface and provides the necessary legibility to allow complete accessibility.

Adobe Garamond Pro is the secondary typeface, however it's usage is limited to publications and printed pieces that require a more formal approach.

上圖｜風暴設計工作室（Blast） 視覺識別
英國創意藝術大學（University College for the Creative Arts）的視覺識別，利用無襯線字型描繪並呈現品牌。字體家族中的不同成員，在設計中各司其職。

對頁｜風暴設計工作室 品牌識別
etc. venues 出租公司的品牌識別。排字構成的品牌識別可用於各類印刷與電子媒體，由於受網格調控，在不同應用上仍得以維持空間感與比例。

139

對齊指的是字元在文字方塊內水平與垂直方向的排列，藉此增進文字在排版中的位置安排，及與其他元素協調的能力。

靠左對齊／右側不對齊 Range left / ragged right

此對齊方式遵循手寫文字的原則，沿左邊界直線靠緊，每行右緣結束處則不一致。

靠右對齊／左側不對齊 Range right / ragged left

靠右對齊比較少見，因為每一行的起始處不同，較難閱讀。有時以此方式處理圖片說明和其他附加文字。

左右對齊 Justified

左右對齊文字沿左右兩邊界排齊，剛好填滿文字方塊，不過可能因字距加大而產生過多留白；為避免過多留白而使用帶有連字符號的斷字，又可能太過干擾。

置中對齊 Centered

置中對齊文字讓各行對準文字方塊的中線，開頭及結尾都不整齊。可以調整文句結構，將不齊的狀況控制在一定程度內。

強制左右對齊 Forced Justified

強制左右對齊與左右對齊相同，將文字對整左右邊界。不過此操作更包括未填滿的行句，如標題和段落最後一行，因此可能產生間距遙遠的字詞。

●適合目的

文字方塊的對齊方式並沒有真正對錯選擇，但特定作業中可能某一種方式比其他方式恰當。數千年來歐洲皆以靠左對齊為標準，因為這樣經濟單純，閱讀也輕鬆，包浩斯等運動更加深此偏好。解構主義（deconstructionism）等其他觀點則對此標準提出質疑，並偏愛其他對齊方式。

●多重對齊

單一設計中能運用多組對齊方式，為不同資訊清楚劃分差異，例如副標與內文，或問答文章中兩人的言論。列表式呈現資訊時，也常以多重對齊為不同的類別建立差異。

下圖｜《弦波拉》（*Zembla*）雜誌內頁的對齊線
此版面有兩種來源文字，透過不同對齊線加以分辨識別。善用顏色更使此分別加倍明白。

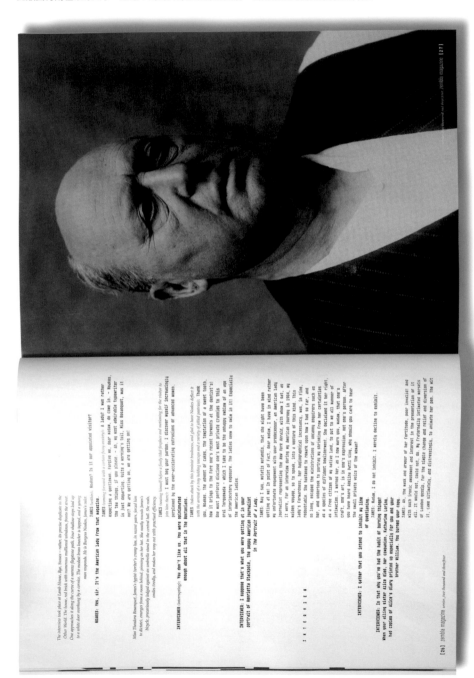

內縮是在文字段落的開頭處插入不定長度的空格，以清楚表示段落開頭。

◄───►
行寬的左側或前緣 外邊界

內縮程度
內縮是文字行寬的一部分。行寬即文字方塊左側到外側右緣的距離。

決定內縮程度
・運用幾何學
行寬是內文段落的寬度。西方傳統上，內縮占行寬三分之二，不過當代傾向較短的內縮，產生的排字問題較少。若使用長內縮，則段落末行的長度須足以接到下一行的內縮文字，否則間距將顯得不太對勁，文句的流暢性受到阻斷。下方文字的行寬是 284pt，故三分之二幾何內縮將造成內縮 189pt，看起來不自然地深陷段落中。

◄───► This text block has a measure of 284pts, so a two-thirds geometric indent gives an indent of 189pts, which looks unnaturally far into the paragraph.

・運用 em
下方文字的內縮方式以字型的 em 長為內縮距離。這樣一來內縮與字型會具有相對長度關係，此處為 10pt（文字設定為 10pt 大小）。

10pt ──► This paragraph is indented using the em of the font as the indent length. This provides an indent that has a length relative to the font, in this case 10pt(as the text is set at 10pt).

・運用行距
下方文字的內縮設定為文字方塊的行距值，一樣能提供相對於文字特性，連貫又協調的感覺。此處使用了 18pt 內縮，因為行距設定是 18pt。

18pt ──► Indents can also be set using the leading value for a text block, again providing an element of consistency and harmony relative to the text characteristics. In this case an indent of 18pt has been applied as the leading is set to 18pts.

●內縮類型
段落內縮的方式千百種，使文字方塊產生不同視覺感受。常見的手法包括換行內縮、首行內縮、定點內縮、連續內縮及裝飾性內縮。內縮手法的選擇常取決於待設計的目標文本和刊物類型，例如小說可能用到換行內縮，年報則會含有定點內縮或裝飾性內縮，以強調重點項目。

換行內縮（drop-line indent）的長度，與前段文字的結束點相同，產生強烈的圖像表達。

如此既提供視覺中斷，也表明了新段落、保持連續性。

首行內縮（first-line indent）的文字從第二段以後，每段第一行的左邊界內縮。

西方文件的標題、副標或通欄標題（crosshead）後的第一段通常不內縮，以免造成突兀的空白。

☛ **裝飾性內縮（ornamental indent）**是傳統手法，從文本裡裝飾符號（ornament）或標題符號（bullet）的插入處開始內縮。

定點內縮（on-a-point indent）：根據設計的要求，內縮於特定的位置，例如在清單中第一個字處內縮。

凸排（outdent）是內縮的相反，段落第一行頂到左邊界，但剩下的所有行句都內縮。

連續內縮（running indent）係左邊界或右邊界連續多行文字內縮。這種操作可能是為了框出較長的引文。

下圖｜卡特利吉 · 萊文（**Cartlidge Levene**）　刊物設計
英國設計協會（UK Design Council）所出版的《設計事業》（*The Business of Design*），列出了一份設計產業的調查結果。刻意運用的內縮，建立瀏覽的階層感，並有助於呈現複雜資料。

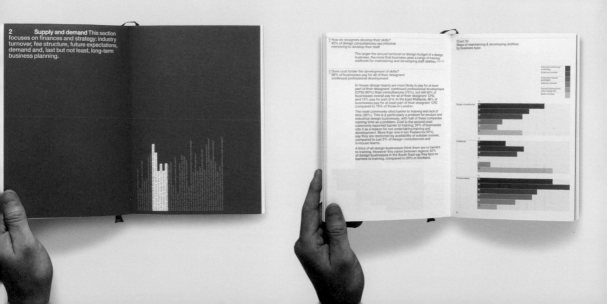

NIELE
TORONI

本頁及對頁｜ **C2F 刊物設計**
瑞士聯邦文化局（Federal Office of Culture）的梅瑞歐本海獎（Prix Meret Oppenheim）刊物，微妙的文字內縮有助於產生識別性，並在左邊界處產生多角形留白，與不整齊的右邊界形成對比。

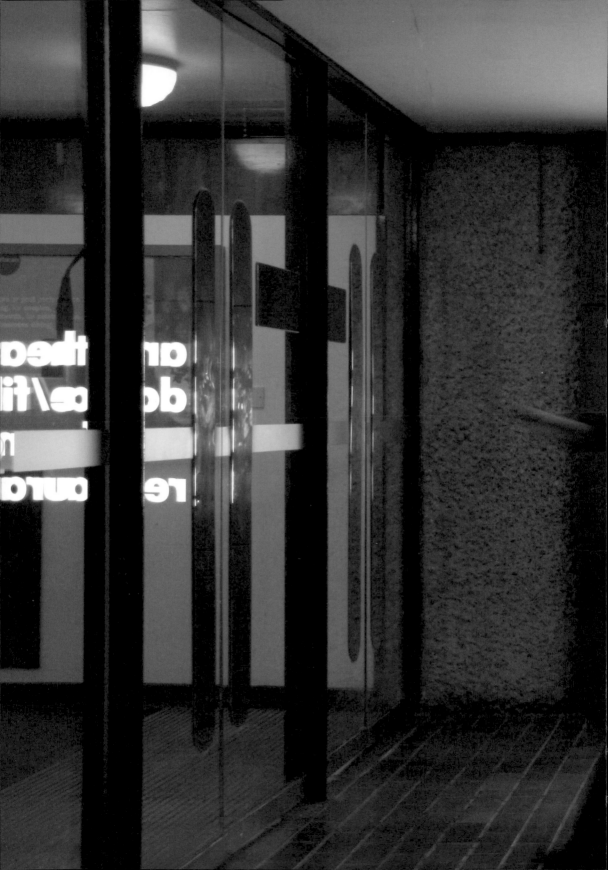

巴比肯藝術中心

英國倫敦的巴比肯藝術中心（Barbican）
的標牌與指示，由卡特利吉‧萊文與麥耶斯
考設計工作室（Studio Myerscough）所設
計。粗體 Futura 字體的運用，建立一致的語
言調性。

barbican

t / eatre / music
/ film / education
ences / library
s rants / bars

階層以視覺化又有邏輯的方式，為不同文字元素的組織方式提供指引，表現出相對重要性。文字階層有助於使排版清楚明白，更易於消化。

●字體排印階層

運用不同字體尺寸，可形成字體排印階層，較大較粗字體表示重要程度超越較小較細者。這些不同的粗細和大小，產生所謂「字體排印色調」（typographic color，見第 172-177 頁）。另一方面，「字體排印安排」（typographic placement）也能帶出階層，透過仔細安排的字體排印元素，帶出節奏與強調重點。

階層還能藉版面上的文字相對位置建立。擺在頁面上方、甚至四周都留白的文字，獲得的關注將蓋過內文主體中的文字。

清晰明確的字體排印階層手法，能進一步成為品牌識別的一部分，有助於點出差異。在發展公司與大眾、產品與使用者的關係時，此差異點就相當重要了。這兩頁及下兩頁由 SEA 設計公司分別為蒙納公司（Monotype）和紙商GF 史密斯（GF Smith）設計的版面，充分展現字體排印階層發展品牌個性的本事。

Sentences and paragraphs. Sentences are not emotional but paragraphs are. I can say that as often as I like and it always remains as it is, something that is. I said I found this out first in listening to Basket my dog drinking. And anybody listening to any dog's drinking will see what I mean.

Gertrude Stein
"Poetry and Grammar," Lectures in America, Random House (1935).
Set in Cochel

Nothing could be more inappropriate to American literature than its English source since the Americans are not British in sensibility.

Wallace Stevens
Set in Rockwell

Poetry is concerned with using with abusing, with losing with wanting, with denying with avoiding with adoring with replacing the noun. It is doing that always doing that, doing that and doing nothing but that. Poetry is doing nothing but using losing refusing and pleasing and betraying and caressing nouns. That is what poetry does, that is what poetry has to do no matter what kind of poetry it is. And there are a great many kinds of poetry.

Gertrude Stein
"Poetry and Grammar," Lectures in America, Random House (1935).
Set in Camphor

IT IS NOT EVERYDAY THAT THE WORLD ARRANGES ITSELF INTO A POEM.

Wallace Stevens
Set in Amitch Roman

上圖及下圖 ｜ SEA 刊物設計

蒙納收藏（Monotype Collections）系列專題是一套專門策劃的刊物。業界領袖如蘭金（Rankin）、多梅尼克‧里帕（Domenic Lippa）、賽門‧伊斯特森（Simon Esterson）、杰瑞‧雷歐尼達斯（Gerry Leonidas）及小林章，在刊物中表明他們最珍愛的字體。完成的書刊清楚利用字體排印階層和文字擺位，因此生成有創意並令人印象深刻的排印效果。

上圖｜SEA　手冊設計
SEA 為 GF 史密斯造紙（GF Smith）所做的這個設計，顯示出文字階層和擺位，如何能作為品牌個性與差異點的重要組成。簡單明瞭的階層，透過印刷技術與精緻的紙材，宣揚工藝之美。這些設計超越一般，成就不凡，紙張樣品變身誘發設計師想像力的物品。

減少視覺元素並將其融合於網格系統，
能產生明白的感覺，並暗示設計的秩序性。
這份秩序會令資訊更添可信度，使人信服。

—— 米勒‧布羅克曼《平面設計中的網格系統》
Josef Müller-Brockmann, *Grid Systems in Graphic Design*

●字體排印階層預先計劃

務必要為字體排印階層做一定程度的預先規劃。並非所有字體都充分備有適用任何場合的粗細及樣式。有些字體如 Trajan，只有兩種粗細，還是全大寫，因此顯然合適的應用範圍有限。

TRAJAN
TRAJAN BOLD

另有些字體像對頁的 Swiss 721，提供的變化無論在粗細或樣式，種類都多太多了。當階層數超過一般的一級與三級階層時，這樣的字體就格外有用。

發展較完整的階層範例如下：

Primary Swiss 721 BT Roman

Secondary Swiss 721 BT Italic

Tertiary Swiss 721 BT Condensed

Quarternary Swiss 721 Black

Quintary Swiss 721 BT Bold Condensed Italic

Sextary Swiss 721 Bold Condensed Outline

瞭解哪些字體具特定可用面向，也是相當有價值的事。舉例來說，Times 10 即特別為 12pt 以下的字級「量身訂做」，有較寬的字元和較粗的細線，並提供正體（Roman）和真小型大寫體（proper small caps）。某些字型還設計了特殊用途的粗細，譬如海報、書籍，甚至是標示說明字型，如下所示。

TIMES TEN SMALL CAPS
Warnock Pro Caption

Swiss 721 BT Light Condensed

Swiss 721 BT Light Condensed Italic

Swiss 721 BT Condensed

Swiss 721 BT Condensed Italic

Swiss 721 BT Bold Condensed

Swiss 721 BT Bold Condensed Outline

Swiss 721 BT Bold Condensed Italic

Swiss 721 BT Black Condensed

Swiss 721 Black Condensed Italic

Swiss 721 Thin

Swiss 721 Thin Italic

Swiss 721 Light

Swiss 721 Light Italic

Swiss 721 Roman

Swiss 721 Italic

Swiss 721 Medium

Swiss 721 Medium Italic

Swiss 721 Bold

Swiss 721 Bold Outline

Swiss 721 Bold Rounded

Swiss 721 Bold Italic

Swiss 721 Heavy

Swiss 721 Heavy Italic

Swiss 721 字體
該字體由馬克斯·米丁格（Max Miedinger）與愛德華·霍夫曼（Eduard Hoffmann）設計，粗細及樣式變化繁多，包括外框（outlines）、縮窄（condensed）與拉寬（extended）版本。選擇靈活多變化的字型組，對於需要多重階層的工作相當重要。

●縮圖

縮圖（Thumbnails）是頁面或影像的縮小版，用途包括供設計師取作參考，確認出版品的節奏或色調。對頁的版面即刊物縮圖，供人即時概覽刊物的連續頁面。藉由縮圖可調整物件的擺放或版面的順序，改變刊物的整體效果。此處能明顯看到顏色和影像運用的演進過程。

●巨觀／微觀

設計師在廣泛的巨觀視角與聚焦的微觀視角間切換，便能對刊物版面進行微調，並估算其整體平衡。可先從巨觀角度評審排版的連貫性，再到微觀層級施行改變。

本頁及對頁｜艾默里工作室（Emery Studio）　刊物設計
澳洲皇家建築師協會（Royal Australian Institute of Architects）的隔熱獎（RAIA Sisalation Prize）期刊。當中將巨觀圖片分割成多個細部或微觀元素，分別填滿頁面，形成巨觀／微觀結構。

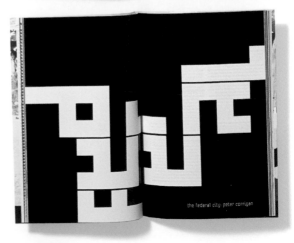

行寬是文本的單行長度，以排字單位派卡計算。行寬、字體尺寸和字體，構成設計師為內文決定最佳行句長度時的三要素。三者間任一變化，都會影響整體的行句長度。

字寬

Avant Garde 和 Helvetica 字型，兩者字級大小的點數相同，但字寬不同。字寬的差別雖然不大，卻足以改變頁面的排版。

abcdefghijklmnopqrstuvwxyz
abcdefghijklmnopqrstuvwxyz

・字寬

不同字體的字元造型各有千秋，因此占據的面積互異，也就是說其字寬有所變化，如上所示。替換字型時，有時必須連帶調整字體尺寸或行寬，修正後才能達到排版美觀的文字作品。

・欄寬

通常會選擇讓欄寬與整體頁面尺寸呈固定比例，若有邊註的需求，還要留出空間。欄寬也將決定文字方塊的行寬，而又因為行寬、字體尺寸和字體之間的關係，可能需根據使用字體的字寬增減欄寬。

右圖 | SEA 手冊設計

傢俱公司蓓永（Beyon）的型錄，其中文字以單欄填滿整頁。文本字級大小的點數夠多，所以能輕鬆閱讀。請注意到此設計的上下邊界也不尋常。

●字體尺寸和字體

改變字體尺寸或字體，是設計師改變設計氛圍的主要方式之一。然而，換新的字體尺寸或字體，也可能使設計大崩壞。某個點數大小或樣式的文字也許在一定行寬中稱得上適合，但受到更改後也許會產生問題，必須調整行寬或欄寬，以確保彼此仍能協調。

字體尺寸能相當程度地將文字方塊填滿、上色，因此在頁面外觀上扮演重要角色，如下面這兩個範例所示：

Typesize plays a vital role in the visual appearance of a page because of the extent to which it fills and colors a text block, as these examples show.

Typesize plays a vital role in the visual appearance of a page because of the extent to which it fills and colors a text block, as these examples show.

增大字體尺寸

增大字體尺寸，同時減少了行間留白（行距）與每行字數，使文字方塊既不美觀又不好讀。

・決定行寬

設計師多依據經驗法則制定行寬，構成好讀的文字方塊。如果行寬對字體和尺寸來講太長了，讀者讀到行尾回頭時會難以找到下一行。如果行寬太短，則不停換行讓眼睛很吃力。經驗法則之一是將行寬限制在四十個字元左右，或是六個單字，每個單字約六個字母。另一條法則，是設定行寬為字體全套小寫字母長度的一點五至兩倍。

不同欄寬為特定字型、特定尺寸的文字，提供大小不一的喘息空間：

abcdefghijklmnopqrstuvwxyz

136pt

Different column widths provide a varying amount of space for a body of text set in a particular font and size, to breathe.

欄寬

10pt 大小的 Helvetica 字體，全套小寫字母長度為136pt。行寬若設定為全字母長的一點五或兩倍，就增加至 204pt 與 272pt，每行可排列的字元更多。左邊兩段 Helvetica 文字的行寬分別是 136pt 的一點五倍（上例）與兩倍（下例），兩種手法做出的文字方塊看起來截然不同，後者空間寬敞多了。

Different column widths provide a varying amount of space for a body of text set in a particular font and size, to breathe.

頁面本質上是平的，但透過版面上元素的擺位和交疊，建立出不同層次，能為設計增添深度。

●增加深度

為作品擴增層次的方式很多，從知性方面的多層意義、到堆疊數個印面，或是以彩色墨水進行套印，如對頁範例所示。

使用視覺階層或揭露（reveals），將資訊組織並呈現，也能使設計更有深度。這些技巧能引導觀者，產生節奏感，讓設計更鮮活。添加資訊式或表格式圖層，應該要有助於敘事變得更清楚或更進一步發展，而不是單純耍個花招。

・景深類比

攝影師透過調整光圈大小，控制照片的景深，決定有多少影像在焦距內。些許景深調控即能將部分影像清晰聚焦，並模糊其他部分，產生階層與層次的效果。看待頁面的方式若由二維轉譯成三維，便可拿景深來類比頁面排版。頁面當然還是「平」的物件，但透過文字和圖像，累積深度和層次，即產生多重堆疊的效果，既美觀也提供資訊。此效果形成一股繪畫或甚至攝影的質感，同時也強制建立階層，某些物件「突出」到前面，某些則隱入「背景」。

下圖及對頁｜湯瑪斯 · 曼司公司（**Thomas Manss & Company**）　刊物設計
佛捷歌尼造紙公司（Fedrigoni）的《佛捷歌尼飯店》（*Fedrigoni Hotel*）書刊。多種技術如鏤空（cut outs）、揭露、裁成不同寬度的頁面、壓紋（embossing）皆展示其中，表現造紙概念含括的各式層次和質地。

BROCHURE

La brochure è uno dei più importanti strumenti marketing, non se ne può fare a meno, nemmeno nell'era di Internet. Il design e i materiali prescelti devono contribuire a esaltare le caratteristiche dell'hotel e del luogo in cui si trova. La brochure rappresenta l'inizio di un viaggio immaginario.

Le copertine è composta da tre differenti carte: Freelife Mérida Kraft, una riciclata di alta qualità, marcata a feltro su entrambi i lati, Nettuno Tabacco, marcata su entrambi i lati e Sirio Stardust Caffè, colorata in impasto e non pigment effetto polvere di stelle. Per i fogli all'interno è possibile utilizzare Stucco Sirio, una carta trattata superficialmente su entrambi i lati che consente una stampa nitida e brillante.

The brochure is an essential marketing tool for any hotel, a must-have to complement even the most suitably designed website. It is an opportunity to seduce potential guests. It represents the beginning of an imaginary journey. The design and materials chosen will help enhance and portray the image of the hotel.

The brochure cover is made from three different papers: Freelife Mérida Kraft, a high quality recycled board with a felt-marked finish; Nettuno Tabacco, a coloured board felt-marked on both sides and Sirio Stardust Caffè, a fleck pulp brand which shimmers when the light hits it. For the inside pages Stucco Sirio can be used. It is an uncoated range of papers and boards with a 'stucco' treatment on both sides for particularly bright and sharp printing.

Sirio Color 'Girchiano 290 g/m²

上圖｜沃特・德・弗林格爾（Wout De Vringer） 刊物設計
在文字之上堆疊其他文字片段，產生影像或圖案。此時除了取文字的內容意思，字母的形狀也被
拿來利用，有時功能甚至超越了文意表達。

Michael Bowdidge
Jemima Burrill
Thomas Chaffe
Greg Cox
Gordon Dalton
Nicolas Deshayes
Sean Edwards
Blue Firth
S Mark Gubb
Antony Hall
Mark Harasimowicz
Richard Higlett
Daniel Keeling
Morag Keil
Jonty Lees
Sara MacKillop
Rachel Meek
Dan Mott
Andrew Palmer
Richard Paul
Matt Robinson
Elizabeth Rowe
Niki Russell
Gabriela Schutz
Ralph Smith
Jessica Warboys
Miranda Whall

14 December
2005—
26 January
2006.
Gordon Dalton
vs S Mark Gubb
in The Battle of
Forest Hills.

輸出工作室 (**Studio Output**)
手冊設計

Moot 藝廊的手冊，創意運用套
印法，產生交織如畫的文字與
圖像，讓版面質地與顏色更豐
富。

Top: View through Project Room 1 (Archizines on left, Public Offer on right)
Bottom: View through Project Room 2.

An initial public offering (IPO) involves shares of a stock in a company being first sold to the general public. To buy into the equity of a business suggests there is something of value to share — even if this value depends upon metrics that fluctuate as much as the financial markets. The idea of making a 'public offer', to share and exchange value, also suggests having a position on what is of value to a broader audience.

It is the sharing and broadcasting of value that goes to the crux of *Public Offer*, a survey of design publishing in Melbourne over the last 60-odd years. In this exhibition, this declaration of worth is made by designers as a social projection, a proposition that says 'We have something to say: Is anyone listening?' It is the generous, sometimes arrogant or angry, but always enthusiastic and usually polemical publishing of viewpoints or a call made to convene. This public offering is at times a reaction: tired with what's on offer and seeking change, or seeing an abyss and wanting to fill a gap. Just read the editorials of issue number one or the initial postings of each publication, regardless of the discipline, and you will discover that the public offer is made in clear terms: the thirst to engage.

PROJECT ROOMS 1 & 2 » 1 FEBRUARY – 27 MARCH 2013

ARCHIZINES is an exhibition that celebrates the current resurgence of independent architectural fanzines, journals and magazines

Archizines at the Architectural Association London, 2011.
Photography courtesy of S w Jasm & the AA Sydney.

Design Hub hosts the exciting internationally touring exhibition Archizines, curated by Elias Redstone and initiated in collaboration with the Architectural Association in London. Archizines is an exhibition that celebrates the current resurgence of independent architectural fanzines, journals and magazines that are being produced around the world by independent and alternative sources. Starting in 2011 in London the exhibition

has been displayed in 18 other cities and will continue to travel after Melbourne.

In its Australian iterations, Archizines will feature an edited and expanded list of contributing publications that have launched after 2005. The touring exhibition, now features 90 architecture magazines, fanzines and journals from over twenty countries.

Archizines is showing at Design Hub until 27 March, before heading off to UTS in Sydney.

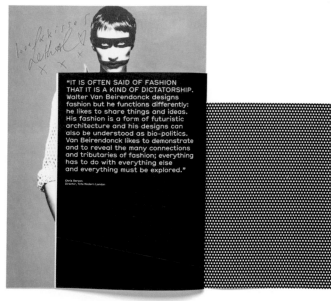

本頁及對頁｜法比歐 · 昂加拉托設計公司（**Fabio Ongarato Design**）　手冊設計
該手冊呈現多層不同格式的紙面，交替覆蓋與揭露下方圖層。此操作為刊物增添一股趣味，
並讓讀者能與之互動，來回翻頁，揭露或遮蔽內容。

Parole #2:
Phonetic
Skin / Ph
tische H

ALLEN S. WEISS / The Sonic Skin of Water / MLADEN DOLAR: T
NAOMI SEGAL: Playing the Strange Statue: Sound, Silence and
Touch in Didier Anzieu and »The Piano« / IMOGEN STIDWORTH
Topography of a Voice / PAUL DICKINSON: Sleep Talk Record
JANET BEIZER: Inscribing the Body / BRANDON LABELLE: So
Bodies / ANISH KAPOOR: Marsyas / LEIF ELGGREN: Suderian
St. Veronica / DAVID LOCKE: Talking Drums / LEONARDO GU
O livro Urbano do Profeta Gentileza / DE GEUZEN: Wearable Resist
TRIKOTON: Knitted Voices / MARIA JOSÉ ARJONA & ANDRÉ LEPE
STEVEN FELD: Suikinkutsu / HUBERTUS VON AMELUNXEN: The S

ISBN 978-3-89770-320-9 Edite

Parole #1:
The Body of
the Voice /
körper

es of the Voice / BRIGITTE FELDERER: Die Stimme
Voice / KARL CLAUSBERG: Tabakrauch im Atem-
TERER: Mnemocity / NIKOLAUS GANSTERER & CON-
OMAS KNOEFEL: Materialisationen / GEORG NUSS-
ter Notebook / FABIENNE AUDÉOUD: Brothers and
INE DENIZE & LAURENT COLOMB: Pousse-pousse
ture / MELLE HAMMER: Typo-Voice-Guitar / JAAP
JANOI: Mobile Alphabete / FRIEDRICH W. BLOCK:
tionen über den Körper / JENNY SCHRÖDL & VITO
the Future of Radio Art / DORIS KOLESCH: Die Num-
s time / OLIVIER FOULON: His Voice fits his Mouth

tahmer SALON

Parole #1:
The Body of
the Voice /
Stimmkörper

164

本頁及對頁｜安妮特・史達默（Annette Stahmer）　刊物設計
飛行粒子（fliegende Teilchen）設計師安妮特・史達默編輯的《言說》（*Parole*）刊物
版面，其中頁面排版取自既有書籍，基本上如同作家引用其他作家的句子，「引用」既
有版面並填入新的內容。

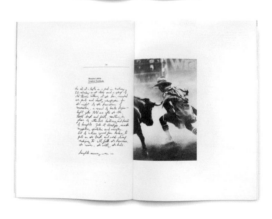

留白即設計中空白、未印刷、未利用的空間,圍繞著圖像元素,能給予元素喘息空間。留白為設計作品建立平靜區域,具有多重功能,包括建立視覺階層。

留白處不一定是白色的,它指的是設計中任何不含文字或圖像元素的地方。設計師會自然安插留白在作品中,例如頁面上下左右保留邊界,在文字方塊四周產生空間,幫助組織架構,讓人更容易理解設計傳達的資訊。瑞士字體排印師奇肖爾德稱留白為「好設計的肺部」。若是未留白而填滿整個設計版面,則作品搞不好會感覺擁擠、難以理解。

●使用留白

能否運用留白,常受制於經濟考量,設計師也許要經一番抗爭才能合理使用。報紙發行的經濟狀況使得其版面寶貴至極,將內文塞進有限頁數這項優先需求,壓縮了供給留白的空間。有趣的是,雖然網際網路提供無限的頁面,許多網站仍複製報紙這種資訊填塞的樣式,新聞網站尤然。

上圖|湯瑪斯 · 曼司公司(**Thomas Manss & Company**) 型錄設計
當代建築師安藤忠雄事務所的型錄。最右端的彩頁圖片擔任間隔角色,讓書籍步調得以暫歇。相片呈現則以外框打造一致感。

Forest of Tombs Museum

正負之間的關係會自然生成，
是任何設計工作最重要的對比事件之一。
當中所附產的空間，
重要性不亞於產出此空間的元素本身。

—— 霍夫曼《平面設計手冊》 Armin Hofmann, *Graphic Design Manual*

167

Die kademuur was een complete verrassing. Een lange muur van 17e eeuwse baksteentjes, keurig gevoegd, mooi afgewerkt, met fraaie rollagen erin. Een muur die je verwacht in de kadewerken van een stad, als Schoonhoven, of Gouda. Of bij 17e of 18e eeuws fort. Maar niet in een simpele dijk. Wij stonden voor een raadsel. En we weten het nog steeds niet, eigenlijk, want er is helemaal niets over gevonden. Helemaal niets.

Terwijl, als je ziet hoe die muur is uitgevoerd, zestig tot tachtig meter prachtig metselwerk, daar heeft zeker een gedachte achter gezeten.

René Proos,
Provinciaal Archeoloog
Provincie Zuid-Holland

Nu maakt hij dan deel uit van de vooroeververdediging.

Zo'n mooie muur.
Het zou toch zonde geweest zijn hem te slopen.
Hij is helemaal opnieuw gevoegd en gerestaureerd.
Je ziet er alleen niks van.
Tenzij je het water opgaat.

Het afgraven van de oude dijk
werd archeologisch begeleid door
de Provincie Zuid-Holland

Lekdijk-West

Ik ben aan die oude dijk geboren.
Waar nu het water is,
waar het is afgegraven,
daar stond mijn ouderlijk huis.
Dat is er voor afgebroken.
Mijn zoon woonde er,
met zijn gezin.
Mijn vader was net overleden.
Gelukkig maar,
want die had het allemaal
niet overleefd.

Gijs Rietveld,
inwoner Bergambacht

In 1953 heb ik het hoge water hier zelf gezien. Op deze plek. Ik was nog een kind natuurlijk, maar dat vergeet je nooit meer. Het stond tot bovenaan de dijk. Eén grote plas water, van dijk tot dijk.

Midden in de winter was het, en hartstikke koud. Met sneeuw en storm en enorme golven. De veerpont van Streefkerk lag hier tegen de dijk. En dode koeien en dergelijke.

Als je dát een keer gezien hebt, staat het voorgoed op je netvlies gebrand, dat kan ik je wel vertellen. Het was precies op mijn verjaardag, ook nog. Zeven werd ik. Of acht.

Lekdijk-West

Het is zeer waarschijnlijk dat de waterstanden in de toekomst zullen stijgen.

Vroeger zeiden we dan altijd: we moeten de dijken verhogen, maar daar kun je niet eeuwig mee doorgaan. In dit veengebied zakt sowieso alles langzaam weg in de prut, ook de dijken. Dus hoe zwaarder je ze maakt, hoe meer onderhoud ze nodig hebben. En hoe hoger ze zijn, hoe meer water er door komt als ze wél een keer doorbreken.

Nu bekijken we dus liever hoe we de rivier op andere manieren meer ruimte kunnen geven, met dezelfde dijkhoogte. En liefst zelfs nog wat lager.

Tussen de nieuwe dijk en daar waar ooit de oude lag, ligt nu een natuurgebiedje. Een smal stukje uiterwaard, een gors. Een slikveld, dat droogvalt bij eb, en bij hoogwater overstroomt.

Zoetwatergetijdegebied.

Een uniek type natuur, waar soorten leven die vrij zeldzaam zijn, en waardevol om te behouden. Spindotter, driekantige bies. Vissoorten, en vogels. Daar is verder niks aan gedaan, planten en dieren komen er vanzelf op af.

Piter Hiddema,
Rijkswaterstaat,
Directie Zuid-Holland

De bochtafsnijding in de Lekdijk
bij Bergambacht werd uitgevoerd
in opdracht van Rijkswaterstaat
Directie Zuid-Holland en het
Hoogheemraadschap van de
Krimpenerwaard

Lekdijk-West

●期待與負面觀感

留白依使用方式及周遭內容，會引發觀者不同的解讀。整頁單張相片旁的留白，可能給人華麗奢侈的印象，但在擺滿物件的版面上留白亦有機會造成漏洞感，更糟的情況下，令人以為內容缺乏，不足填滿頁面。報紙會試著在頁面元素空間分配上達到合理平衡，既符合排版的敏感性和可讀性這兩種互斥需求，同時又放入充分的新聞，讓讀者購買時覺得划算。讀者習慣報紙很「滿」，表示要達到排版的平衡比較困難。相對地，不用那麼注重填滿空間時，留白就明顯成為設計的一部分，如本版示例。

對頁｜班・費德貝（Ben Faydherbe）　試版
在單色系、著重文字的版面呈現中，把留白當作有效的設計元素，產生趣味。各版本的文字元素相同，不改變字體大小或樣式，只移動排列位置。可以觀察到擺位釋出或減少的空間，有些看起來有組織，有些則組織感較弱。

169

對頁及左圖｜阿敏·霍夫曼
（**Armin Hofmann**）
攝影平版《吉賽兒，巴賽爾露
天劇場》（*Giselle, Basler
Freilichtspiele*, 1959）與平
版印刷《巴塞爾城市劇院》
（*Stadt Theater Basel*,
1963）
兩幅作品利用黑色區域的留
白框住影像，在幾乎沒有文
字出現下產生戲劇性張力。
黑色的留白更與芭蕾舞者的
動作及一系列手勢形成強烈
對比。

●現代主義及其與留白的關係

現代主義是二十世紀前半開始的創新運動，主要著重於單純乾淨的構造及減
少裝飾，因此促成無襯線字體的流行與留白的使用量增加。隨著「少即是多」
的手法成為主流，人們不再執著於填滿、妝點空間，取而代之的是將留白
當作獨立的設計元素，充分應用。這種簡單化的手法下，設計師聚焦於一兩
個元素，尋求最佳展示方式，以留白圍繞四周，鎖定觀者的目光。現代主義
時期，雜誌興起，並在許多面向上成為現代主義設計師的完美載體，譬如俄
羅斯裔攝影師暨設計師阿列克謝·布羅多維奇（Alexey Brodovitch，1898-
1971），後來就成為哈潑時尚雜誌（*Harper's Bazaar*）藝術總監。雜誌這
種拋棄式媒體必須吸睛並誘發人們的興趣，因此設計師進行試驗、推開版面
限制，創意地搭配留白、文字和影像。

質地與字體排印色調

為設計添加質地的方式很多，有意識地使用字體排印色調就是其中之一。在此所說的色調並非指元素在頁面上的特定色彩，而是元素在頁面上的密度（density）。

只要更改字型、字型粗細、字體尺寸、行距、字距微調（kerning）／字距（tracking）、邊界和留白的使用等變數，就算是單色設計也能蘊含高度色澤。頁面填充越多文字，便擁有越多色調或色塊，如以下段落所示。

In a text-heavy publication, using different type weights and sizes can create color blocks that provide a pause or break from the text. Finer characters, such as scripts, print with less color or weight than grotesques of the same point size. The difference in type weight of these lines set in Aachen and Avant Garde, clearly shows how different fonts color the page in different intensities.

在充滿文字的刊物中使用不同粗細大小的字體，能產生多個色塊，讓文字中有所休止或間斷。書寫體（script）等精細字元印出的色調和重量，比同點大小的無襯線體（grotesque）來得少。上面分別用 Aachen 與 Avant Garde 排版的文字，明顯表達出不同字型為頁面上色程度的差別。

雜誌也常拿其他字體排印元素如標題、副標和拉出式引言，打破大量文字的視覺單調感。

下圖及對頁｜麥耶斯考設計工作室（Studio Myerscough）書籍設計
為《未來の臉》（*Future Face*）這本書設計的版面，利用排字色調在文字中帶入視覺暫停與喘息空間，藉此掌控節奏。

bare essentials

Where does a face begin and end? It may be a skull, a few lines of a cartoon or a caricature, a simple mask, a silhouette. For Jenny Diski's Bella in *The Dream Mistress*, whose face has been removed by laser surgery, 'face' is neither inner nor outer, subject nor object, but exists somewhere between the living human form, science and art.

The structure of the face begins with the facial bones and skull, which facilitate the movement of the jaw and respiration and determine its unique shape (the relative spacing of the eyes, the angle of the jaw and so on).

James Deville, *William Blake*, 1823

Anchored to the skull, and connected and activated by the facial nerves, facial muscles control the movement of the fat and skin that covers them and in which they are embedded. The human eye looks for and can detect the slightest deviation from the accepted norm in another's face.

Facial musculature and its relation to facial expression is still incompletely understood, although this matrix of moving tissue is crucial for the functions of the face (opening and closing the eyes, eating, speaking and so on). The sequence and strength of each

Antonio Durelli, *Écorché head and neck*, 1837 (p. 48)
Primal Pictures, *Interactive head and neck*, 2003 (p. 49)

People in the ancient world also sculpted famous faces on busts and statues, minted coins and medallions with faces on them and painted portraits of key public figures on wall paintings and sarcophagi. Even today, famous historical figures, such as Julius Caesar, are recognisable through lasting portrait images on coins, gems and sculpted heads.

In the Hellenistic period, there were the Greek writer Theophrastus's book *Characters* and the Roman Marcus Terentius Varro's 700 painted portraits of particular individuals from the worlds of sport, politics and the academy. As critics Peter Hamilton and Roger Hargreaves note in their book on celebrity portraiture, there is something iconic about these, in the manner of celebrity images today.

Portraiture as we know it, however, established itself in the dynastic courts of Renaissance Europe as a result of royal and noble patronage. Before that, faces in portraits were generally universalised to epitomise and exemplify a type. Medieval portraits of kings, queens and saints, for example, are symbolic. In a lecture entitled 'The Director faces his collection', Marc Pachter, Director of the Smithsonian National Portrait Gallery in Washington, remarks that the history of art is full of faces that represent anything but particular individuals. The face was often the least important part of the depiction. The aim was to portray a wider philosophical meaning and not a likeness.

In the era of saints' lives and the icons that represent them, as well as in the portrayal of royals, character and greatness adhered least in the particular face. In fact the face was universalised beyond the individual facial quirks to the universal ideals represented by the life. Inquiring whether the icon looked like the saint would have been the most ridiculous question to ask of it.

But in the sixteenth century, Renaissance families established private picture galleries for their portraits, which explained the family's importance and incidentally reflected those conventions that defined its character (by age, gender, beauty, occupation and class). The popularity of portraiture and with it the social construction of the individual face (rather than sophisticated emblematic representations) quickly spread through the upper classes as an expression of power, wealth and social status. By the eighteenth century, the new moneyed middle classes (especially lawyers, the clergy and merchants) were also extending their patronage. From Holbein and Velázquez to Reynolds and Rembrandt, from Degas and Sargent right up to Lucien Freud today, artists have tested and extended their skills and made their fortunes representing the face. Portraiture predominated at the annual programme of public exhibitions of the Royal Academy in London from its founding in 1768, and found a permanent home with the establishment of the National Portrait Gallery in 1856. In support of the Gallery's foundation, Lord Palmerston, the Prime Minister of the day, informed Parliament

There cannot, I feel convinced, be a greater incentive to mental exertion, to noble actions, to good conduct on the part of the living, than for them to see before them the features of those who have done good things that are worthy of our admiration, and whose examples we are more induced to imitate when they are brought before us in the visible and tangible shape of portraits.

Even today portrait galleries around the world remain concerned with the persona (politician, sportsman, scientist and so on) rather than with the private individual.

By the nineteenth century, however, the development of a more individualist 'humanist' cultural tradition led to a movement towards the depiction of the individual and the idiosyncratic in portraiture. In the expanding visual cultures of commerce and science, there was an increasing desire to find and display the quintessential character of the subject in the face. Portraits began to invite speculation about the personality of the sitter and their inner self and soul. Photography (in the form of 'daguerreotypes' and 'cartes de visite') provided the answer to a widespread and increasingly affordable desire to represent the self and to have a realistic picture of a friend or loved one as a token of them in their absence. As the critic Roland Barthes notes in his *Reflections on Photography*:

It seems that in Latin, 'photograph' would be said 'imago lucis opera expressa'; which is to say: image

revealed, 'extracted', 'mounted', 'expressed' by the action of light. And if Photography belonged to a world with some residual sensitivity to myth, we should exult over the richness of the symbol: the loved body is immortalised by the mediation of a precious metal, silver (monument and luxury); to which we might add the notion that this metal, like all the metals of Alchemy, is alive.

The impact of early photography must also be measured in the context of the fact that, until the mid-nineteenth century (when mirrors became commonplace), many people did not really know what they looked like. Not surprisingly therefore, within two decades of the invention of the camera, photography had become an industry, 'a household word and a household want', as the writer and critic Elizabeth Rigby (Lady Eastlake) wrote in 1857, 'used alike by art and science, by love, business and justice'.

The development of cartes de visite in the 1860s created a kind of revolution in portraiture. These low-cost miniature portraits, containing three or four poses fitted to a single glass negative and supplied in bulk, were exchanged and circulated throughout society. They also answered a deeply felt need for realistic pictures of the dead, as a *memento mori*. 'Secure the Substance – Ere the Shadow Fade' was one of the earliest advertising slogans. Extraordinary though it may seem today, from the 1850s until the first decade of the twentieth century, professional photographers openly advertised their willingness 'to take

Brossempuoy Venus (p. 32)
Fruitstone amulet (p. 32)

Plastered skull from Jericho, circa 7000–6000 BC (p. 33)

Stripped of all its flesh, the exposed muscle, veins, arteries and nerves wove intricate patterns around each other to provide a latticework of scaffolding behind the skin no longer there to conceal them. Delicate blood vessels, veins and arteries, with tiny tributaries running off them like tree roots, snaked between and beneath bundles of striated muscle spanning the space between her temple and jaw bones like rope bridges . . .

But aside from the obvious usefulness of the arrangement, it made a pattern of breathtaking beauty, though not the human beauty which flits around a complete face as the underlying mechanisms create the mobility we generally recognise as beautiful. Without expression, without even a suggestion of its possibility, this face had the cool beauty of architecture or abstract art, and Bella knew it did not tell a truthful tale about how she might have looked in her fully epidermal form . . . But with all the life subtracted, she had acquired a monumental and timeless symmetry, a still perfection of form which almost stopped the heart.

Jenny Diski, *The Dream Mistress*

本頁及對頁｜**Poulin+Morris** 　環境標誌

為《建築連結》（*Building Connections*）特展設計的環境標誌，展現出不限於頁面的字體排印色調應用。因為有字體排印色調變換節奏與階層，建構出更加高明的環境。

*science, social studies
but even more so
ections the students
en able to forge with
nd them."*

ool Coordinator

h-
m
er-

CFAF achieves these goals by building on
students' existing knowledge of the built envi-
ronment and introducing new images, ideas
and vocabulary to broaden their understanding
of the topic and to strengthen observation
skills. Through guided neighborhood walks, dis-
cussions and real-world analysis, students
are taught to ask questions and think critically to
gain a better understanding of the elements
of design and the design process. Hands on ac-
tivities such as drawing, 2-D design and 3-D
model-making equip students with the skills and
sensibility needed to create their own designs.
Presentation and reflection encourages students
to communicate and refine their ideas.

CFAF's methodologies prepare students,
both inside and outside the classroom, with
the skills necessary to identify and resolve new
and ongoing problems in a changing world.

12

e-
ess

n-

81/

410/ sk
mo

5,358

/ tud nt

M

H

Utbildningsrum
Study room

A118

Mötesrum
Meeting room

D2.502

Kopiering
Copying

D2.505

Offertrum
Offert room

A112

Toaletter
Toilets

Toaletter
Toilets

Mötesrum

A204

本頁及對頁 | 加柏 · 巴羅戴設計事務所（**Gabor Palotai Design**）　品牌識別
時尚服飾零售商 H&M 的部分識別，包括書刊和總部標誌，以單色系抽象圖案增添視覺質感。

襯邊一詞來自法文 passepartout，原指裱畫時襯在畫作與框面玻璃之間的卡紙墊。同樣的詞彙也用來稱呼頁面或設計元素外緣四周的邊界或留白。如此可讓影像有空間喘息、清楚定義出影像邊界，或為一系列影像建立一致的表現方式。

●框住影像

傳統上，襯邊在影像周圍延伸，產生統一的白色（或其他顏色）邊框。現代的表現法形態各異，但首要目的仍然是為作品提供連貫性或活力。不過，若頁面裁切不夠精準，頁寬受到顯著改變，則使用襯邊將使缺陷展露無遺。

上圖 I 無題設計（Untitled）　手冊設計
倫敦的聖約翰街 18 號律師事務所（18 St John Street Chambers）手冊，其中以 3 ／ 4 襯邊框住頁面內容，而印刷內頁本身，又含括在由大型外頁構成的全襯邊中。內頁與外頁的上光（coated）與未上光（uncoated）組合，更加強框架效果。

Defining Punch Out
Liliana Pomazan

Material By-Product's design philosophy and concepts are based upon a simple credo: that their studio design systems, not products. The realised product or ensemble is embedded in the theoretical and ideational elements of the systems. Therefore, the by-products of the systems comprise the collections. Susan Dimasi and Chantal McDonald's pivotal and key design system is entitled *Punch Out*.

The *Punch Out* system is a well conceived method where the designers carefully compose pattern pieces over a length of cloth. The punched out pattern pieces form the "classic" tailored garment, and as a result of this unique technique, an intact fabric frame remains. This meticulously composed frame constitutes the "anti" garment. The frame of fabric, or the "anti" is then draped over the body to become another garment. Before the pattern pieces are cut, Dimasi and McDonald spend many hours considering the composition of the positive and negative spaces within the piece of cloth. The figure-ground relationship is carefully orchestrated and refined. So careful is this consideration that, before the punching out of pieces occurs, the result seems to uncannily resemble a George Braque Cubist drawing or a sophisticated jigsaw puzzle. Through this innovative technique at least two garments are simultaneously cut from the one length of cloth. Depending on the design, "anti" garments may be patched with other fabrics to complete the garment, or other "anti" garments may be left open and constructed without any additions.

These two designers re-interpreted the terms "classic" and "anti" to explore their particular characteristics and uses within the framework of their fashion systems and to clearly differentiate between the "classic" and the "anti" garments. The composition of the "classic" and the "anti" garments are not placed randomly onto the piece of cloth nor are they placed onto the fabric just to satisfy the designers' aesthetics. After much exploration and experimentation, Dimasi and McDonald have found that positioning the "classic's" sleeve centrally within the cloth's composition achieves the best result in the "anti" garment. Simply put, the "classic" sleeve is punched out and its negative space, the centre or shoulder sleeve-head curve is left within the frame, which is then positioned and expertly draped back over the shoulder. To put this more clearly, the sleeve-head is directly draped back to the same construction points as the original reference of the "classic". The designers realised that the circumferences of the two sleeve parts stay the same and they work sympathetically with both the positive and negative spaces. The same measurement in the "anti's" sleeve-head so that when the cutting of the sleeve-head takes place one just takes that back in. The same dimensions apply to the sleeve's design lines and the same principle can also be applied to necklines, waistlines and so on. This technique is based on careful mathematical or geometrical experimentation as well as unique design formulation.

Since Dimasi and McDonald began working with systems of fixing tailoring and the use of an entire length of cloth, they have produced three collections; *Material By-Product* in 2003; *Material By-Product: Clothes Mechanics* in 2004 and *Material By-Product: Punch Out* in 2005. They have consistently taken their collections to Milan and Paris, where the design investigations that once started in the workroom are compared and contrasted with the aesthetic actualities of international standards.

Punch Out is designed to minimise waste by integrating an entire piece of cloth with no fabric wastage. This is at the opposite end of the classical and established technique of traditional European tailoring. They enjoy the play between the polar opposites of traditional tailoring merging with a piece of cloth. Their use of a piece of cloth is informed by the issues of sustainability and the concept of thrift.

Highly conceptual discussion generates Dimasi and McDonald's designs and defines their avant-garde collections. They constantly critique their designs through the theories of their systems. Theirs is a fashion born of a wellspring of "true" design ideology. Their systems are keen and reflective processes entrenched in a Postmodern design culture. Their intelligent approach to fashion comes from their desire to originate fashion systems appropriate for the early Twenty-First Century and blend them with a respect for the past while presenting a perspective on present culture.

Like the Postmodern designers Rei Kawakubo of Comme des Garçons and Martin Margiela, Material By-Product's systems and collections "speak" of intellectual discourses within the higher echelon of fashion. Dimasi and McDonald are sympathetic to Kawakubo and Margiela's design philosophies. To understand these systems is to comprehend the language of form that creates Material By-Product's collections. In Paris and Milan in 2004, Dimasi and McDonald were noted by fashion experts for their directional collection, which encapsulated a very high level of workmanship within an integrated fashion system.

Many mainstream fashion companies produce garments that are style and trend driven and border on being trivial commodities. By contrast, Material By-Product is like a beacon – sending out beams of bright insights – lighting up the aura of innovative fashion design and moving it to a place of privilege and respect. Within the ground of established and accepted fashion theories, whether Modernist or Postmodernist, Material By-Product continues to give currency to fashion new meanings and impetus. Their systems are based on design theory, repeatable methods and sound practice. The resultant systems are exceptional because they are based upon the application of fine design thinking and intellectual rigor. It is these attributes that have swiftly moved their ensembles to a special radical place within the fashion hierarchy. Their work has a hand writing – a signature – the designers have a direct engagement with the work.

本頁 | **3 Deep 手冊設計**
本手冊利用襯邊將影像固定在位，而書溝則作為影像相互對映的參考點。文字的排版頁面以襯邊框住，創造出協調感，貫穿整本書的其他部分。

本頁｜NB: Studio　手冊設計
倫敦的房產開發公司騎士橋 100 號（100 Knightsbridge）手冊，內含四色黑（four-color black）
印製的整頁雙色相片，色澤飽滿，並以襯邊圍框。左頁的「100」則印成局部上光。

CHAPTER

5

第五章

訪談

本章主要是與當代重要設計師的系列訪談，設計師將帶我們洞悉其創作過程和作業手法。訪談中請設計師描述版面設計的特定層面，如字體排印，或海報設計等專門應用。

聆聽其他設計師的經驗、觀察他們如何將想法顯現於作品中，是相當具啟發性的事。當我們認識到如何應用不同操作、程序和技術解決問題，則自己的創意思考也會更活躍。

最後，務必明白，保持開放的觀念、隨時隨地尋找靈感，這些都非常重要。

奧福第許 1990 年和凱西‧瓦利納（Kathy Warinner）共同創立「奧福第許與瓦利納」，並自 1991 年起任教於加州藝術學院（California College of the Arts）。

您的工作經常要排列大量其他藝術家的作品。您如何著手這項作業？

這類工作涉及許多有趣的議題，每件案子的狀況都不同。將影像排序或分組的部分，通常由策展人決定。展覽型錄的主角若是單一藝術家，通常會依年代排列；若展出者是一群藝術家，則多根據字母順序。設計攝影師專書時，排列等於是在為照片定序。有時候攝影師進行了編輯，但沒有設定順序，這時我喜歡嘗試拿編輯過的照片做不同定序呈現。當然，最終決定權在攝影師本人。

下圖｜奧福第許與瓦利納型錄設計
羅根家族收藏的《後現代人像》型錄，該版面呈現乾淨寬敞的風格，融合襯邊外框與滿版圖像。許多肖像在右頁展示作品全貌，左頁擺上細部放大圖。

不過，排序還有其他意義，關係到瀏覽與擺位。羅根家族收藏（Logan Collection）的《後現代人像》（*Post Modern Portraiture*，下圖）共達 320 頁，因此我認為瀏覽方式會是書籍設計的一項重點。五個章節間分別設置滿版分隔頁，再以沿書側排列的小字標明章節名稱。

之後出版的 278 頁相關書籍《情不自禁：羅根家族收藏，紙張作品》（*Impulse: Works on Paper From the Logan Collection*，對頁）中，收藏品依概念區分為四節，各以白色書籤線標示，再取一條黃色書籤線指示文章處。《後現代人像》書中每件作品都有自己的版面，右邊是較小的全圖，左邊則是滿版出血的大型細部圖（見右上圖）。細部圖讓讀者瞭解收藏家為何將該作品視為「肖像」，因為收錄的肖像並非全屬傳統形式。一般傾向將畫作盡量放大，但各作品尺度有明顯差異時，就會出現相對比例的問題，若兩畫出現在同一版面則影響更深。設計目標是讀者能看見全圖，但不會受混淆，誤將大小不一的作品當成尺寸相似。

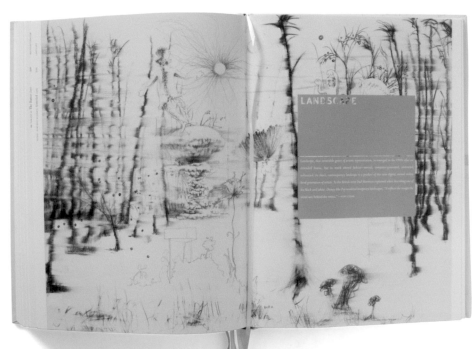

本頁及下跨頁｜奧福第許與瓦利納　型錄設計
這本《情不自禁：羅根家族收藏，紙張作品》利用色
塊表明各章，製造出清楚的分節。

184

185

●安妮特・史達默／飛行粒子 Annette Stahmer/fliegende Teilchen

史達默與安德烈・海爾斯（André Heers）是柏林設計公司飛行粒子的共同創辦人。飛行粒子主要進行字體排印和書籍設計工作。

隨著數位設計崛起，您覺得哪些印刷設計的課題仍然必要？數位設計為何能向印刷設計學習？

我認為數位設計是根據我們數世紀以來運用印刷物的經驗而來。有關編排文字使其好讀、選擇字型、字體尺寸大小、間隔、頁面元素間的層級，和如何組織文字、圖像與版面，我們對這類事項的瞭解，在數位設計中也一樣非常重要。然而我們知道，電子書等產品目前還不擅長處理這些面向，經常缺乏質感。當然，書本作為實體的一切物質性如大小、重量、表面等等，也還有發展空間，我們處理印刷書籍的方法也會延續至此。這些是我覺得數位設計應該多加思考的議題。

您的作品《閱讀動作。書寫動作》（Bewegung Lesen. Bewegung Schreiben）在印刷書籍中加入時間感，顛覆了我們一般對版面設計的期待。您是否認為，設計師的職責是挑戰人對設計的認知？

依特定的設計工作領域而定。我們主要為文化界的客戶服務，例如藝術家、藝廊、大學和美術館。在這個領域內，有機會將設計理解成研究的一部分，從異位觀點（meta-perspective）切入，設計的可能性在我們腦中更寬廣。我們常在想，將特定主題藝術作品或理論文本轉換為書籍、海報或傳單媒體，這樣的意義何在，然後我們試著利用各媒體的特有潛能，從物件到物質性、呈現方式、版面以至字體。每一個設計元素都是加強、闡述實際內容的機會，或者也能對它提出質疑。如此說來，表達的方式，往往是以支持、延伸內容的原始意旨為最終目標。

兩位在工作室一般如何處理設計問題？使用哪些正式或非正式機制培養創意？

整體來說，我們的處理手法很有機，我們總希望維持一定程度的純真，對手上的案子充滿好奇和興趣。專案啟動時，我們盡量對新的可能性保持開放心態，在內容與形式間找到有趣的關係。我們問自己，這個主題的海報能是什麼模樣？如果是書呢？這個物件能成為什麼？針對此問題，物質性的議題就很重要了。開始在紙本或電腦上繪製草稿後，會產生新概念，許多是出錯或誤會導致的。我們灌溉這些工作中意外的時刻，建立不那麼明確定義的空間。作品要具有詩意，這點不可或缺。

構築我們作業基礎的還有一件事：我們兩個人其實南轅北轍。安德烈是字體排印師兼字體設計師，他會觀察形態和組織；我則是比較概念化、藝術性的人，對於物件和感官層面也很有興趣。我們的合作是不斷的對話，也是創意張弛與磨擦，所以共事起來比獨立作業更好玩、更有層次。

本頁｜飛行粒子　書籍設計

柏林自由大學（Berlin Free University）研討會的書籍《閱讀動作。書寫動作》，嘗試探討文本中的動作這個主題。左右頁的文字區域隨著翻頁呈緩慢位移，微妙的過程在閱讀書本時幾乎不會察覺。

●南西・斯科勒斯與湯瑪斯・威代爾／斯科勒斯 - 威代爾 Nancy Skolos and Thomas Wedell/Skolos-Wedell

以下數頁為斯科勒斯和威代爾製作的一系列海報。斯科勒斯是畢業於克蘭布魯克藝術學院（Cranbrook Academy of Art）的平面設計藝術學學士，暨耶魯大學（Yale University）藝術學碩士；威代爾是密西根大學（University of Michigan）藝術學學士，並同為克蘭布魯克藝術學院校友，取得攝影及設計藝術學碩士學位。倆人都任教於羅德島設計學院（Rhode Island School of Design）。

攝影是驚人有力的媒材。影像可以擔任清楚溝通的觸媒、文化連貫的標誌，有時還作為純粹的詩意詮釋，激發人心中強烈的情感。相機提供一種自由、生產力旺盛的作業方式：透過非對稱框邊、拼貼、不同取景觀點、陰影及鮮明強調，測試各式構圖可能性。

為影像添加文字，一直是我們工作中富有創意卻充滿挑戰的部分。2006 年出版的書籍作品《文字、影像、訊息》（Type, Image, Message），給我們機會分析文字和影像搭配的方式，書中針對融合這兩種明確對立的溝通形式會遇到的必然衝突，做出正面迎擊。（西方文化的）正式文件由左至右、由上至下閱讀，但影像擁有不只一組切入點與消失點。相片通常包含一系列色調和質感，文字則呈現高對比。影像出自於多重感官的個人經歷，故自然依個別觀者引發較為廣泛的解讀。另一方面，文字是學習而來的代號系統，受到文化影響，並對特定意義有高度針對性。

下圖｜斯科勒斯 - 威代爾海報設計
呂刻昂獎學金（Lyceum Fellowship）學生系列競賽海報。此競賽每年徵召建築系學生投稿參與。

本頁｜斯科勒斯 - 威代爾　海報設計
《卡蘿里維拉 100 邀請海報》（Kahlo Rivera 100 Invitational Poster），100 位設計師為紀念芙烈達‧卡蘿（Frida Kahlo）與迪亞哥‧里維拉（Diego Rivera），策劃了一系列的作品，這張海報為其中之一。

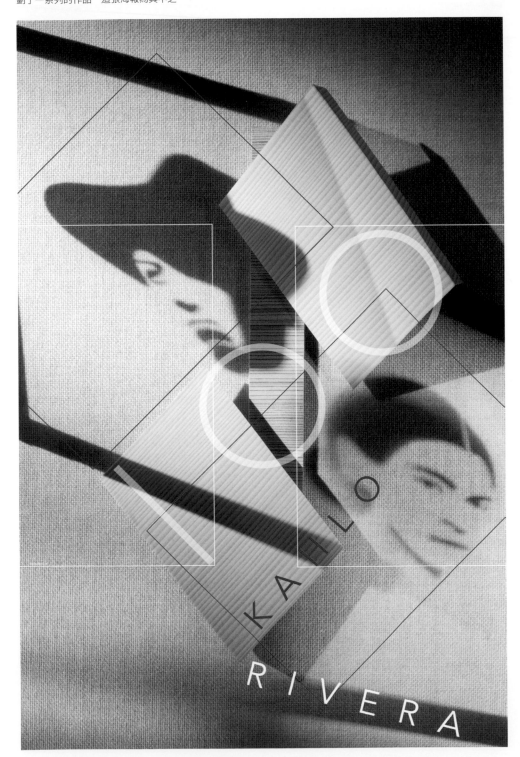

Common
Knowledge

In the age of information, universities should be at the forefront of preserving and strengthening our information commons – the shared wellspring of ideas and innovation from which everyone may draw.

HAL

ABELSON

shared voices

2013 RISD Presidential
Speaker Series

Wednesday

February 20

at 7:30 pm

RISD Auditorium

17 Canal Walkway

Providence, RI

free and open to the public with online reservations required (available on a first-come, first-served basis)

sharedvoices.risd.edu

hosted by RISD faculty members Shona Kitchen and Kevin Zucker

兩位的作品明顯參考構成主義的形式和立體派的影像手法。這是兩位刻意發展出的結果嗎？

工業時代推崇邏輯與機能性工程，也促成新形態的藝術表達，透過在二維構圖中運用多重性（multiplicity）、主要元素（primary elements）及抽象系統，為理念的表現開啟了革命性操作。在我們看來，這個領域生產力極高，從未匱乏，所以我們也一直透過各種方式延續那些藝術家的理念。

現今的工作領域已進入新科技革命。我們目前想做的是連結過去的代表性系統，同時應用更多當代的數位技術。90 年代初期《眼》（Eye）雜誌曾刊載一篇文章稱我們是「科技立體派」（Techno-Cubists），我們為此感到莫大鼓勵。我們的目標是既回應構成主義和立體派的精神，又立足於自己的時代。

上圖 | 斯科勒斯 - 威代爾　海報設計
羅德島設計學院年度特邀系列講座的海報，主講人是丹‧艾瑞利（Dan Ariely）。

上圖 | 斯科勒斯 - 威代爾　海報設計

為波蘭托倫的沃索尼亞美術館（Wozownia Art Gallery）的海報回顧展《扮相 2013》（*Persona 2013*）製作之海報。

海報這個媒材在設計界明顯備受推崇，既要立刻抓住觀者的目光，視覺內容又必須夠豐富，令人持續感興趣。兩位如何看待海報設計的限制或束縛？

我們可能應該去當畫家，因為對我們來說，為二維空間賦予生命是再有趣不過的事。海報就像無窮宇宙，包含無限可能。我們當它是通往想像世界的入口門戶。

海報光靠著本身尺寸就能自然吸引目光。隨著距離變化，更能發現其他訊息。當距離還遙遠時，海報就該攫住你的目光；到了大約兩到三公尺外，更明確的訊息將鼓勵你繼續接近；最後，你跟海報的距離近到能品味其細節和精妙。

再深入點，將海報視為一種版畫形式加以欣賞，其本身的製作表現便不乏各種嘗試機會：絹印、平版印刷、或數位印刷技術，設計師可擇一或組合搭配使用，充分自由地表達作品性質和內容。

右下｜斯科勒斯 - 威代爾
海報設計
呂刻昂獎學金年度建築系學生競賽徵稿海報。2009 年的競賽主題是設計彭蘭藝術學院（Penland School of Crafts）的金工工作室。

左下｜斯科勒斯 - 威代爾
海報設計
宣傳羅德島設計學院的數位媒體藝術學碩士學程的海報。

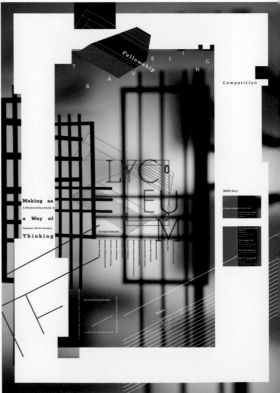

●彼得・道森／層級設計 Peter Dawson/Grade Design

層級設計位於倫敦，是道森與保羅・帕摩 - 愛德華茲（Paul Palmer-Edwards）創辦的設計顧問公司，主打各類印刷與線上媒體設計。

有人說版面設計的本質變了，設計事務所如今參與網路、印刷出版、動態影像、裝置與展覽設計。您認為好設計的基本原則依然如初嗎？還是隨著設計越來越普及、科技將設計開放給更廣大受眾，這些原則也受到威脅？

我極度主張好設計的原則維持不變：要有強烈概念，並輔以精緻美學。雖然我們的作業媒材更多了，設計師擁有的技術能力仍然適用，使我們與眾不同。科技的確對大眾有幫助，但不會增進創意或領悟力，僅只提供生產方式的選擇。而作品中如果沒有上述關鍵特質，將明顯地曝露缺陷。

從印刷到更多元的輸出模式，您是如何過渡的？

這情況也不能說司空見慣，卻出乎意料地簡單。我們的努力過程就跟進行任何案件時一樣，但一定還會測試最後輸出，以提供適合終端媒體的最佳方案。製作環境標誌設計時，我們總會以實際大小試驗多種處理方式，這樣像是藝廊訪客對展覽的感受等，才有辦法評估。從使用者的角度看事情，對最終作品及對我們的客戶都有好處。

層級設計承接過許多書籍設計案，這類案件需處理大量頁面，又常要整理編輯相當複雜的資訊，令設計師感到嚴苛與規訓。平面設計的敏感度對您進行設計有什麼影響？

每件書籍案開始時，我們會和出版商坐下來討論，徹底瞭解我們設計內容的類型，不單是對方希望得到哪樣的書籍結構，還包括文字要如何編排。要得到最佳解，通常作者、出版商和我們要共同合作。大部分書籍的可讀性來自某種「建築結構」，即小節、章節、主題等。但這些結構亦包含文字元素如標題階層、內文、標示說明、拉頁資訊和引言。我們對平面設計有敏感度，就能快速有邏輯地在頁面間組織分配不同元素，然後利用一致的設計呈現原則深入各頁，讓讀者得以輕鬆瀏覽刊物，獲得最好的閱讀經驗，並使成品具有獨特的視覺個性。

對頁｜層級設計　書籍設計
布魯姆斯伯里出版社（Bloomsbury）的書籍《新林木誌》（*The New Sylva*）。繪圖者為莎拉・席姆伯特（Sarah Simblet），頁面元素則特別費心安排，刪減或增添了某些內文，讓各別版面的文字長度不至過長或過短。

196

●麥可·沃辛頓／更真？感實性時代的藝術 Michael Worthington/More Real? Art in the Age of Truthiness

沃辛頓是全球知名的設計師，目前在加州藝術學院（California Institute of the Arts）擔任平面設計學程共同主任。

您的創作經常挑戰所謂的線性敘事。例如《更真？感實性時代的藝術》一書，連書籍本身形式都做出顛覆，以數位螢幕當作扉頁。可以談談這個案子的由來以及您的創作過程嗎？包括概念、圖像，和您的排版手法等等。

策展人早在構思展覽階段，就和我接觸了。我和兩位策展人——明尼亞波利斯美術館（MIA）的麗茲·阿姆斯壯（Liz Armstrong）及聖塔非基地美術館（SITE Santa Fe）的艾琳·霍夫曼（Irene Hofmann）都合作過，所以已經感到一定程度的自在。我喜歡和合作的藝術家及策展人進行有意義的對談，一般是為了切身瞭解案子，並對於可能的圖像或形式產生初步想法。由於當時展覽本身還在構思中，便開啟機會讓書籍成為「敘述性」（discursive）空間的試驗場，展覽理念在其中圖像式播放，不像正常型錄那樣虔敬地陳列展出作品。我們將本書視作展品之一，而非展覽紀錄。

本跨頁及下跨頁∣麥可·沃辛頓、安妮亞·迪亞柯夫（Ania Diakoff） 型錄設計
《更真？感實性時代的藝術》（*More Real? Art in the Age of Truthiness*）封面，此書是為明尼亞波利斯美術館同名展覽製作的型錄，探討關於真實的變動經驗。間斷的標題文字令讀者要多看一眼才能確認讀到的內容。

本書講述事實（truth）與虛構（fiction）、真實（reality）與超真實（hyperreality）、及新聞與娛樂間的衝突，還有當代科技與文化的模糊重疊。全書的主要策略是想像報紙與網站結合會發生什麼事。報紙似乎代表真相，網站則屬於虛構方，然而這些定義也並不明確。基本上，我們因此得以設計師的角色拋棄書籍設計的慣例。每個專題都有不同的概念驅使著設計，於是產生不同形式。圖片刻意披露其「過去」，有些露出色條、有些顯示低畫質的原版。印刷方塊如窗般飄浮、橫列文字中途夾帶彈出元素，或文字無限放大再放大。扉頁來自書名「More Real」（更真）的 Google 搜尋結果，故意和佈滿裝飾圖案的扉頁作對。封面本身呈書衣包裹，書衣卻裁短露出底下一模一樣的影像，一個是霧面、一個是亮面。哪個才是真的呢？就連書的標誌也有兩種讀法。內頁選紙希望反映報紙印刷的粗糙對比螢幕世界的高解析光彩，全書一半採用霧面，一半採用亮面。中間兩種紙相交之處，幾乎等同的兩幅「假」景觀彼此對照。

我接手案子的當下，對於這本型錄應有的外觀或結構並無概念。我試著透過內容，以及與合作對象的討論，發展出設計。我認為這本型錄掌握到主題的活潑、戲謔及趣味，以表現力十足的圖像形式取得自身個性的同時，仍配合內容建立出作品的框架。

有此一說，人們的閱讀量越來越少。尼爾・波茲曼（Neil Postman）在其 1985 年的著作《娛樂至死》（*Amusing Ourselves to Death*）中表示「一種思考模式正在喪失」。就這方面，您怎麼看待設計慣例的演變？換言之，設計屬於此問題的促成原因，還是解決方法？

設計有形成問題的潛力，也有解決問題的潛力。但我不敢說人們閱讀量減少了，我認為只是閱讀方式改變。我看報的時間比從前還多，但如今是在各類尺寸的螢幕上閱讀。螢幕閱讀有不同的形式和構造、不同的傳遞系統、不同的物質性……等等，有人好好設計時，這種線上經驗就很棒。我不會懷念紙本報紙（除了填字遊戲的部分），因為報紙很短暫，你看完就丟掉。書本就另當別論了。我喜歡擁有書，喜歡書這個實體物件。我希望保留書本。另外，這件事與世代有關，對我十歲的女兒來說，在電子書閱讀器（Kindle）或平板電腦（iPad）上看書，跟閱讀實體印刷頁面沒什麼兩樣。也許喪失的並不是「思考模式」，是「經驗模式」或「擁有模式」。我的確感到書籍設計因數位時代的崛起而明顯受影響：現在的書本必須是誘人的物品，不單只有內容，因為書必須超越短暫性。

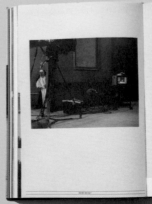

●**大衛・皮爾森／字體圖像** David Pearson/Type as Image

皮爾森是倫敦設計師，專長書籍設計。

書籍工作常需要「多筆」進行。能請您說明一下這個過程嗎？

當你開始展開系列設計時，數不清的可能性與龐大工作量，沒多久就會把人淹沒。我認為，這時限制是有幫助的，無論是不是自我設限，都能作為挑戰目標。剔除大量候選項目後，只需聚焦於必要事物，懾人的大型專案好像也能進入掌控。

選擇以字體排印作為主要的意象根源，就是這類限制之一。使用有限的色系也是一種方式，開工時我明白手上的武器只有這些了，便感到暢快。

您認為網格和排版手法是設計師的解放還是束縛？或根本兩者都有？

我欣賞網格協助下乾淨明白的表達方式，但當我們沒有其他選擇，網格手法就變成頗為貧瘠的領域了。想想看，書封建立關係的方式是將「易讀性」（legibility）複雜化，鼓勵讀者解析。置入這些空洞顯然會增加誤導的風險，但同時也開發機會，促成有意義、令人印象深刻的連結。

當然，使用網格能給人很多信心，不必承擔繁重的決策工作。不過如此能夠做嘗試的空間也相對減少，設計師的探索性會變得較差。這樣算不算好處，我想見仁見智吧。對我來說，傑瑞・辛那蒙（Jerry Cinamon）這類設計師的厲害之處就在於此。辛那蒙嚴格遵照瑞士現代主義（Swiss Modernism）的教條，但關鍵是他沒忘了添加人性化的元素，以一道溫暖或機智引人進門。網格設計作品經常給人盡力朝反方向走的感覺。

右圖｜大衛・皮爾森　書籍封面
為祖而瑪出版社（Éditions Zulma）設計的書封，利用形狀和圖案，構成系列叢書的整體識別。

對頁｜大衛・皮爾森　書籍封面
強烈的幾何造型和剛硬字體，搭配出引人注目的書封。

VAULT

DAVID
ROSE

AN
ANTI-
NOVEL

您的作品相當多元，有時使用網格，有時則否。這是有意識的設計抉擇，或者比較是出於設計的發展過程？

很大一部分是作品性質迫使我採取多變的設計手法，因為每個文本都空前絕後，絕無僅有。要捨棄過去效果良好的手法顯然需要相當自信，但一直走同樣的路很快會令人感到不安，尤其這份工作就是要為獨特的書寫作品打造獨特的存在感。

無聊是另一個推動力。我是坐不住沒耐性的那種人，如果覺得自己在故技重施，沒兩下就會意志消沉。

在平面設計的整體脈絡下，您怎麼看待自己的作品？您認為作品是「新的」東西，還是歷史發展的延續？

我的作品，說得好聽，代表一種新舊雜揉。說得難聽，則過度傾向於模仿。我內心是個復興主義者（revivalist），在檔案庫、圖書館或印刷品會展挖寶，最令我開心不過了。因此我自然成為頗情緒化的設計師，但我盡量添加某個奇特對比的現代元素做平衡。其中道理是，如果先提供熟悉而安定人心的東西，那麼推翻體制、玩弄設計的潛力就巨大無比。企鵝出版集團（Penguin Books）2013 年出版的《一九八四》（*1984*）是個好例子：企鵝出版集團標誌性的設計與配色，構成此概念的跳板，要是沒有這些，人們不會對編輯過的部分產生興趣。

《一九八四》
本書封面使用的套印色塊完全隱藏作者和書名──喬治·歐威爾（George Owell）《一九八四》──直接呼應極權統治的審查制度。

CHAPTER

6

第六章

練習

本書介紹了許多排版設計的指引準則，能建立秩序並提供彈性，製作出意義明確的設計。本章列出的一系列練習與書中談到的案例相關，讓讀者應用與練習前幾章討論的一些原則。

這些練習由歐美教師提供，包含廣泛的排版設計教學手法。有些練習是關於字體安排，有些則與整體敘事發展和講述故事較相關，全部都有其價值，將以各種方式考驗學生。變換的風格和操作手法，進一步證明排版設計的多變性，及可能達到的多重結果。

這些練習，更強調了排版設計和圖像擺放皆由基本原則支撐。設計師擁有運用這些原則的知識，就具備能夠處理任何設計大綱的基本技能。

● 練習一　范‧德‧格拉夫網格 The Van de Graaf Grid

出題者：加文‧安布羅斯（Gavin Ambrose），英國布萊頓大學（Brighton University）資深講師。本練習使用傳統網格，快速有效地產生效果強烈的版面。

此練習根據第 28 頁的范‧德‧格拉夫準則及其衍生建立的簡單複合式網格。這份設計大綱刻意對網格的建立加以規範，但設計成果的形式應當自由表現。學生進行此練習，能快速建立網格形式和頁面排版，進而使文字和圖像元素的排列更有效率。

建立基本網格

1 取大小為 864pt（寬）乘 648pt（高）的頁面。這些數值為 12 的倍數，本練習中我們將建立基本的 12pt 網格，故如此選擇。也可以用 10、14 或 18 的倍數建立網格進行練習。

2 接著繪製范‧德‧格拉夫圖形。由於要做 12pt 網格，因此將產生下列寬度的邊界：上緣 72pt、下緣 144pt、內緣 48pt、外緣 96pt。可以觀察到內外邊界的關係，外邊界是內邊界的兩倍，上下邊界的關係亦同。范‧德‧格拉夫準則將助你繪出 9 × 9 網格。

3 從 0pt 處開始，每 12pt 畫一條網格線，將一個 72pt 高、用以排放文字的網格六等分（72pt／6 = 12pt）。做出來的這個網格，其文字基線將與范‧德‧格拉夫網格的比例對齊。

放置網格物件

取一段文字。此練習中，學生倪基‧布魯斯特（Nikki Brewster）被分派了碧翠絲‧沃德（Beatrice Warde）的《水晶杯》（*The Crystal Goblet*）。透過多個連續版面，探索如何運用網格來提示字體排印的位置。進行此練習時應控制文字尺寸的種類數，以最少的字體大小變化產生最強的字體排印趣味和力道。本練習主要探討網格及其與字體排印的關係。在另一個層面上，也探究字體排印的變化及空間配置如何啟發排字邏輯和節奏感的建立。

考慮點

擺位、字體尺寸、與邊界的關係、予人驚奇感的「流動」或順序、字體排印「色調」、常見元素與特異元素的關係、節奏、差異與相似、鼓勵人翻頁的因素，及同等重要的──鼓勵人停駐的因素。

The Crystal Goblet, or Printing Should Be Invisible

by Beatrice Warde (1900 — 1969

Imagine that you have before you a flagon of wine. You may choose your own favourite vintage for this imaginary demonstration, so that it be a deep shimmering crimson in colour. You have two goblets before you. One is of solid gold, wrought in the most exquisite patterns. The other is of crystal-clear glass, thin as a bubble, and as transparent.

Pour and drink; &

according to your choice of goblet, I shall know whether or not you are a connoisseur of wine. For if you have no feelings about wine one way or the other, you will want the sensation of drinking the stuff out of a vessel that may have cost thousands of pounds but if you are a member of that vanishing tribe, the amateurs of fine vintages, you will choose the crystal, because everything about it is calculated to reveal rather than hide the beautiful thing which it was meant to contain.

Bear with me in this long-winded and fragrant metaphor; for you will find that almost all the virtues of the perfect wine-glass have a parallel in typography.

There is the long, thin stem that obviates fingerprints on the bowl. Why? Because no cloud must come between your eyes and the fiery heart of the liquid. Are not the margins on book pages similarly meant to obviate the necessity of fingering the type-page? Again: the glass is colourless or at the most only faintly tinged in the bowl, because the connoisseur judges wine partly by its colour and is impatient of anything that alters it. Now the man who first chose glass instead of clay or metal to hold his wine was a 'modernist' in the sense in which I am going to use that term. That is, the first thing he asked of his particular object was not 'How should it look?' but 'What must it do?' and to that extent all good typography is modernist.

Wine is so strange and potent a thing that it has been used in the central ritual of religion in one place and time, and attacked by a virago with a hatchet in another.

There are a thousand mannerisms in typography that are as impudent and arbitrary as putting port in tumblers of red or green glass! When a goblet has a base that looks too small for security, it does not matter how cleverly it is weighted; you feel nervous lest it should tip over. There are ways of setting lines of type which may work well enough, and yet keep the reader subconsciously worried by the fear of 'doubling' lines, reading three words as one, and so forth.

That is man's chief miracle, unique to man.

There is only one thing in the world that is capable of stirring and altering men's minds to the same extent, and that is the coherent expression of thought. That is man's chief miracle, unique to man. There is no 'explanation' whatever of the fact that I can make arbitrary sounds which will lead a total stranger to think my own thought. It is sheer magic that I should be able to hold a one-sided conversation by means of black marks on paper with an unknown person half-way across the world. Talking, broadcasting, writing, and printing are all quite literally forms of thought transference, and it is the ability and eagerness to transmit the contents of the mind that is almost alone responsible for human civilisation. If you agree with this, you will agree with my one main idea, i.e. that the most important thing about printing is that it conveys thought, ideas, images, from one mind to other minds. This statement is what you might call the front door of the science of typography. Within his humble job typography. Within his humble job there is the long, thin stem that this subject will but say ly by assuming that printing

It is meant to convey specific and coherent ideas, it is very easy to find yourself in the wrong house altogether. Wine is so strange and potent a thing that it has been used in the central ritual of religion in one place and time, and attacked by a virago with a hatchet in another. There is only one thing in the world that is capable of stirring and altering men's minds to the same extent, and that is the coherent expression of thought. That is man's chief miracle, unique to man. Before asking what this statement leads to, let us see what it does not successfully lead to. If books are printed in order to be read, we must distinguish readability from what the optician would call legibility. A page set in 14-pt Bold Sans is, according to the laboratory tests, more 'legible' than one set in 11-pt Baskerville. A public speaker is more 'audible' in that sense when he bellows. But a good speaking voice is one which is inaudible as a voice. It is the transparent goblet again! I need not warn you that if you begin listening to the inflections and speaking rhythms of a voice from a platform, you are falling asleep.

A page set in 14-pt Bold Sans is, according to the laboratory tests, more 'legible' than one set in 11-pt Baskerville.

Type well used is invisible as type, just as the perfect talking voice is the unnoticed vehicle for the transmission of words, ideas.

Calligraphy can almost be considered a fine art nowadays, because its primary economic and educational purpose has been taken away; but printing in English will not qualify as an art until the present English language no longer conveys ideas to future generations, and until printing itself hands its usefulness to some yet unimagined successor.

When you listen to a song in a language you do not understand, part of your mind actually does fall asleep, leaving your quite separate aesthetic sensibilities to enjoy themselves unimpeded by your reasoning faculties. The fine arts do that; but that is not the purpose of printing. We may say, therefore, that printing may be delightful for many reasons, but that it is important, first and foremost, as a means of doing something. That is why it is mischievous to call any printed piece a work of art, especially fine art: because that would imply that its first purpose was to exist as an expression of beauty for its own sake and for the delectation of the senses.

There is no end to the maze of practices in typography and this idea of printing as a conveyor is, at least in the minds of all the great typographers with whom I have had the privilege of talking, the one clue that can guide you through the maze.

Without this essential humility of mind, I have seen ardent designers go more hopelessly wrong, make more ludicrous mistakes out of an excessive enthusiasm, than I could have thought possible. And with this clue, this purposiveness in the back of your mind, it is possible to do the most unheard-of things, and find that they justify you triumphantly. It is not a waste of time to go to the simple fundamentals and reason from them. In the flurry of your individual problems, I think you will not mind spending half an hour on one broad and simple set of ideas involving abstract principles. I once was talking to a man who designed a very pleasing advertising type which undoubtedly all of you have used. I said something about what artists think about a certain problem, and he replied with a beautiful gesture: 'Ah, madam, we artists do not think—we feel!' That same day I quoted that remark to another designer of my acquaintance, and he, being less poetically inclined, murmured:

'I'm not feeling very well today, I think!'

He was right, he did think; he was the thinking work, and that is why he is not as good a painter, and to my mind ten times better as a typographer and type designer than the man who instinctively avoided anything as coherent as a reason. I always suspect the typographic enthusiast who takes a printed page from a book and frames it to hang on the wall, for I believe that in order to gratify a sensory delight he has mutilated something infinitely more important. I remember that T.M. Cleland, the famous American typographer, once showed me a very beautiful layout for a Cadillac booklet involving decorations in colour. He did not have the actual text to work with in drawing up his specimen pages, so he had set the lines in Latin. This was not only for the reason that you will all think of, if you have seen the old typefoundries' famous Quousque Tandem copy (i.e. that Latin has five descenders and thus gives a remarkably even line). No, he told me that originally he had set up the dullest 'wording' that he could find (I dare say it was from Hansard), and yet he discovered that the man to whom he submitted it would start reading and making comments on the text. I made some remark on the mentality of Boards of Directors, but Mr Cleland said: 'No: you're wrong, if the reader had not been practically forced to read—if he had not seen those words suddenly instead with glamour and significance—then the layout would have been a failure. Let me start my specific conclusions with book typography, because that contains all the fundamentals, and then go on to a few points about advertising. He may put up a stained-glass window of marvellous beauty, but a failure as a window: that is, he may use some rich superb type like text gothic that is something to be looked at, not through. Or he may work in what I call transparent or invisible typography.

The book typographer has the job of erecting a window between the reader inside the room and that landscape which is the author's words.

Setting it in Italian or Latin is only an easy way of saying "This is not the text as it will appear".

That is that the mental eye focuses through type and not upon it. The type which, through any arbitrary warping of design or excess of 'colour', gets in the way of the mental picture to be conveyed, is a bad type.

I have a book at home, of which I have no visual recollection whatever as far as its typography goes; when I think of it, all I see is the Three Musketeers and their comrades swaggering up and down the streets of Paris. The third type of window is one in which the glass is broken into relatively small leaded panes; and this corresponds to what is called 'fine printing' today, in that you are at least conscious that there is a window there, and that someone has enjoyed building it. That is not objectionable, because of a very important fact which has to do with the psychology of the subconscious mind. Our subconsciousness is always afraid of blunders (which if logical setting, tight spacing and too-wide unleaded lines can trick us into), of boredom, and of officiousness. The running headline that keeps shouting at us, the line that looks like one long word, the capitals jammed together without hairspaces—

— these mean subconscious squinting and loss of mental focus.

(Originally printed in London in 1932, under the pseudonym Paul Beaujon. This version printed in London 1955).

And if what I have said is true of book printing, even of the most exquisite limited editions, it is fifty times more obvious in advertising, where the one and only justification for the purchase of space is that you are conveying a message that you are implanting a desire, straight into the mind of the reader. It is tragically easy to throw away half the reader- interest of an advertisement by setting the simple and compelling argument in a face which is uncomfortably alien to the classic reasonableness of the book-face. Get attention as you will by your headline, and make any pretty type pictures you like if you are sure that the copy is useless as a means of selling goods; but if you are happy enough to have really good copy to work with, I beg you to remember that thousands of people pay hardearned money for the privilege of reading quietly set book-pages, and that only your wildest ingenuity can stop people from reading a really interesting text. Printing demands a humility of mind, for the lack of which many of the fine arts are even now floundering in self-conscious and maudlin experiments. There is nothing simple or dull in achieving the transparent page. Vulgar ostentation is twice as easy as discipline. When you realise that ugly typography never effaces itself you will be able to capture beauty as the wise men capture happiness by aiming at something else. The stout 'typographer' learns the fickleness of rich men who hate to read. Not for them are long breaths held over serif and kern, they will not appreciate your splitting of hair-spaces. Nobody (save the other craftsmen) will appreciate half your skill. But you may spend endless years of happy experiment in devising that crystalline goblet which is worthy to hold the vintage of the human mind.

本頁丨學生倪基‧布魯斯特（Nikki Brewster） 版面設計

該版面設計的任務，是將沃德的《水晶杯》文字進行排版。成果作品展現基礎網格所提供的靈活性與排列效率。注意到網格的微妙協調以及字體的不同粗細與尺寸，如何產生較強力道與趣味。

出題者：湯瑪斯·威代爾與南西·斯科勒斯，羅德島設計學院。本練習使用外框與拼貼的手法創作構圖。

對頁（左上起順時針方向）｜學生金素真（Soojin Kim）、凱蒂·史密斯（Katie Smith）、馮如廷（Ruting Feng）和艾曼紐·阿薩約斯（Emanuel Azajusz）拼貼作品
這些作品的使用材料有黑色圖畫紙、裁邊器、口紅膠或膠帶、鉛筆、8.5 × 11 英吋白紙、剪刀或筆刀（X-acto）、切割墊。

結構拼貼

利用現有的剪貼紙片，盡可能快地框住所有你能看見的有趣構圖，將其貼合定位，修剪後保留它們。尋找影像間的關係，如顏色和表面。隨著排列的組合越多，要更注意對齊。選擇最有力的一組構圖並將其複印，當顏色被移除且表面變得更同質時，觀察其中的不同。要注意到即使構圖偏弱，其字母的修剪方式、或圖片與文字的交界方式，仍可能具啟發性細節。跨越成見，引出空間與意義，並形塑出更流暢的創作過程。

作業

以你的拼貼作品作為構圖起點，設計地方文化活動的海報。瀏覽大學網站、博物館網站、以及地方報紙，研究可行的主題。海報應包括機構名稱及活動內容（含日期、時間、地點）。自行撰寫的文案、詩句或引言，只要與主題相關，也可納入。

將自己最喜歡的三份原創拼貼放大至小報尺寸（tabloid size，11×17 英吋），覆上描圖紙說明它們是如何傳達海報的特定主題，然後將它們帶來。以拼貼作為框架，但可自由打破其間的區隔。

●練習三　編列複雜性 Editorial Complexity
（起床，嘗嘗瑪德蓮蛋糕）

出題者：**加州藝術學院**（California Institute of the Arts）**平面設計學程的麥可‧沃辛頓**（Michael Worthington）**及蓋兒‧史萬隆**（Gail Swanlund）。**本練習探索敘事的發展。**

專案概覽

為一本大型書刊設計一系列的編列式版面，內容由你生命中的單一事件衍生而來。頁面要求為緊密且有組織，係需要設計師出手、既複雜又多元的資料。可以將它想成是充實、繁複的百科全書或雜誌，有各式各樣的材料和資訊存在同一頁面上，由設計師（也就是你！）神手打造結構和風格。

1 挑選你人生中重要的一刻，力求鮮明有意義。列出你對事件的所有記憶及與這個事件相關的所有事物，清單盡量長而完整。將這些內容和一切關聯事物製作成示意圖（例如，我在六歲時撞破了頭，我從蹺蹺板上跌下來，頭撞到磚面階梯。那麼我的研究可能包括蒐集頭部損傷的相關資訊⋯⋯蹺蹺板相關資訊⋯⋯支點的物理學⋯⋯戰後郊區建築⋯⋯1960 年代末期的流行時尚⋯⋯英國的醫療保健系統等等⋯⋯）。

2 對每個調查領域進行研究，蒐集影像和文字。選擇性地尋找有趣的相關資料，請明智取決，這將是你的內容。擁有好的內容，你的編列設計工作會更輕鬆。

快速展示你的研究。必要的話，我會用 InDesign 示範，查看網格、主版頁面（master page）、樣式表（style sheet）等，以在多頁文件的安排上給予技術協助。

3 帶兩組不同方向的初始版面設計過來。初始設計不需精細，但應使用實際資料，以電腦製作而成。開始決定頁面尺寸／字體排印／影像處理／網格／整體結構／元素數量等。

4 展示兩份校對精修過的黑白版面（我們會更深入討論字體排印）。

5 展示四份精修的彩色版面（我們會深入察看影像處理和整體結構）。

6 展示四份校對精修過的版面，外加粗略的目錄頁和封面設計。

7 展示四份完成的版面，外加完成的目錄頁和封面設計。

210

8 展示最終版面、目錄頁和封面設計。

本頁丨凱文・芮（Calvin Rye） 版面設計
這些設計展現出頁面安排與設計的多元性質。

● 練習四　動作排版 Action Layout

出題者：布萊恩・克拉克（Bryan Clark），英國法爾茅斯大學（Falmouth University）平面設計主任。這些練習以較實驗性、體驗性的方式探索排版。

版面設計練習要求學生做的事，可能出乎意料。很多設計練習的目標都是要學生離開舒適圈，嘗試沒接觸過的新技法，以加強概念生產的方式，並有更多方法對付設計上的問題。

思考身體經歷，以不同角度看待設計原則，並在傳達設計時，確保其形式以既動態又主動的方式反映內容。錄製、拍攝或記下想法，供未來專案使用。

內容形式

敘事如何決定設計形式？口頭的言說或更強烈的投射，如何改變感知？去跟一位演員合作，講述一段感動人心的個人故事。口頭的言說如何協助文字轉譯至二維平面？步履、呼吸和情緒要怎麼表達，並為文字排版增色？

使用空間

你對空間可以多有創意？身體探索能建立更創新的見解嗎？與現代舞者合作，以一種三維的理解方式，來認識舞臺中的元素。在你構築設計手法的系統時，要考慮組件彼此之間的關係，如何形成張力、衝擊、群聚或影響定向，及分隔空間。

瀏覽

從極為不同的角度來探索已知的路線，看看失去方向或混亂，會不會加強你看待「瀏覽」的方式。從另一個方向或換一種交通方式回家，你迷路了嗎？還是發現更特別或更簡便的途徑？破壞或重新發明，能否讓版面更有效或更吸引人，為使用者帶來助益？

風格和節奏

你可以如何挑戰自己的風格直覺和版面節奏？去聽爵士樂手演奏，觀察爵士樂是如何表達不同主題，並據以自由變化。怎麼透過各種節奏強化頁面設計，或開啟整體專案風格的新觀點？

出題者：約翰・保羅・道林（John Paul Dowling），現任國際字體設計師協會（International Society of Typographic Designers，ISTD）教學主任。此練習的目的在於挑戰學生對「書本」的看法。

在這份設計大綱，你將轉向接觸既有內容：維多利亞時代愛德溫・A・艾勃特（Edwin A. Abbott）的中篇小說《平面國》（*Flatland*, 1884）。你的任務是製作一份新版提案，且跟我們熟悉的「書本」慣例不一定要互通，雖然可能包含文字內容、頁面和書封，但也可以不包含這些。提案也許是本小冊子、一座地景、一場事件、一場夢境、裝置、文字、聲音、動畫或時刻。內文以字體排印詮釋，至少處理一整章的全部文字，並表明剩餘文本的發展模式。沒有限制，沒有慣例，沒有規則也沒有特定格式。成品會變成什麼模樣？請定義你的市場及你要如何打中市場。

下圖｜學生馬修・克洛（Matthew Crowe）為《平面國》作業發想的設計　2011
該設計的排版文字破出欄位結構，灑滿頁面，產生流動感。

●練習六　視覺敘事與記敘形式 Visual Storytelling and Narrative Form

出題者：理查・波林（Richard Poulin），美國紐約的視覺藝術學院（School of Visual Arts）兼任教授。本練習探究視覺敘事與記敘形式。

對頁左上｜
約翰・吉爾摩（John Gilmore）
《美國天使》海報　2007

對頁右上｜
趙娥朗（Ah Rang Cho）
《美國天使》海報　2013

對頁下｜
尹琳恩（Lynne Yun）
《美國天使》海報　2012

此練習有兩個作業，標題是「視覺敘事與記敘形式」。學生分別拿到東尼・庫許納（Tony Kushner）的劇本《美國天使：千禧年近了》（*Angels in America: Millennium Approaches*）或瑪雅・安傑洛（Maya Angelou）的詩作《於清晨的脈動中》（*On the Pulse of Morning*），進行閱讀、分析，並以字體排印和照片影像，做視覺化的解析。這兩份文本雖然形式迥然不同，卻都大量使用象徵符號、比喻和豐富的描述性敘事元素。

視覺敘事與記敘形式

針對劇本，學生應產生照片影像的概念，以視覺的方式傳達自己及對劇作主題的看法和詮釋。不過所有的照片僅限利用 35 釐米相機創作，讓學生有機會在沒有電腦或影像處理軟體的協助下，進一步開發自己生成影像的獨到律則和語言。字體排印、色彩和構圖等，則應發展為支持照片影像的解讀性元素。最終將元素構築成一系列供劇作上映用的戲院海報。

詩作的概念操作也和上述差不多，由詩作的敘事出發，不過學生的最終成品必須是書的形式。每位學生都要開發出一套概念，透過排字詮釋和照片影像兩種操作，從自身觀點對詩人用字、比喻、象徵及主題做出回應，以視覺的方式傳達。關於本作業的照片影像，學生應研究美國攝影師（如沃克・艾文斯〔Walker Evans〕、伊莫金・坎寧安〔Imogen Cunningham〕、哈利・卡拉漢〔Harry Callahan〕、南・戈丁〔Nan Goldin〕、羅柏・梅普索普〔Robert Mapplethorpe〕及亞倫・西斯肯〔Aaron Siskind〕），挑選照片作為有意義、有效達意的視覺元素，充分表明與強調自己對詩作敘事的解讀。

這些作業的靈感源於我第一次觀看這部劇作，以及第一次聆聽詩人本人朗讀這首詩的經驗。身為設計師及視覺說書人，兩次經驗都直接影響了我和書面文字的關係及對文字的評價。這兩種敘事方式都仰賴讀者的想像力，作者的文句因此得以帶你到達非常私人的視角。我希望學生也能感受到類似的反應，受到相當的啟發。

A GAY
FANTASIA
ON NATIONAL THEMES

**ANGE
LS**
**IN
AME
RICA**

PART ONE:
**MILLENIUM
APPROACHES**

WALTER
KERR
THEATER
219 WEST 48TH
STREET
212 582 4536

ANGELS
TONY KUSHNER

IN AMERICA

A GAY FANTASIA ON NATIONAL THEMES

PART 1 - MILLENIUM APPROACHES

Tony Kushner
Angels in America
Part One, Millennium Approaches

A gay fantasia on national themes

Walter Kerr Theatre
219 West 48th Street
New York, NY 10036

Contact Information

212 239 2820
www.walterkerrtheatre.com

●練習七

6 × 6 協作式活版印刷專題 6 × 6 Collaborative Letterpress Project

出題者：倫敦傳媒學院（London College of Communication）的亞歷山大‧庫珀（Alexander Cooper）、創作藝術大學埃普索姆校區（UCA Epsom）的蘿絲‧葛利涅夫（Rose Gridneff）及金士頓大學（Kingston University）的安德魯‧哈斯蘭（Andrew Haslam）。在統一的形式和網格系統下，期能探索活版印刷的過程。

本專題旨在探討活版印刷，這項工具的功用已由技術教學大幅轉變成探索與試驗。活版印刷不再是技術傳承，轉而支援如平面設計或插畫課程等學生教育。

以學院方圓 1,200 英呎的環境為題，請學員利用活版印刷製作出相對應的作品。這份設計大綱刻意保持開放，讓學員個人發揮。除了指明工作室的實際位置，還需指明活版印刷的過程手法在當前的定位。

頁面格式為 48 × 60 派卡，請用 6 × 6 派卡的網格設計作品。一派卡是 12pt，大約相當於六分之一（0.16666666666667）英吋。點數系統根據英制測量單位（imperial unit）制定，相較於十進位系統，優點是能被 2、3、4、6 整除，符合工作室裡的間隔材料（spacing material）。以雙色印刷作品，每個顏色都要有獨立的鎖固版架（lock-up）。這些條件受到程序限制，減少了決策項目，進而助長實驗操作。

左下｜詹姆斯‧艾德加（James Edgar）坎伯威爾藝術學院（Camberwell College of Arts）

中間｜亞歷山大‧庫珀（Alexander Cooper）倫敦傳媒學院

右下｜崔西‧華勒（Tracey Waller）坎伯威爾藝術學院

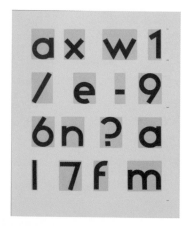

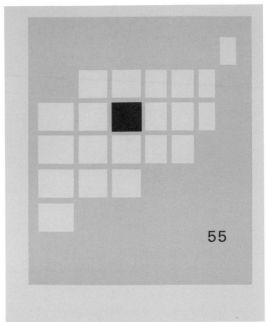

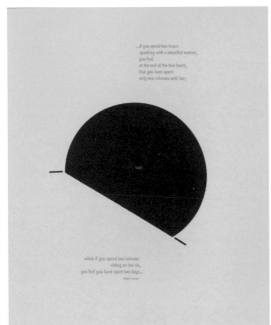

左上 | 巴尼・史提普尼（Barney Stepney）　布萊頓大學（University of Brighton）

右上 | 安・哈克（Anne Haack）　坎伯威爾藝術學院

左下 | 亞麗安娜・蒂爾切（Arianna Tilche）　倫敦傳媒學院

右下 | 尼基-喬・巴克斯特（Nicki-Joe Baxter）　坎伯威爾藝術學院

誌謝 Thank you

感謝製作過程中支持我們的大家，包括大方應允我們複製其作品的多位藝術總監、設計師和創作者。

特別感謝那些搜尋、整合、彙集和重現書中案例作品的人們。最後還要向雷絲里·萊普利（Lesley Ripley）致意，謝謝她努力生出這本《版型研究室》二版。

書中呈現的任何影像都已盡可能追蹤、釐清並標明適當的版權擁有者。然而若有不小心列名缺漏或失誤之處，出版者將盡力於下次印刷時修改。

Image credits: pp 6-7, 57, 130 and 172-173 © Studio Myerscough; pp 8, 67, 131, 188, 189, 190, 192, 193, 194, 195 © Skolos-Wedell; pp 9, 42-43 © designed and directed by hat-trick design; pp 13, 64-65, 68-69 Poulin+Morris: Jeffrey Totaro; p 14 Private Collection, Joerg Hejkal/Bridgeman Images; p 17 Boy Bastiaens; p 18 Printed communications materials for The Hepworth Wakefield. Design by A Practice for Everyday Life, 2010 Photograph © A Practice for Everyday Life; p 19 Victoria & Albert Museum, London UK/The Stapleton Collection/Bridgeman; p 20 JMW Turner, Diagrams after Samuel Cunn's Euclid's Elements of Geometry, Lecture Diagram: 'Euclid's Elements of Geometry', Book 4, Propositions 14, 19 © Tate Modern; p 23 (top) Galleria deli Uffizi, Florence, Italy Giraudon/ Bridgeman Images; p 23 (bottom) © 2014 The National Gallery, London/Scala, Florence; pp 24-25 © Jan Tschichold; pp 26-27 © We are Vast; p 41 (top) © 2014 Photo Scala, Florence; p 41 (bottom) © 2014. Photo Scala, Florence; pp 46, 141 Frost* Design for Zembla, pp 108-109 Frost* Design 'Get on Board', pp 120-121 Frost* Design for OzHarvest; p 49, 178 © Untitled Design; pp 52-53, 158-159, 166-167 © Thomas Manss & Company; pp 54-55 © João Nunes/Atelier Nunes e Pã; pp 56, 57 © Morag Myerscough, photo: Gareth Gardner; pp 58 (left), 58 (right), 59 Reproduced by Permission of Penguin Books Ltd, designer: David Pearson; pp 59 (left), 60-61, 202-204 © David Pearson; p 63 © Jovan Trkulja, Peter Gregson Studio; pp 70-71 Design: Planning Unit, Web development: busterdrummond.co.uk, pp 90-91 Design: Planning Unit, Web development: archivestudio.co.uk; p 72 Private Collection/Bridgeman Images; pp 73, 86 Design © Motherbird; pp 74-75 © Design is Play; P 77 © 2014 DeAgostini Picture Library/Scala, Florence; pp 95, 115 © Bedow; p 97 (top and bottom), 179 © 3 Deep; pp 102-103, Daria Martin—Sensorium Tests. Designed by A Practice for Everyday Life, published by JRP/Ringier, 2012. Photograph: © A Practice for Everyday Life; 116, 117 Pre-enactements by Steve Beard and Victoria Halford. Designed by A Practice for Everyday Life, Published by Book Works, 2013. Photograph: © A Practice for Everyday Life; pp 106-107, 114, 144-145 © C2F; p 111 Private Collection, De Agostini Picture Library/Bridgeman Images; pp 118, 180 © NB Studio; p 119 © Morse Studio; p 122 Design: F&B Happy; pp 126-127, 128-129 ©Purpose; pp 135, 138, 139 © Blast Studio; p 143 © Design: Cartlidge Levene; pp 148-149, 150-151 SEA; p 160 © Wout de Vringer; p 161 © Studio Output Ltd, photo by Philip Jackson Photography; pp 162-163, © Fabio Ongarato; pp 164-165, 187 © fliegende Teilchen; pp 168-169 © Ben Faydherbe for Faydherbe/De Vringer Design Studio; pp 170, 171 © 2014. Digital Image. The Museum of Modern Art, New York/Scala, Florence; pp 176-177 © Gabor Palotai Design; pp 182-185 Design: Bob Aufuldish; pp 197 © Grade Design, Peter Dawson; pp 198-201 © Designed by Michael Worthington with Ania Diakoff at Counterspace, Los Angeles; pp 208-209 Exercise: Thomas Wedell and Nancy Skolos; p 213 Exercise: John Paul Dowling; p 215 (top left) John Gilmore; p 215 (top right) Ah Rang Cho; p 215 (bottom) Lynne Yun; pp 214-215 Exercise: Richard Poulin; pp 212 Exercise: Bryan Clark; pp 210-211 Exercise: Michael Worthington and Gail Swanlund; pp 216-217 Exercise: Alexander Cooper, Rose Gridneff, Andrew Haslem.

版型研究室【長銷經典版】
學會平面設計中難懂的數學題&美學邏輯，最基礎的版型理論

作　　者　加文·安布羅斯Gavin Ambrose、保羅·哈里斯Paul Harris
譯　　者　莊雅晴
封面設計　白日設計
內頁設計　白日設計
內頁構成　詹淑娟
校　　對　吳小微
執行編輯　劉鈞倫

行銷企劃　王綬晨、邱紹溢、蔡佳妘
總　編　輯　葛雅茜
發　行　人　蘇拾平

出　　版　原點出版 Uni-Books
　　　　　Facebook: Uni-Books 原點出版
　　　　　Email: uni-books@andbook.com.tw
　　　　　10544 台北市松山區復興北路333號11樓之4
　　　　　電話：(02) 2718-2001　傳真：(02) 2719-1308

發　　行　大雁文化事業股份有限公司
　　　　　10544 台北市松山區復興北路333號11樓之4
　　　　　24小時傳真服務 (02) 2718-1258
　　　　　讀者服務信箱Email: andbooks@andbooks.com.tw
　　　　　劃撥帳號：19983379
　　　　　戶名：大雁文化事業股份有限公司

初版一刷　2019年9月
二版一刷　2023年8月

定價　　　490元

ISBN 978-626-7338-12-4 (平裝)
ISBN 978-626-7338-10-0 (EPUB)

國家圖書館出版品預行編目(CIP)資料
版型研究室 / Gavin Ambrose, Paul Harris著. --二版. --臺北市：原點出版：大雁文化發行, 2023.08
224面；17×23公分　譯自：The Layout Book, 2nd edition　ISBN 978-626-7338-12-4 (平裝)
　1.平面設計 2.版面設計
964.6
112010682